The

# ARTS

and the

# CREATION

of

# MIND

The
# ARTS
and the
# CREATION
of
# MIND

**ELLIOT W. EISNER**

YALE UNIVERSITY PRESS/NEW HAVEN & LONDON

Published with assistance from the foundation
established in memory of Philip Hamilton McMillan of
the Class of 1894, Yale College.

Designed by Mary Valencia
Set in Meridien type by Integrated Publishing Solutions.
Printed in the United States of America by R.R. Donnelley & Sons,
Harrisonburg, Virginia.

The Library of Congress has cataloged the hardcover edition as follows:
Eisner, Elliot W.
    The arts and the creation of mind / Elliot W. Eisner.
        p.    cm.
Includes bibliographical references and index.
    ISBN 0-300-09523-6 (cloth : alk. paper)
    1. Art—Study and teaching—Philosophy.  2. Art and society  3.
    Art—Study and teaching—United States.   I. Title.
    N84. E38 2002
    707'.1'273—dc21                                          2002005871

A catalogue record for this book is available from the British Library.

The paper in this book meets the guidelines for permanence and durability
of the Committee on Production Guidelines for Book Longevity
of the Council on Library Resources.
ISBN 0-300-10511-8 (pbk. : alk. paper)
10 9 8 7 6 5

*For my grandsons, Ari, Seth, and Drew. "MAY THE FORCE BE WITH YOU."*

# CONTENTS

# ACKNOWLEDGMENTS

My interest in the visual arts began in elementary school. In fact the visual arts were a source of salvation for me at both the elementary and secondary school levels; I might not have got through without them. Upon graduating from my secondary school in Chicago, I enrolled as a student in the School of the Art Institute of Chicago and later in the Institute of Design of the Illinois Institute of Technology. After completing a master's degree at the Institute of Design of the Illinois Institute of Technology, I taught art in the Chicago Public Schools and later at the Laboratory School of the University of Chicago. I have worked in the field of art education for over thirty-five years. Much of what I have to say about the arts in education has been informed by my experience as a painter and as a teacher of art.

In the preparation of this book, as anyone knows who has written one, debts are owed to many people. Some are owed to scholars whose work has influenced my thinking, including the values I embrace. Rudolf Arnheim, John Dewey, Nelson Goodman, and Susanne Langer, from the philosophic arena, are among those to whom I owe my deepest philosophical debts.

In the arts in education, among many others I am indebted to Manual Barkan, David Ecker, Edmund Feldman, Jerome Hausman, and Ellen Winner.

In the field of education I am indebted to Mike Atkin, Tom Barone, Larry Cuban, Stephen Dobbs, Howard Gardner, Maxine Greene, Philip Jackson, Ray McDermott, and Alan Peshkin.

Among the most important of those on whom I have depended and tested ideas, and with whom I have consulted, are my former students. Over many years, students come to shape your life in a multitude of ways. They challenge, cajole, deflate, and encourage. I am surely indebted to those I have had the privilege of teaching.

I also wish to thank Rebecca Chan and Mary Li, from Macao and Hong Kong, respectively, for their assistance in securing for me student work done in Rebecca's class. She is an extraordinary teacher of art, and when I had the opportunity to obtain her students' work, I took advantage of the opportunity with alacrity.

Several colleagues read and commented on the manuscript in draft form. It is better because of their advice. I want to thank Hilary Austen, Doug Boughton, Kerry Freedman, and Mary Ann Stankiewicz for their helpful advice.

I especially want to express my appreciation to Shifra Schonmann for her careful and helpful constructive review of the entire manuscript. Her assistance has been invaluable.

Finally, there are two others for whom my gratitude is boundless. The first is Tanya Chamberlain, my secretary, friend, and utility infielder at Stanford. This book simply would not have been written without her care and constructive assistance in finding just the right material for me, often before I knew I needed it. She provided what I needed in countless ways.

To my wife, Ellie, I express my deepest gratitude. She knew when to afford me space, when to allow me to work on the dining room table rather than in my study, and when to turn up the heat so that I maintained the focus I needed to write coherent prose. I owe her more than I can say.

# INTRODUCTION

*The Arts and the Creation of Mind* situates the arts in our schools and examines how they contribute to the growth of mind. Traditional views of cognition and the implications of these views for the goals and content of education have put the arts at the rim, rather than at the core, of education. Schools see their mission, at least in part, as promoting the development of the intellect. "Hard" subjects such as mathematics and science are regarded as primary resources for that development, and the processes of reading, writing, and computing are believed to be the best means for cultivating the mind. We want, especially in America today, a tough curriculum, something rigorous, a curriculum that challenges students to think and whose effects are visible in higher test scores. At best the arts are considered a minor part of this project.

Although the arts in American schools are *theoretically* among the so-called core subjects, and although school districts and indeed the federal government identify them as such, there is a huge ambivalence about their position in the curriculum. No one wants to be regarded as a philistine. Yet at the same time privilege of place is generally assigned to other subject areas. Despite the recent hoopla about their contributions to academic performance, the arts are regarded as nice but not necessary.

One aim of *The Arts and the Creation of Mind* is to dispel the idea that the arts are somehow intellectually undemanding, emotive rather than reflective operations done with the hand somehow unattached to the head. In the following pages I advance quite a different view. I argue that many of the most complex and subtle

forms of thinking take place when students have an opportunity either to work meaningfully on the creation of images—whether visual, choreographic, musical, literary, or poetic—or to scrutinize them appreciatively. To be able to create a form of experience that can be regarded as aesthetic requires a mind that animates our imaginative capacities and that promotes our ability to undergo emotionally pervaded experience. Perception is, in the end, a cognitive event.[1] What we see is not simply a function of what we take from the world, but what we make of it.

The world that students now live in and that they will enter as adults is riddled with ambiguities, uncertainties, the need to exercise judgment in the absence of rule, and the press of the feelingful as a source of information for making difficult choices. Whether work in the arts has consequences that extend to all aspects of the world cannot now be determined with any degree of confidence. What can be determined with a high degree of confidence is that work in the arts evokes, refines, and develops thinking in the arts. We might cautiously reason that meaningful experience in the arts might have some carryover to domains related to the sensory qualities in which the arts participate.

But carryover to the extra-artistic or extra-aesthetic aspects of life is not, in my view, the primary justification for the arts in our schools. The arts have distinctive contributions to make. I count among them the development of the thinking skills in the context of an art form, the expression and communication of distinctive forms of meaning, meaning that only artistically crafted forms can convey, and the ability to undergo forms of experience that are at once moving and touching, experiences of a consummatory nature, experiences that are treasured for their intrinsic value. These are experiences that can be secured when one attends to the world with an aesthetic frame of reference and interacts with forms that make such experience possible.

But the arts do more than serve the needs of individuals, as important as such a contribution might be. The arts, I argue, can serve as models of what educational aspiration and practice might be at its very best. To be able to think about teaching as an artful undertaking, to conceive of learning as having aesthetic features,

to regard the design of an educational environment as an artistic task—these ways of thinking about some of the commonplaces of education could have profound consequences for redesigning the practice of teaching and reconceiving the context in which teaching occurs.

We have had a tendency, especially in the United States, to embrace a form of technical rationality designed to assuage our anxiety about the quality of our schools. The tack that we have taken is to specify in no uncertain terms our expectations, to prescribe content and procedures related to them—"alignment" it is called—and then to monitor and to measure the consequences. The tacit view is to create an efficient system, a system that will help us achieve, without surprise or eventfulness, the aims that we seek.

The arts, in contrast, have little room on their agenda for efficiency, at least as a high-level value. Efficiency is largely a virtue for the tasks we don't like to do; few of us like to eat a great meal efficiently or to participate in a wonderful conversation efficiently, or indeed to make love efficiently. What we enjoy the most we linger over. A school system designed with an overriding commitment to efficiency may produce outcomes that have little enduring quality. Children, like the rest of us, seldom voluntarily pursue activities for which they receive little or no satisfaction. Experiencing the aesthetic in the context of intellectual and artistic work is a source of pleasure that predicts best what students are likely to do when they can do whatever they would like to do.

As you read this book, you will find that it often dances between references to art, by which I mean the visual arts, and references to the arts, by which I mean all the arts. I am afraid that consulting the context is the only way to resolve this potential ambiguity. I hope that this acknowledged inconsistency will cause no consternation.

Another issue that should be mentioned has to do with my conviction that not all works of art are created equal. There are human achievements in every culture on this earth that represent the quintessential attainments of the human imagination, works of such stunning accomplishment that they alter the ways in which those who see or hear or read them look upon the world.

At the same time, I want to acknowledge that any practice whatsoever can have aesthetic or artistic qualities. This includes three-year-olds building castles in the sand as well as surgeons engaged in a life-sustaining operation. What is aesthetic depends at least in part on the way some feature of the phenomenal world is addressed. Castles in the sand may be among the beginning efforts. It falls to those of us in education to try to design the situations in which children's efforts become increasingly more sophisticated, sensitive, imaginative, and skilled. This is no small task, and no minor achievement when realized.

# 1 THE ROLE OF THE ARTS IN TRANSFORMING CONSCIOUSNESS

*EDUCATION IS THE PROCESS OF LEARNING HOW TO INVENT YOURSELF*

To understand the role of the arts in transforming consciousness we must start with the biological features of the human organism, for it is these features that make it possible for us humans to establish contact with the environment in and through which we live. That environment is, in its most fundamental state, a qualitative one made up of sights and sounds, tastes and smells that can be experienced through our sensory system. Although the world of the newborn may indeed be the blooming, buzzing confusion that William James once described, it is, even in its apparently chaotic condition, an empirical environment, an environment that all humans, even newborns, can experience.[1]

Experiencing the environment is, of course, a process that continues throughout life; it's the very stuff of life. It is a process that is shaped by culture, influenced by language, impacted by beliefs, affected by values, and moderated by the distinctive features of that part of ourselves we sometimes describe as our individuality. We humans give simultaneously both a personal and a cultural imprint to what we experience; the relation between the two is inextricable. But despite these mediating factors, factors that personalize and filter experience, our initial contact with the empirical world is dependent upon our biologically evolved sensory system. That

system, an extension of our nervous system, is, as Susanne Langer says, "the organ of the mind." Listen as Susanne Langer, in her classic *Philosophy in a New Key,* describes the connection between the sensory system and the mind:

> The nervous system is the organ of the mind; its center is the brain, its extremities the sense-organs; and any characteristic function it may possess must govern the work of all of its parts. In other words, the activity of our senses is "mental" not only when it reaches the brain, but in its very inception, whenever the alien world outside impinges on the furthest and smallest receptor. All sensitivity bears the stamp of mentality. "Seeing," for instance, is not a passive process, by which meaningless impressions are stored up for the use of an organizing mind, which constructs forms out of these amorphous data to suit its own purposes. "Seeing" is itself a process of formulation; our understanding of the visible world begins in the eyes.[2]

The senses are our first avenues to consciousness. Without an intact sensory system we would be unaware of the qualities in the environment to which we now respond. That absence of consciousness would render us incapable of distinguishing friend from foe, of nourishing ourselves, or of communicating with others.

The ability to experience the qualitative world we inhabit is initially reflexive in character; we are biologically designed to suckle, to respond to temperature, to be sated with milk. Our biological system is designed to enable us to survive—with the help of others.[3] But we also learn. We learn to see, to hear, to discern the qualitative complexities of what we taste and touch. We learn to differentiate and discriminate, to recognize and to recall. What first was a reflex response, a function of instinct, becomes a gradual search for stimulation, differentiation, exploration, and eventually for meaning. Our sensory system becomes a means through which we pursue our own development. But the sensory system does not work alone; it requires for its development the tools of culture: language, the arts, science, values, and the like. With the aid of culture we learn how to create ourselves.

The term *culture* is said to have hundreds of meanings. Two are particularly relevant to education, one anthropological, the other

biological. A culture in the anthropological sense is a shared way of life. But the term *culture* in the biological sense refers to a medium for growing things. Schools, I believe, like the larger society of which they are a part, function as cultures in both senses of the term. They make possible a shared way of life, a sense of belonging and community, and they are a medium for growing things, in this case children's minds. How schools are organized, what is taught in them, the kind of norms they embrace, and the relationships they foster among adults and children all matter, for they all shape the experiences that students are likely to have and in the process influence who children will become. Experience is central to growth because experience is the medium of education.[4] Education, in turn, is the process of learning to create ourselves, and it is what the arts, both as a process and as the fruits of that process, promote. Work in the arts is not only a way of creating performances and products; it is a way of creating our lives by expanding our consciousness, shaping our dispositions, satisfying our quest for meaning, establishing contact with others, and sharing a culture.

Humans, of all living species, have the distinctive, if perhaps not the unique, ability to create a culture through which those in their community can grow. Humans can leave a legacy. Even chimpanzees, our closest genetic relatives, have, as far as we know, no cultural development that is transmitted in a progressive way from generation to generation.[5] Three hundred years ago chimps lived as they do today. We are not only able to experience the qualitative world, as can chimps; we can also form concepts. Concepts are distilled images in any sensory form or combination of forms that are used to represent the particulars of experience. With concepts we can do two things that may very well be unique to our species: we can imagine possibilities we have not encountered, and we can try to create, in the public sphere, the new possibilities we have imagined in the private precincts of our consciousness. We can make the private public by sharing it with others.

Transforming the private into the public is a primary process of work in both art and science. Helping the young learn how to make that transformation is another of education's most important aims.

It is a process that depends initially upon the ability to experience the qualities of the environment, qualities that feed our conceptual life and that we then use to fuel our imaginative life.

I do not want to draw too sharp a distinction between the formation of concepts and the imaginative generation of the forms needed to create, for example, twentieth-century architecture or the improvisational riffs of an Ella Fitzgerald solo; concept formation is itself an imaginative act. Yet there is a difference between recalled images and their imaginative transformation. Were we limited to the recall of the images we had once experienced, cultural development would be in trouble. Imagination gives us images of the possible that provide a platform for seeing the actual, and by seeing the actual freshly, we can do something about creating what lies beyond it. Imagination, fed by the sensory features of experience, is expressed in the arts through the image. The image, the central term of imagination, is qualitative in character. We do indeed see in our mind's eye.

## THE ROLE OF THE ARTS IN REFINING THE SENSES AND ENLARGING THE IMAGINATION

The arts have an important role to play in refining our sensory system and cultivating our imaginative abilities. Indeed, the arts provide a kind of permission to pursue qualitative experience in a particularly focused way and to engage in the constructive exploration of what the imaginative process may engender. In this sense, the arts, in all their manifestations, are close in attitude to play.[6] Constraints on the imagination are loosened. In the arts, in the West at least, permission is provided to explore, indeed to surrender, to the impulsions the work sends to the maker, as well as those sent from the maker to the work. We see this perhaps most vividly when we watch preschoolers engaged in play. It is during this period that children take special pleasure in the sheer exploration of the sensory potential of the materials they use. It is at this time that their imaginative abilities, uninhibited by the constraints of culture, make it possible for them to convert a stick of wood into a plane they can fly, a sock into a doll they can cuddle, or an array of lines

drawn so they stand for daddy. For young children the sensory world is a source of satisfaction, and imagination a source of exploratory delight. And it is these inclinations toward satisfaction and exploration that enlightened educators and parents wish to sustain rather than to have dry up under the relentless impact of "serious" academic schooling. A culture populated by a people whose imagination is impoverished has a static future. In such a culture there will be little change because there will be little sense of possibility.

Imagination, that form of thinking that engenders images of the possible, also has a critically important cognitive function to perform aside from the creation of possible worlds. Imagination also enables us to try things out—again in the mind's eye—without the consequences we might encounter if we had to act upon them empirically. It provides a safety net for experiment and rehearsal.[7]

As for sensibility, the arts invite us to attend to the qualities of sound, sight, taste, and touch so that we experience them; what we are after in the arts is the ability to perceive things, not merely to recognize them.[8] We are given permission to slow down perception, to look hard, to savor the qualities that we try, under normal conditions, to treat so efficiently that we hardly notice they are there.

Sensibility and imagination can, of course, remain entirely private affairs: we can enjoy the rosy radiance of dusk in private, the colored brilliance of a Cézanne still life in silence, the symmetrical strength of a Baule mask in quiet awe. The contents of our imaginative life can be kept to ourselves. Appreciation, though active, can be mute. Something else is needed if the products of our imagination are to make a social contribution to our culture. That something else is representation.

THE MEANING OF REPRESENTATION

Representation, like sensibility and imagination, also performs critically important cognitive functions. Consider the process through which it occurs.

Representation can be thought of, first, as aimed at transforming the contents of consciousness within the constraints and affordances of a material.[9] Representation can and often does begin with an elusive and sometimes evanescent idea or image. I say evanescent because there is nothing quite so slippery as an idea; here now, gone a moment later. Images emerge and, like the subtle changes of the setting sun, may be altered irrevocably with a blink of the eye. Representation stabilizes the idea or image in a material and makes possible a dialogue with it. It is through "inscription" (I use the term metaphorically) that the image or idea is preserved—never, to be sure, in the exact form in which it was originally experienced, but in a durable form: a painting is made, a poem is written, a line is spoken, a musical score is composed.

It is through this very concreteness that representation makes possible a second, critically important process of editing. Although editing is usually associated with writing, it occurs in all art forms—painting and sculpture, music performance and music composition, theater, film and video, dance, and the rest. Editing is the process of working on inscriptions so they achieve the quality, the precision, and the power their creator desires. It is through the editing process that attention to the "wee bit" that Tolstoy believed defined art is conferred upon a work.[10] It is in the process of editing that transitions are made graceful, colors harmonized, intensities modulated, and, indeed, seasoning to suit the palette adjusted. In the domain of writing, editing allows us carefully to inspect the precision of language, the aptness of metaphor, the logic of argument. In painting it consists in brightening a passage of color. In music it involves shifting to the minor mode. In dance it is changing the pace of a movement. Editing is paying attention to relationships and attending to details; it is a process of making the work, work. Unless one is a genius, editing is a crucial aspect of the creative process, a way of removing the rough edges from one's work.

Inscription and editing are directly related to a third cognitive function of representation, one we usually take for granted: communication. The transformation of consciousness into a public form, which is what representation is designed to do, is a necessary condition for communication; few of us read minds. How this trans-

formation occurs, I believe, is taken much too much for granted. It is so natural a process that we hardly notice it. Yet we can ask, "How does speech, or an imagined image, or a melody we hear in our head get communicated? What must the maker do? And then what must the 'reader' do for it to make sense, that is, to be meaningful?"

What is clear is that culture depends upon these communications because communication patterns provide opportunities for members of a culture to grow. We develop, in part, by responding to the contributions of others, and in turn we provide others with material to which they respond. The relationship, at its best, is symbiotic. Thus the social contribution of the educational process is to make it possible for individuals to create symbiotic relationships with others through the development of their distinctive and complementary abilities and in so doing to enrich one another's lives.

Inscribing, editing, and communicating are three cognitive processes used in the act of representation. As I have described them, each appears as if the process of representation occurred from the top down, that is, from idea or image, through the hand, into the material, and then into the head of an eager reader of text or image, sound, or movement. However, the process is not so linear. The process of representation is more of a conversation than it is like speaking into a tape recorder. The ideas and images are not so much blueprints for action detailing specific directions and destinations; they are more like embarkation points. Once into the sea, the ship rides the currents of the ocean, which also help set the course. In the process of working with the material, the work itself secures its own voice and helps set the direction. The maker is guided and, in fact, at times surrenders to the demands of the emerging forms. Opportunities in the process of working are encountered that were not envisioned when the work began, but that speak so eloquently about the promise of emerging possibilities that new options are pursued. Put succinctly, surprise, a fundamental reward of all creative work, is bestowed by the work on its maker.

Thus we can add to inscription, editing, and communication a fourth cognitive function of representation, the discovery of ends in process, which in turn generates surprise. Surprise is itself a source

of satisfaction. Familiarity and routine may provide security, but not much in the way of delight. Surprise is one of the rewards of work in the arts. In addition, it is from surprise that we are most likely to learn something. What is learned can then become a part of the individual's repertoire, and once it is a part of that repertoire, new and more complex problems can be generated and successfully addressed. At the same time it must be acknowledged that it is quite possible to do something very well in a particular work and not know how to repeat it.

The process of representation is always mediated through some form. Some of these forms are carried by the meanings that language makes possible, including prosody, the cadences and melodies of the language itself. The way language is crafted, especially through its form and its connotative qualities, expresses emotions and adumbrates meanings that cannot be conveyed through literal denotation. But language, while a central and primary form of representation, is by no means the only form of representation. Forms that appeal to our sense of sight are also fundamental modes of communication and have been since humans inscribed images on the walls of the caves in Lascaux some seventeen thousand years ago. Sound in the form of music is also a means through which meanings are conveyed. Indeed, there is no sensory modality that humans have not used to express what imagination has generated. Forms of representation are means through which the contents of consciousness are made public. The process of making the contents of consciousness public is, as I indicated earlier, a way of discovering it, stabilizing it, editing it, and sharing it.

The selection of a form of representation is a choice having profound consequences for our mental life, because choices about which forms of representation will be used are also choices about which aspects of the world will be experienced. Why? Because people tend to seek what they are able to represent. If your camera is loaded with black-and-white film, you look for shadows, for light and dark, but if the same camera is loaded with color film, you seek color. What the film in your camera can do influences what you will do. If the only tool you have is a yardstick, you look for what you can measure. Put another way, the tools you work with

influence what you are likely to think about. Measuring tools lead to quantification; the tools used in the arts lead to qualification.

Consider the implications of the relationship between forms of representation for the selection of content in the school curriculum. Learning to use particular forms of representation is also learning to think and represent meaning in particular ways. How broad is the current distribution? What forms of representation are emphasized? In what forms are students expected to become "literate"? What modes of cognition are stimulated, practiced, and refined by the forms that are made available? Questions such as these direct our attention to the relationship of the content of school programs to the kinds of mental skills and modes of thinking that students have an opportunity to develop. In this sense, the school's curriculum can be considered a mind-altering device.[11] And it should be.

Although we seldom think about the curriculum this way, parents send their children to school to have their minds made. In school, children learn how to think about the world in new ways. The culture provides the options in the various fields of study included, and various communities make the selections through choices reflected in graduation requirements, state education codes, college admission requirements, and the like. These selections are among the most significant policy decisions a community can make. Such decisions help influence how we think.

## THE COGNITIVE FUNCTIONS OF THE ARTS

What are the cognitive functions performed by the arts? By the term *cognition* I mean to include all those processes through which the organism becomes aware of the environment or its own consciousness. It includes the most sophisticated forms of problem-solving imaginable through the loftiest flights of the imagination. Thinking, in any of its manifestations, is a cognitive event. The noncognitive pertains to forms of life of which we have no awareness. Blood flows through our veins, but typically we are not aware of the course it takes. Events occur about which we are unaware. This is not to say that factors about which we are unaware cannot

influence our behavior or attitudes; they can. But to the extent that we are unaware of them, those events are outside the realm of cognition.

With respect to art and its meaning, I share Dewey's view that art is a mode of human experience that in principle can be secured whenever an individual interacts with any aspect of the world. The arts are typically crafted to make aesthetic forms of experience possible. Works of art do not ensure that such experience will emerge, but they increase the probability that it will as long as those in their presence are inclined to experience such work with respect to their aesthetic features. The Parthenon and the Sistine ceiling can be ignored by someone in their presence; yet even a stone can be attended to so that its aesthetic character can serve as a source of that special form of life we call art.

One cognitive function the arts perform is to help us learn to notice the world. A Monet landscape or a Paul Strand photograph makes possible a new way of seeing: Monet's shimmering color gives us a new way to see light. Paul Strand's photographs provide a new way to experience the geometry of industrial cities. Art provides the conditions for awakening to the world around us. In this sense, the arts provide a way of knowing.

Aside from promoting our awareness of aspects of the world we had not experienced consciously before, the arts provide permission to engage the imagination as a means for exploring new possibilities. The arts liberate us from the literal; they enable us to step into the shoes of others and to experience vicariously what we have not experienced directly. Cultural development depends upon such capacities, and the arts play an extraordinarily important role in their contribution to such an aim.

Work in the arts also invites the development of a disposition to tolerate ambiguity, to explore what is uncertain, to exercise judgment free from prescriptive rules and procedures. In the arts, the locus of evaluation is internal, and the so-called subjective side of ourselves has an opportunity to be utilized. In a sense, work in the arts enables us to stop looking over our shoulder and to direct our attention inward to what we believe or feel. Such a disposition is at the root of the development of individual autonomy.

Another cognitive function of the arts is that in the process of creation they stabilize what would otherwise be evanescent. Ideas and images are very difficult to hold onto unless they are inscribed in a material that gives them at least a kind of semipermanence. The arts, as vehicles through which such inscriptions occur, enable us to inspect more carefully our own ideas, whether those ideas emerge in the form of language, music, or vision. The works we create speak back to us, and we become in their presence a part of a conversation that enables us to "see what we have said."

Finally, the arts are means of exploring our own interior landscape. When the arts genuinely move us, we discover what it is that we are capable of experiencing. In this sense, the arts help us discover the contours of our emotional selves. They provide resources for experiencing the range and varieties of our responsive capacities.

To discover the cognitive functions of other visual forms of representation, consider the use of maps. Why do we draw them? Why do we use them? Maps are drawn and used because they help us grasp relationships that would be harder to grasp, for example, in narrative or number. We use maps because they display, by a structural analogue, relationships in space that provide a useful image of the world we wish to navigate. Maps lay it out for us. So do histograms, charts, diagrams, and sketches. The inscription of visual images makes vivid certain relationships. They help us to notice and understand a particular environment and our place in it.

They also obscure. Thus the paradox: a way of seeing is also, and at the same time, a way of not seeing. Relationships that are made visible through maps also obscure what any particular map does not illuminate—the feel of a place, its look and color, what is idiosyncratic about it, its aroma, the lifestyles of the people who live there. Maps effectively simplify. We want them to, but we should not forget that the map is not the territory. The view they provide is always partial—as is any view. And precisely because any single view is partial, it is important, depending upon our purpose, to secure other views that provide other pictures.

I have been speaking of the cognitive functions of the arts largely in terms of the way they illuminate, that is, what they help

us see. But the arts go well beyond making visible the visible; they also tell us something about how places and relationships feel. They speak to us, as Susanne Langer said, through the emotions: "A work of art presents feeling (in the broad sense I mentioned before, as everything that can be felt) for our contemplation, making it visible or audible or in some way perceivable through a symbol, not inferable from a symptom. Artistic form is congruent with the dynamic forms of our direct sensuous, mental, and emotional life; works of art are projections of 'felt life,' as Henry James called it, into spatial, temporal, and poetic structures. They are images of feeling, that formulate it for our cognition."[12]

Through the arts we learn to see what we had not noticed, to feel what we had not felt, and to employ forms of thinking that are indigenous to the arts. These experiences are consequential, for through them we engage in a process through which the self is remade. What are the features of this transformational process? How does it proceed? What does it mean in the context of education?

## THE ARTS AND PERSONAL TRANSFORMATION

Every task and each material with which we work both imposes constraints and provides opportunities for the development of mind. For example, if students are to develop their ability to think metaphorically, they need opportunities, examples, and encouragement to use metaphors in their speech and writing. The ability to think metaphorically is not the outcome of a single occasion; it requires repeated opportunities to explore the poetic use of language, a use of language that generates meaning through indirection, allusion, and innuendo. It is literalism that suppresses the almost natural tendency to use language poetically, as very young children often do. Similarly, if students are to learn to see and talk about visual qualities, they need occasions for such seeing and talking.

Seeing is an achievement, not merely a task.[13] It is the result of *making* sense of a part of the world. Learning to see the qualities that constitute a visual field requires a mode of attention that is rarely employed in "ordinary" living. Most of our so-called seeing

is instrumental in nature. We see in order to recognize, and recognition, according to Dewey, is completed as soon as a label is attached to what we have seen. In such "seeing," seeing is aborted.[14] It is stopped well before the qualities of the visual field are explored. When the qualities of the visual field are explored, the stage is set for their public articulation.

Developing a language with which to talk about visual qualities is an attitudinal as well as a linguistic achievement.[15] To talk about qualities of a visual field—how, for example, colors and forms play off each other—often requires the use of simile and the invention of words—neologisms—that will, through innuendo more than through explicit language, convey the distinctive sense of the qualities perceived. Again, the skillful use of such language is the result of having developed both certain modes of thought and a receptive attitude toward their use. When teachers provide opportunities for students to engage in tasks that practice such skills and attitudes, they are providing opportunities for the development of mind. And when they organize the tasks students address so that students learn to connect what they have learned in their school to the world beyond it, they are developing their students' ability to extend and apply what they have learned to other domains, a process that in the psychological literature is referred to as transfer, an ability teachers are encouraged to foster.[16]

The point here is that the kind of deliberately designed tasks students are offered in school help define the kind of thinking they will learn to do. The kind of thinking students learn to do will influence what they come to know and the kind of cognitive skills they acquire. As I said earlier, the curriculum is a mind-altering device. We design educational programs not merely to improve schools, but also to improve the ways in which students think. Each of the fields or disciplines that students encounter provides a framework, that is, a structure, schema, and theory, through which the world is experienced, organized, and understood. Each imposes different demands upon the student. Different fields, for example, require the use of different techniques and an understanding of the materials and ideas that will be used. In a sense, we get smart with a form of representation as we discover its limits and

possibilities, what it will do and what it won't. Let me illustrate by describing the forms of thinking used in watercolor painting.

Watercolor is an unforgiving medium. By this I mean that watercolor does not tolerate indecisiveness well. Mistakes are hard to camouflage. Unlike oil painting, in which changes of mind can be covered up, in watercolor everything shows. The practical implications of this fact are significant. Timing is crucial. A sheet of watercolor paper that has been soaked with water in preparation for pigment dries at different rates depending on the amount of water it has received, the ambient temperature, and the amount of time that has elapsed since it was soaked. Since the amount of wetness the paper possesses affects the flow of pigment, knowing when to apply a brush charged with pigment is crucial. This form of knowing also requires one to know how much pigment is on the brush; too much for the amount of water on the paper will make the color puddle or bleed. How does one know how much pigment is on the brush? One way is to be aware of the weight of its tip, a very fine-grained assessment that experienced watercolorists possess.

Even when these skills have been mastered, the watercolorist needs to think strategically. Strategic thinking in watercolor painting means deciding what must be painted in what order. Because watercolors are transparent, dark colors will cover light colors or be altered by them. Thus, knowing when to leave white space on the paper and when to lay a colored wash on the paper is of critical importance if the work is to cohere visually. Here, too, timing and tempo matter.

But although timing is critical, it is essentially a technical achievement. The aesthetic aspects of the work must also be addressed. How forms relate to the artist's intention, how colors interact, and how vitality is maintained so that the image is not dead on arrival are at the heart of the artistic enterprise. And because the "variables" are so numerous and complex and because there are no formulas to employ to guarantee a rightness of fit, an immersed engagement, one that commands all of one's attention and intelligence is necessary. Indeed, regarding the demands upon intelligence in creating a work of art, John Dewey had this to say:

Any idea that ignores the necessary role of intelligence in the production of works of art is based upon identification of thinking with use of one special kind of material, verbal signs and words. To think effectively in terms of relations of qualities is as severe a demand upon thought as to think in terms of symbols, verbal and mathematical. Indeed, since words are easily manipulated in mechanical ways, the production of a work of genuine art probably demands more intelligence than does most of the so-called thinking that goes on among those who pride themselves on being 'intellectuals.'[17]

What occurs as individuals become increasingly competent in watercolor painting is the development of intelligence in that domain. This development requires the ability to deal effectively with multiple demands simultaneously.[18] And it is in learning to engage in that process that perception is refined, imagination stimulated, judgment fostered, and technical skills developed. Given the complexities of these demands it is ironic that the arts should be widely regarded as noncognitive.

Thus far we have talked about the role of the senses in concept formation, the function of the imagination in envisioning worlds we can create, and the process of representation through which inscription, editing, communication, and discovery take place. But how do forms of representation become meaningful? How do they come to express or refer? Let me describe three ways in which artists treat forms of representation so that they affect how meanings are conveyed.

## THREE MODES OF TREATMENT

One mode of treatment is *mimetic*. By mimetic I refer to forms that look or sound like what they are intended to represent. For centuries artists struggled with the development of techniques through which to put (visual) "holes" in canvases; they were concerned with inventing ways to create the illusion of the third dimension, and in the West, around the fifteenth century, they began to find out how.[19] In Western culture many children from about eight to

twelve years of age desire to learn how to create convincing illusion. Artistic progress in their eyes is defined by the mimetic quality of their rendering. If an adult should suggest that they use their imagination to draw an animal, the suggestion may be rejected as a cop-out; they want their animal to look like a *real* animal!

Mimesis, however, need not achieve a high level of verisimilitude. Consider signage designating men's and women's rest rooms. Here the simplified structural features of male and female forms are enough to designate. Indeed, in this situation a simplified image is preferable: it communicates more easily than one that is individualized through detail excessive for its function. What is wanted is an image that is both general and specific enough to differentiate men from women.

We find such forms used by young children. According to Rudolf Arnheim, children create within the affordances of the material with which they work the *structural equivalences* of the images they wish to render.[20] And because the drawings made by children between four and eight are often didactic in aim—that is, children of this age are often more interested in depicting a set of events or a story than in mastering the ability to create verisimilitude—the relevant criterion for them is whether their image is sufficient to depict the story. This concern with the didactic or storytelling functions of visual form often leads to the use of visual conventions that stand for the subject they wish to represent. Thus, pictures of houses with peaked roofs can be found in the drawings of children who live in suburban neighborhoods in which there are no houses with peaked roofs. Children acquire visual conventions to stand for a house, or tree, or person, or sun, or bird. In fact many of these conventions are widely shared by children in our culture. The peaked-roof houses are also often drawn with windows having curtains pulled to each side.

Mimesis is not the only way of representing images and conveying meaning. The arts can depict not only what is seen or heard; they can also depict what is felt. This brings us to a second mode of treatment, the creation of *expressive form*.

The representation of feeling is achieved in many ways. Perhaps the most important is the way in which visual form—line,

color, shape, value, texture, all aspects of form—is composed. Those working in music, dance, literature, poetry, and theater craft other qualities for expressive purposes. According to Gestalt theory, the forms that artists create generate fields of energy that are picked up by our nervous system, which in turn creates a resonance in the perceiver. Thus, fast and loud music produces a kind of experiential equivalent in the listener; slow and soft music creates a quite different resonance and hence a different experience. By manipulating form, artists manipulate experience.

But if all responses could be explained by the formal relations among the composed qualities of the artwork, everyone's response to the same visual form would be essentially alike. Clearly, it isn't. Culture and personal experience interact. The meaning secured from a work depends not only on the features of the work but also on what the individual brings to it. Different backgrounds lead to different experiences of the same work. A painting of Jesus for a practicing Catholic takes on a meaning different from that for an agnostic. A person who has long collected nonobjective painting and who understands its place in the history of art is likely to experience a painting by Willem de Kooning quite differently from someone who has never heard of Abstract Expressionism.

Nevertheless, the primary point should not be lost: the way forms are treated by the artist—or by the child—has a great deal to do with what the work expresses. And it is the possession of a fertile imagination and an array of technical skills that enable artists to shape forms that influence how we feel in their presence.

The crafting of expressive form does not preclude the presence of mimetic forms. On the contrary. Nonobjective art is a comparatively recent arrival on the artistic landscape. The religious paintings made in Europe in the thirteenth century secure their tranquillity from the way the monks who painted them treated form. That treatment is found in the way figures are depicted as well as in the way the entire composition is organized. Again, young children can create similar effects, more often through accident than through the intentional and the reflective control of the material. Yet their paintings and drawings also evoke emotion through the way forms are rendered. In fact, *all* forms possess what are called

physiognomic properties.[21] That is, all forms possess qualities that express or evoke feeling or emotion. In the arts the expressive character of forms is brought under the intelligent control of experience and technique. Artists, by virtue of their experience and technical skills, are able to compose form in the service of feeling. Thus, artistry requires, in part, the ability to conceive of the emotional quality desired and the technical ability to compose form capable of evoking the feeling or emotion desired.

A third mode of treatment occurs through the use of *conventional signs*. Conventional signs are socially agreed-upon symbols that refer to ideas, objects, or events and the like. A flag made up of fifty white stars on a blue field and thirteen red and white stripes is likely to refer in certain contexts to the United States of America; a cross and a six-sided star in certain contexts refer by social agreement to two different religions.

You will notice that I restricted the meaning of these conventional signs with the qualifier "in certain contexts." The qualification is necessary because meaning is always influenced by the particular context in which a work appears. The American flag can mean one thing on the grave of a dead soldier and quite another on the floor of an art museum. In fact artists frequently place familiar conventional signs in unusual contexts to awaken us from our customary modes of perception. These contexts evoke meanings that depend on "the shock of the new." Perhaps some of the most vivid examples of visual recontextualization are to be found in Surrealism and some kinds of Pop Art.

The study of conventional signs in the arts is the focus of a field called iconology. Iconologists study symbols that do not necessarily look like what they refer to or represent but that nevertheless refer to them: the golden fleece, the mirror, the cross, the key, the lantern all have iconographic meaning. A viewer would need to understand the significance of these signs and symbols in order to secure a "full reading" of the picture.

What we find in looking at art is that artists often employ all three modes of treatment in the same work. And so too do children. The ability to create images in which mimesis, expressiveness, and conventional signs convey the creator's aims is a sub-

stantial cognitive accomplishment. It requires a repertoire of technical skills, a sensitivity to relationships among the forms, and the ability to use appropriate conventional signs. The kind of thinking required to create such images cannot be conducted by appeals to algorithms, formulas, or recipes. And even when the schema for the creation of forms is familiar, there is always significant uniqueness in the particular configuration, so that the formulaic use of such a schema is unlikely to achieve a satisfying aesthetic resolution. Somatic knowledge must be employed.[22]

Somatic knowledge, what is sometimes called embodied knowledge, is experienced in different locations. Some images resonate with our gut, others with our eyes, still others with our fantasies; artists play with our imagination. Some visual images are essentially tactile experiences. Works of art can call upon both the ideational and any of the sensory resources we use to experience the world; the fact that an image is visual does not mean that the experience we have of it will be visual. All of us have synesthetic experiences. In a sense all these capacities for human experience are resources the artist can call upon in the crafting of the image. In the hands and mind of the artist they are avenues for communication.

## THE ARTS AND TRANSFORMING CONSCIOUSNESS

So how do the arts affect consciousness?[23] They do so in a number of ways. They refine our senses so that our ability to experience the world is made more complex and subtle; they promote the use of our imaginative capacities so that we can envision what we cannot actually see, taste, touch, hear, and smell; they provide models through which we can experience the world in new ways; and they provide the materials and occasions for learning to grapple with problems that depend on arts-related forms of thinking. They also celebrate the consummatory, noninstrumental aspects of human experience and provide the means through which meanings that are ineffable, but feelingful, can be expressed.

Before we move on, let me recount the argument I have advanced so far. In distilled form it is as follows:

1. Humans are sentient creatures born into a qualitative environment in and through which they live.

The ability to experience the full range of qualities that constitute the empirical environment is directly related to the functions of our sensory system. We are biologically designed to be sensitive to the array of qualities that constitute that environment. Our ability to see depends upon the capacities of sight, hearing, touch, and the like. If we were congenitally deaf or blind, we would lack the ability to experience the auditory or visual aspects of the world.

But of course the activation of our sensory system also depends upon our being in an environment that possesses the qualities to which our senses are responsive. When, for example, visual stimulation is unavailable, our visual experience is also absent, and indeed the development of our visual system may be irrecoverably undermined. Kittens whose eyes have been occluded during the first few months of life lose their capacity to see when the occlusions are removed.[24] The actualization of capacity, that is, its transformation from capacity to ability, depends on both what the individual brings to the environment and what the environment brings to the individual. During the course of human development there are certain critical periods during which stimulation and nurture of sensory capacities are crucial.

2. The sensory system is the primary resource through which the qualitative environment is experienced.

Observations of infants and preschoolers provide compelling evidence of their need to experience and understand the world by exploring its qualities. Almost everything they encounter is not only touched, but when possible tasted, listened to, explored through as many sensory channels as lend themselves to knowledge of its qualitative features. Getting to know the world for the preschool child means, in large measure, getting to know how it can be experienced through all the sensory modalities.

3. As children mature, their ability to experience qualities in the environment becomes increasingly differentiated.

The child's initial experience with the qualitative world in and through which she lives is not a form of experience that is automatically given to the child. In a very significant sense, what the

child learns about the world is influenced by the way in which she explores its features. This exploration leads to the construction of distinctions among the qualities encountered: there are varieties of sweetness, varieties of puppies, varieties of hardness, varieties of sound. A child learns over time to differentiate among qualities, to recognize her mother's face, for example, among all the faces the child can see. Differentiation is a way of recognizing what is familiar, categorizing qualities, and anticipating the consequences of action upon those qualities. One of the potentially large lessons of work in the arts is the contribution good arts teaching makes to the child's ability to perceive subtleties and to recognize complexities among the qualitative relationships encountered in the phenomenal world.

4. Differentiation enables children to form concepts. Concepts are images formed in one or more sensory modalities that serve as proxies for a class of associated qualities.

The formulation of concepts is, in a sense, a data-reduction process of distilling the essential features of an array of qualities so that they stand for a larger class of phenomena. Distinguishing between dogs and cats requires the ability to notice differences between them. The concept "dog" and the concept "cat" are qualitative abstractions of those essential differentiating features, and over time children learn to make those distinctions and to give them a name. Put another way, concept formation is an imaginative activity in which images in one or more sensory modalities are formed that stand for an array of qualities associated with a signifier.

The symbol of the Red Cross, given the particular proportions of its shape, stands as a signifier for a class of meanings related to services provided to those in need of medical care. For such a signifier to be meaningful, the individual must have some conception of the meaning of medical care. Meanings are nested into levels of abstraction, but are reducible to a proxy. This proxy can be visual, as in the case of the Red Cross; it can be auditory, as in the case of "God Save the Queen"; it can be linguistic, as in the meanings associated with the phrase "The Constitution of the United States."

5. Concepts and the meanings they acquire can be represented in any material or symbolic system that can be used as a proxy for it.

Our conceptual life operates in each of the sensory modalities and in their combination. We not only can generate in the mind's eye a visual image; we can see that image even while hearing music "around" it. We can taste a banana without actually tasting it. We can envision an opera without actually seeing or hearing it. Our capacity to envision is transformed by the effort to *re*present what we have experienced. Representation can be pursued in any material or form that can be crafted; thus, the same theme can be danced, painted, or described literally or poetically. In a metaphorical sense, becoming multiliterate means being able to inscribe or decode meaning in different forms of representation.

6. The child's developing ability to differentiate, to form concepts, and to represent those concepts reflects the use and growth of mind.

Our conceptual life takes on a public form when the images distilled and formed as concepts are "embodied" in some form of representation. As intelligence is promoted in the representation process and as individuals become increasingly imaginative and technically competent at transforming concepts and their associated meanings into forms, the use and the growth of mind are revealed.

Intelligence, in a sense, has to do with the competence or skill with which we conduct some activity. The character of that activity, particularly as it is revealed over time, is a marker on the road toward cognitive development. Thus we can see in children's drawings, in their musical performances, in their ability to write poetry, in their sensitivity in the area of dance, the mind being practiced and its growth made manifest in a public form.

7. Which aspects of the environment will be attended to, the purposes for which such attention is used, and the material the child employs to represent it influence the kind of cognitive abilities the child is likely to develop. More broadly, the child's mind is shaped by the culture of which the foregoing conditions are a part.

The human mind is a kind of cultural invention. To be sure children come into the world well wired, but how they develop, which aptitudes are cultivated and which are left to atrophy, what modes of thinking they become good at are all influenced by the

culture in which they reside. The forces within that culture are given operational significance through the formation of purposes.

The aim of the inquiry or act and the type of material the child uses impose their own constraints and provide their own affordances. The ability to swim well requires material we call water. Without it, our capacity to swim would never achieve the status of an ability; abilities are realized capacities. Thus, the features of the culture to which the child will be exposed and the manner in which the child will address that culture are the most powerful indicators of the kind of thinking and therefore the kind of mind a child is likely to develop during the course of childhood.

8. The decision to use a particular form of representation influences not only what can be represented, but also what will be experienced. We tend to seek what we are able to represent.

The representational process is normally regarded as a means through which the contents of our consciousness are made public. This conception is all too tidy. We represent not only what we aim at, but also what we discover in the course of expressive action.

But even more, the medium we choose to use and the particular form of representation we select—say, sound rather than a visual form—affect our perception of the world. If we are to represent something through a medium, we try to find qualities of experience or features of the world that will lend themselves to the medium we have selected. Thus, representation influences not only what we intend to express, but also what we are able to see in the first place.

9. The arts invite children to pay attention to the environment's expressive features and to the products of their imagination and to craft a material so that it expresses or evokes an emotional or feelingful response to it.

In the context of practical activity, the criterion of efficiency matters a great deal. Normally we try to see the world and act upon it with the least amount of energy that will satisfy the realization of our purposes. Put another way, we typically see things in order to classify and use them.

We try to do things efficiently to avoid wasting time, effort, energy. What we do not typically seek are the expressive features or

the emotional tone of what we pay attention to. We speed up perception to get on with our work. One of the large lessons the arts teach is how to secure the feelingful experience that slowed perception makes possible; the arts help students learn how to savor qualities by taking the time to really look so that they can see.

10. A major aim of arts education is to promote the child's ability to develop his or her mind through the experience that the creation or perception of expressive form makes possible. In this activity sensibilities are refined, distinctions are made more subtle, the imagination is stimulated, and skills are developed to give form feeling.

The phrase "the child's ability to develop his or her mind" is intended to reemphasize the point that education is a process of learning how to become the architect of your own experience and therefore learning how to create yourself. The arts have distinctive contributions to make to that end through their emphasis on the expression of individuality and through the exercise and development of the imaginative capacities.

We now turn to alternative visions of arts education.

# 2 VISIONS AND VERSIONS OF ARTS EDUCATION

*A WAY OF SEEING IS ALSO A WAY OF NOT SEEING*

Visions of the aims and content of arts education are neither uniform nor discovered simply by inspection. What is considered most important in any field—the aims to which it is directed—is a value, the result of a judgment, the product not only of visionary minds and persuasive arguments, but of social forces that create conditions that make certain aims congenial to the times.[1] Yet we often assume that the aims to which a field is directed are given by the field itself: mathematics has aims defined by mathematics, scientific studies aims defined by science, historical studies aims defined by history, and so forth. This is only partially so. Mathematics can be taught in order to accomplish various ends; science can be used to teach scientific modes of inquiry to students or it can be taught, for example, to advance their understanding of the content of a chemistry course. Similar options exist in the arts. There is no single sacrosanct vision of the aims of arts education. Examples of this diversity abound in the broad field of arts education today and in the past. Let me describe some of the visions that direct the aims and content of arts education today. In describing these various visions I do not imply that they are likely to be found in their "pure" form. I describe them separately to make each vision vivid; in practice, however, there is likely to be a mix of these visions in any school or classroom.

## DISCIPLINE-BASED ART EDUCATION

One of the important visions of art education is represented in what is called discipline-based art education.[2] Especially in the visual arts, the art form in which this conception is dominant, DBAE addresses four major aims. First, DBAE is intended to help students acquire the skills and develop the imagination needed for high-quality art performance.[3] Such performance requires, it is argued, sophisticated forms of thinking. In this vision, art educators should design curricula that develop such skills. To acquire them, students need to learn to think like artists. This means they will need to develop their sensibilities, foster the growth of their imagination, and acquire the technical skills needed to work well with materials.

Second, DBAE is aimed at helping students learn how to see and talk about the qualities of the art they see. Seeing, a form of cognitive achievement, cannot be taken for granted. Nor can one assume that experience in the creation of art will, by itself, be sufficient to develop the ability to see the qualities that collectively constitute visual art or any visual display from an aesthetic frame of reference. Seeing from an aesthetic perspective is a learned form of human performance, a kind of expertise. DBAE programs are intended to foster its development. Being able to see from an aesthetic perspective requires an ability to focus on the formal and expressive qualities of form rather than solely on its utilitarian functions. It requires the ability to slow down perception so that visual qualities can be inspected and savored. It requires one to search for qualitative relationships and to note the quality of experience they engender. Such dispositions and modes of attention can be fostered through teaching.

In addition to developing students' ability to create and perceive art, DBAE programs have two other aims. One of these pertains to helping students understand the historical and cultural context in which art is created, the other to questions regarding the values that art provides.[4] The former is closely tied to art history, the latter to a philosophical field called aesthetics, which addresses questions pertaining to the justification of claims about the

value and function of art. Historical and cultural understanding is believed to help students grasp the relationship between the social context in which the arts are created and their content and form. Understanding this context can significantly influence the kind of meaning students are likely to derive from the work. Addressing questions related to aesthetic theory is believed to help students become a part of a deep and enduring philosophical conversation. Is there an objective basis for justifying judgments of quality in art? Does art provide knowledge? Can works of art lie? Can everything be art or only some things? How important is beauty in a work of art? Can a work of art be ugly?

Advocates of DBAE claim that it provides a more comprehensive approach to art education than other approaches, that it addresses the four sorts of things that people do with art: they make it, they appreciate its qualities, they locate its place in culture over time, and they discuss and justify their judgments about its nature, merits, and importance. The four major curricular components of DBAE parallel these activities.

I indicated earlier that ideas about the aims of a field are influenced not only by visions of educational virtue promoted by charismatic leaders, but also by their congeniality to the times. These two features, visions of what is important and its acceptability to a community at certain periods in its history, apply to DBAE. The theoretical basis of DBAE was first advanced by Jerome Bruner through his ideas about the relationship between curriculum and the structure of the disciplines.[5] These ideas were developed in response to the Soviets' launching of *Sputnik I,* the first manned spacecraft to circle the Earth, on October 4, 1957. That event prompted the U.S. government to try to improve science and mathematics education in the schools to help our nation catch up. Preparation in the sciences and mathematics seemed crucial to national interests. Bruner's argument that students learn best when they experience a discipline in a form similar to the form of inquiry used by scholars in that discipline appealed to anxious educators seeking to meet new expectations for more rigorous and substantive curricula.[6]

Supported by large-scale federal funding, curriculum reform in

science and math was soon under way. No comparable funding was available for curriculum development in the arts. But to art educators too, Bruner's ideas seemed to make good sense. The result was the development of a conception of arts curricula that examined the arts in terms of their component disciplines. Art educators found these disciplines in the art studio, in art history, in art criticism, and in aesthetics. It was a vision of curriculum that art educators believed would restore substance and rigor to what was broadly perceived to be a "soft" subject. Since the 1990s DBAE has been the dominant model for curriculum development in the visual arts in the United States. This approach owes much not only to Jerome Bruner but also to the work of Manuel Barkan, an important figure in art education in the 1960s and 1970s.[7]

## VISUAL CULTURE

A second vision of art education has a distinctly different cast. It focuses on using the arts to promote an understanding of visual culture.[8] By promoting visual culture I refer to efforts to help students learn how to decode the values and ideas that are embedded in what might be called popular culture as well as what is called the fine arts.[9]

Since the early 1960s there has been a great interest in matters of cultural, social, gender, racial, and economic equity. Ours is a nation in which everyone eligible can vote, but not everyone has equal influence regarding who gets elected. Money and position make a difference. Those who control images, those who influence decisions about which images will be shown, those who manage the media control a disproportionate amount of power in the society. The arts, some claim, can and should be studied through a process of critical analysis designed to help students learn how people are influenced through the mass media. In this view any art form can be regarded as a kind of text, and texts need to be both read and interpreted, for the messages they send are often "below the surface" or "between the lines." Learning how to read the messages of a visual text is thus a way of protecting personal rights. It

is also a way of determining whose interests are being served by the images that surround us.[10]

Reading images as texts in order to reveal their political and often covert purposes is one form of reading. Another is developing the student's ability to use the arts to understand the values and life conditions of those living in a multicultural society. In this view, art education becomes a form of ethnology. Graeme Chalmers, one advocate, writes:

> We in art education listened to psychologists when they provided art related information about child growth and development . . . more recently we have listened to those psychologists who have become concerned with left and right hemisphere brain research. But we need information about groups as well as about individuals. It would seem that the tribal artist is secure so long as he or she is with the tribe and sharing their values. An ethnological approach is a way of looking and a means to help us understand these values.
>
> Anthropology provides knowledge of the nature of people, and cultural anthropology finds its relevance in the contribution it makes to understanding culture. Educators in their roles as administrators, supervisors, curriculum developers, researchers, and teachers need and can make use of relevant social information. Any understanding of the role of arts education in the public schools requires that we examine the values and beliefs of society and its changing institutions, communities, and group relationships, as well as the patterns of small groups or "tribes" within the schools. Any definition of "education" must include reference to teaching, learning and *setting*. It would seem that cultural anthropology, being concerned with holistic understanding, involving the collection and description of cultural artifacts may be a rewarding study for anyone concerned with establishing a foundation for arts education, by assisting us to see both education and art in their total settings.[11]

In Chalmers's view art needs to be studied in its social context, and it is here that anthropology can help. Art education, in this view, becomes a means for understanding and improving the culture.

Now one may very well argue that in a society with as many social and economic inequities as our own, it is appropriate that at-

tention to such inequities surface to a level of priority. After all, if the society is hurting, perhaps our first priority should be to try to alleviate the pain. If the study of the arts can provide such relief, why not?

This general orientation to art education is consistent with a number of other developments in the society. I speak here of the impact of multiculturalism, feminism, and postmodernism, for all these movements represent efforts to bring about substantial change in how the world is viewed. Virtually all of them challenge foundationalism and opt for a perspectivalism that is skeptical about "intrinsic" values; what is artistically good is what people value, and what people value is the result of the social forces I described earlier rather than qualities inherent in the work. The tastemakers working through a controlled medium influence public taste, including what museums purchase and display. The Greek verities of truth, beauty, and goodness are relics of the past; it's one's perspective that matters. Art education, focused on the visual world within this frame of reference, is interested in helping students become astute readers of visual images and sensitive, politically informed interpreters of their meanings. The interpretation of meaning, in this view, is in large measure a matter of social and political analysis.

## CREATIVE PROBLEMSOLVING

A third vision of art education is related to creative problemsolving, particularly the kind used in the field of design. One of the best examples of this approach to art education was the program offered at the German Bauhaus from 1919 to the early 1930s. The German Bauhaus functioned as a school of design, first in Weimar and later in Dessau, Germany, until March 1932, when it was closed by the Nazis. It attracted some of the foremost artists, architects, and designers working in Europe at the time, including Walter Gropius, László Moholy-Nagy, and Wassily Kandinsky. Its aim was to address problems having social import in technically efficient and aesthetically satisfying ways.[12] The task as its members

saw it was to use the machine as an ally in order to create a clean aesthetic that exploited the natural characteristics of the materials with which the designer worked. But perhaps above all, the Bauhaus was interested in preparing designers who could conceptualize and analyze well, who could problematize existing assumptions and challenge traditional expectations when a better way to solve a problem could be found.

The program that the faculty of the school created employed an approach that invited students to become creative problemsolvers. For example, the foundation program, which was offered to students during the first year of their work, would ask them to build a structure out of water-based clay as tall as possible and with no part of the structure thicker than the thin side of a coin. Furthermore, the aesthetic quality of the product they designed was very important. Its form, not only its function as a designed object, mattered.

To accomplish this task, students had to understand and develop a feel for the material and its structural possibilities. Learning to address such tasks, tasks that have an infinite number of possible solutions, prepared students for other, more socially important tasks in a variety of fields such as product design and architecture.

The Bauhaus tradition is currently alive and well in many schools of design and especially in departments of engineering interested in developing the problemsolving capacities of their students and refining their aesthetic judgment.[13] Most such schools are oriented to meeting social needs; to do so they focus on invention, foster analytic abilities needed to figure out what will work, and develop skill in the use of machine tools. The aim is to enable students to think like designers, and designers have problems whose solutions are empirically testable—as General Motors, Sony, and Apple know quite well. This tradition has its counterpart in secondary-school art programs that ask students to deal with practical problems—the design of a new container for CDs, for example— in which both practical and aesthetic criteria are important. Such tasks are intended to help students become aware of a wide variety of considerations—economic, structural, ergonomic, and aesthetic—in the design process.

CREATIVE SELF-EXPRESSION

A fourth vision of art education aims in a very different way at the development of creativity. The approach is articulated by two of the world's most influential art educators, the Austrian Viktor Lowenfeld and the Englishman Sir Herbert Read.[14] Both Lowenfeld and Read were influenced by World War II. Lowenfeld emigrated from Austria to the United States in 1938. Read spent the war in a besieged England. Both saw the conditions in Germany that led to the war as partly the result of an educational system that suppressed the normal human urge to express creative impulses. As a result, that urge found an outlet in aggressive and repressive tendencies; the culture set up the young for the dictatorship that emerged in Germany.

Both Read and Lowenfeld believed the arts to be a process that emancipated the spirit and provided an outlet for the creative impulse. For Lowenfeld, the expression of this creative impulse had not only an educational benefit to offer, but a therapeutic one as well:

> The child who uses creative activity as an emotional outlet will gain freedom and flexibility as a result of the release of unnecessary tensions. However, the child who feels frustrated develops inhibitions and, as a result, will feel restricted in his personality. The child who has developed freedom and flexibility in his expression will be able to face new situations without difficulties. Through his flexible approaches toward the expression of his own ideas, he will not only face new situations properly but will adjust himself to them easily. The inhibited and restricted child, accustomed to imitating rather than expressing himself creatively, will prefer to go along set patterns in life. He will not be able to adjust to new situations quickly but will rather try to lean upon others as the easiest way out. Since it is generally accepted that progress, success, and happiness in life depend greatly upon the ability to adjust to new situations, the importance of art education for personality growth and development can easily be recognized.[15]

Read shared similar sentiments: "Generally speaking, the activity of self-expression cannot be taught. Any application of an external standard, whether of technique or form, immediately in-

duces inhibitions, and frustrates the whole aim. The role of the teacher is that of attendant, guide, inspirer, psychic midwife."[16]

Given the times—the 1940s—the views of the child that Lowenfeld and Read promulgated fell on receptive ears and eyes. When a nation is fighting a war to banish totalitarianism, it is not surprising that a conception of art education that gives center stage to the cultivation and protection of what was most individual about the child would find a receptive audience.

Both Lowenfeld's and Read's ideas about human nature had a psychodynamic quality. In Read's case the influence came from Carl Jung, in Lowenfeld's from Freud. Both thought the artistic impulse resided in the unconscious and that it was the business of teachers, especially art educators, not to interfere with this natural process. For Read, art was not so much taught as caught. The teacher was to be a kind of midwife to the child's creative nature. For Lowenfeld, the arts were a corrective to school practices that were repressive. Both men regarded the arts as a means of human development.

Although the orientation of the Bauhaus also put a premium on promoting creativity, creativity in these two views sprang from different sources and served different ends. The Bauhaus focused on practical problem solving using various materials; a classroom reflecting the ideas of Lowenfeld and Read engaged children in painting and sculpture to foster creative expression of their personal experience, including their fantasy life. Teacher intervention was very limited, with little or no attention paid to historical context. But the dominant idea in both approaches is that children and their art develop largely from the inside out rather than from the outside in.

## ARTS EDUCATION AS PREPARATION FOR THE WORLD OF WORK

A fifth vision of art education is a very pragmatic one, using the arts to develop the skills and attitudes needed in the workplace. Much of the rhetoric concerning school improvement centers on the importance of schooling to increase our competitive economic performance in the world economy. According to some critics, as

our schools go, so goes our economy.[17] Given this position regarding the economic function of schools, what is it that the arts, whose forms of performance look quite different from those with practical work-related outcomes, can offer to the work world? Are there practical consequences to arts education, and if there are, do these consequences relate to the world of work?

The rationale proposed by some is that experience in the arts develops initiative and creativity, stimulates the imagination, fosters pride in craft, develops planning skills, and in some arts fields helps the young learn how to work together. All these personal attributes are vocationally relevant. Thus, even though the projects students work on in an art class might not look as if they have much to do with the workplace, they are very much a part of the "skill set" students need to become productive workers.

Listen as the chief executive officer of a large corporation describes the importance of the arts to the world of work:

> Students must be grounded in the basics. Basic reading. Basic math. Basic composition, Aren't those the only skills students really need? Everything else is icing on the cake, right?
>
> Wrong. Today's students need arts education now more than ever. Yes, they need the basics. But today there are two sets of basics. The first—reading, writing, and math—is simply the prerequisite for a second, more complex, equally vital collection of higher-level skills required to function well in today's world.
>
> These basics include the ability to allocate resources; to work successfully with others; to find, analyze, and communicate information; to operate increasingly complex systems of seemingly unrelated parts; and, finally, to use technology. The arts provide an unparalleled opportunity to teach these higher-level basics that are increasingly critical, not only to tomorrow's work force, but also today's.[18]

For many, the practical workplace justification for the arts in the education of the young is its most persuasive rationale. Aesthetic experience might be nice, but it can be secured outside of school. Preparation for work is something every student will someday need. If the arts can contribute to success in this realm, it will have something really important to offer. As I said earlier, when

there is a social need, people look for ways to meet it. Since the world is believed to be becoming increasingly competitive, the quality of the workforce is increasingly important. Art, those who embrace this view believe, will find a secure home in our schools if it can contribute to the creation of such a workforce.

## THE ARTS AND COGNITIVE DEVELOPMENT

A sixth vision of arts education emphasizes its cognitive consequences; work in the arts contributes to the development of complex and subtle forms of thinking.[19] Ironically, the arts are often thought to have very little to do with complex forms of thought. They are regarded as concrete rather than abstract, emotional rather than mental, activities done with the hands not the head, imaginary rather than practical or useful, more closely related to play than to work. Yet the tasks that the arts put forward—such as noticing subtleties among qualitative relationships, conceiving of imaginative possibilities, interpreting the metaphorical meanings the work displays, exploiting unanticipated opportunities in the course of one's work—require complex cognitive modes of thought. Examined analytically, work in the arts provides an agenda rich in such opportunities.

At a time when the development of thinking skills is particularly important, at a time when schools are expected to prepare people to work in more than a single occupation during their lifetime, the presence of a program that fosters flexibility, promotes a tolerance for ambiguity, encourages risktaking, and depends upon the exercise of judgment outside the sphere of rules is an especially valuable resource. Although the cognitive consequence of engagement in the arts has been advanced since the first quarter of the twentieth century, and despite the fact that it has ardent followers, it is a way of thinking about the aims of art education that is still trying to secure a firm foothold in the larger educational community. The arts have long been perceived as being "affective" rather than cognitive, easy not tough, soft not hard, simple not complex.

Among the major proponents of the cognitive character of artistic activity is Rudolf Arnheim, a scholar whose work bridges the

fields of art history, psychology, and art education. In his book *Visual Thinking,* he argues that perception itself is a cognitive activity:

> By "cognitive" I mean all mental operations involved in the receiving, storing and processing of information: sensory perception, memory, thinking, learning. The use of this term conflicts with one to which many psychologists are accustomed and which excludes the activity of the senses from cognition. It reflects the distinction I am trying to eliminate; therefore I must extend the meaning of the terms "cognitive" and "cognition" to include perception. Similarly, I see no way of withholding the name of "thinking" from what goes on in perception. No thought processes seem to exist that cannot be found to operate, at least in principle, in perception. Visual perception is visual thinking.[20]

Arnheim is not alone in this view. Ulric Neisser, a leading cognitive psychologist, regards perception as a cognitive event, and Jean Piaget was loath to make a sharp differentiation between the cognitive and affective sides of our thought processes.[21] My own conceptual work regards all forms of awareness as cognitive events.[22] Surely the arts, which traffic heavily in acts of perceptual differentiation, meet such a cognitive criterion.

The cognitive character of the arts is recognized not only by psychologists but by philosophers. Nelson Goodman, a former logician who in the 1960s became interested in the arts, has this to say about the relationship of the arts to the process of inquiry, a process fully cognitive in character:

> A persistent tradition pictures the aesthetic attitude as passive contemplation of the immediately given, direct apprehension of what is presented, uncontaminated by any conceptualization, isolated from all echoes of the past and from all threats and promises of the future, exempt from all enterprise. By purification-rites of disengagement and disinterpretation we are able to seek a pristine, unsullied vision of the world. The philosophic faults and aesthetic absurdities of such a view need hardly be recounted until someone seriously goes so far as to maintain that the appropriate aesthetic attitude toward a poem amounts to gazing at the printed page without reading it.

He goes on to say:

I maintain, on the contrary, that we have to read the painting as well as the poem, and that aesthetic experience is dynamic rather than static. It involves making delicate discriminations and discerning subtle relationships, identifying symbol systems and characters within these systems and what these characters denote and exemplify, interpreting works and reorganizing the world in terms of works and works in terms of the world. Much of our experience and many of our skills are brought to bear and may be transformed by the encounter. The aesthetic "attitude" is restless, searching, testing—is less attitude than action: creation and recreation.[23]

What would arts programs look like if they emphasized the cognitive consequences of work in the arts and wanted to exploit such work for educational purposes? In some way such programs would not be very different from the programs that are now available, *as long as the orientations I have described were high-quality examples of their species.* After all, all good work in the arts requires subtle and sophisticated forms of thinking. Yet there are some features of arts activities that seem particularly appropriate for promoting cognitive development. For example, programs that ask students to conceptualize their own aims in the art form they are to work with, programs that are problemsolving in character, programs that invite students to be metacognitive about their own work—that is, reflective about their own thinking processes— and that encourage them to be articulate about their judgments about art.

Cognitive development can be fostered as students are asked to compare and contrast works that became increasingly similar— say, comparing and contrasting original works to fakes and forgeries—and then to select the original and to provide reasons for their choices. There is a host of ways in which curricular tasks could be formed to practice and to assess the development of specific forms of cognition.

Such curricula need not focus exclusively on art production, although they could. They could also make it possible for students to engage in forms of thinking that helped them see connections between the form and content of works of art and events occurring at the same time in the culture in which those works were

created. In so doing students would practice synthetic forms of thinking. For example, understanding the content of seventeenth-century Dutch painting requires some understanding of the geographic location of Holland, its dependency on commerce, and the rise of a wealthy merchant class. The student is at once engaged in geography, history, and economics as well as aesthetics.

The key to this approach to art education is to design curricula around the forms of cognition and understanding one wants to develop. This is much like the tasks designed for students attending the German Bauhaus. They wanted to train designers who understood the social context their work was to serve and who could approach design problems mindful of that context. A similar approach could be taken in creating programs for elementary-school children.

## USING THE ARTS TO PROMOTE ACADEMIC PERFORMANCE

Related to the cognitive orientation to art education I have described is a seventh vision, one that justifies the arts in the schools through their contribution to boosting academic performance in the so-called basics. As I have indicated, society's receptivity to the aims of a field of study is closely related to the extent to which its members believe a field will promote the realization of what it values. This is certainly the case regarding the attractiveness to some of using the arts to increase the academic performance of students. The claim is that the more arts courses children and adolescents take, the better they will do in school. In the area of music, we have what is called the "Mozart effect."[24] Infants and preschoolers exposed to classical music several times a week do better on a test of spatial ability than their peers who have not been so exposed. The result, some claim, is that, in effect, music makes you smarter.[25]

Other data, from large-scale surveys, show that students who enroll in art courses in high school get significantly higher Scholastic Achievement Test scores than students who do not take art courses; the more art courses, the higher the SAT scores. However, more courses in any field are positively associated with higher SAT scores. In fact science and math courses are most highly correlated

with SAT scores. Putting aside for the present the adequacy of the research design and therefore the adequacy of the research, the aim in this orientation is to use art as a way to achieve what some believe are more important ends, higher test scores in math and science.[26]

The reasons for wanting to do so seem clear enough. So many efforts have been made to improve school performance that some citizens are at wit's end about what to do. In the 1980s the reform effort, led by President Ronald Reagan, flew under the banner of "A Nation at Risk." Eight years later President George Bush launched "Goals 2000." Five years after that President Bill Clinton led the way with "America 2000," a new version of the earlier effort. Clearly, U.S. policymakers have made numerous attempts to turn the educational system around; and yet there is a strong feeling that these efforts have not really been successful. Under such circumstances, people ask, "Why not try the arts?"

For some arts educators, especially those who feel professionally marginalized, this newfound utility seems like a life raft. But can a field make its most important contributions through seeking outcomes that other fields might achieve at least equally well? And, more fundamentally, will the data support the claims made about effects on student performance in academic areas? Will the design of the research support the data? What happens to the reasons for a field's place in the schools if research shows that such claims are overblown, or that evidence to support them is weak, or that other approaches to boosting academic test scores are more efficient?

## INTEGRATED ARTS

Another vision of arts education conceives of the arts curriculum as being integrated into other arts and other nonarts curricula. This conception, sometimes described as "integrated arts," is often used to enhance the student's educational experience. The integrated arts curriculum is typically organized into one of four curricular structures.

First, the arts are sometimes used to help students understand a particular historical period or culture. For example, study of the

Civil War might include the photographs of Mathew Brady or the music and architecture of the period. It can explore the forms of dress worn by people of different social classes and can illuminate the period through literature. The objective is to broaden the means through which the student's understanding is advanced by consulting not only academic historical accounts of the Civil War but also other materials of the period, materials that may in the end speak as eloquently as any written history. Thus art, music, literature, and history come together around a particular historical period.

A second form of integration, this one within the arts themselves, is intended to help students identify the similarities and the differences among the arts. For example, all the arts are concerned with the creation of expressive form, but the means employed to achieve such a work are not identical. Indeed, although one can experience rhythm in a visual work of art as well as in music, the meaning of rhythm in music and the meaning of rhythm in the visual arts are different. Students, in this vision of the arts curriculum, have the opportunity to discover what the arts have in common but also what they have to offer that is distinctive.

A third approach is to identify a major theme or idea that can be explored through work coming not only from the arts but from other fields as well. The concept of metamorphosis, for example, can be illustrated through the way in which a melody is altered in a symphony, by the ways in which the demographics of an area change the terrain, and by changes in a sequence of images in film and photography. Metamorphosis is a biological concept, but its manifestations can be located in a host of other domains and disciplines. An integrated curriculum can help students see the connection between biological meaning and other meanings, artistic and nonartistic, that pertain to the concept.

A fourth structure for integration of the arts is related to the practice of problemsolving. Students can be invited to define a problem that requires that it be addressed through several disciplines, including the arts. For example, if high school students were asked to design a play lot for preschool children, design con-

siderations, developmental considerations, physical features of the materials, layout, and aesthetic matters would be taken into account. In other words, the problem itself is one that begs for multiple perspectives, and these multiple perspectives need to be integrated into a whole that makes it possible for the play lot in this case to function successfully. Thus, curricula can be designed that are problem centered and that require the integration of several disciplinary perspectives, including the arts.

Today these and other functions of arts education are put forward as reasons to include the arts in school programs. Among the things we can learn from the descriptions I have provided is that the grounds for including a subject of study in the school curriculum change with the times. We can also learn that it is unlikely that there will be a consensus that there is only one enduring function for arts in the schools. What matters most in any field of study depends on the context, and the context is influenced by the economics and politics of the time.

I have been speaking about the sources of direction for a field and have emphasized what members of a society believe its needs to be and the ways in which they believe a field might meet those needs. But the direction in which a field travels emanates not only from perceived needs, but also from imagined desired possibilities. For example, the development of computer technology has suggested to many that the computer can become a technology of unparalleled importance in the arts. What does such a vision imply for the creation of school programs in the arts? What does a computer allow students to do with images that other technologies don't, and what might such a resource mean for the development of cognitive skills? What we have here is the creation of opportunities through the development of a tool that was little more than dreamed of fifty years ago. The lesson here is that the future is affected by inventions that we cannot now foresee.

But the aims of a field depend upon more than either the context or the time; they also depend upon a view of education and human nature and upon beliefs about how schools and school programs might function given those views of education and human

nature. Put another way, conceptions and convictions about education need not be abandoned, which is not to say that context should be disregarded.

What one has when one looks at the current picture of art education is a field, like all fields in education, whose aims vary over time and whose current aims are diverse. We find a field whose justifications for support rest most often upon a medley of reasons and beliefs, some clear, others not; some grounded, some not; some the result of habit and tradition, some not. As I said, the aims of a field are not determined solely by the field's subject matter. And in all human affairs in which matters of importance are to be decided, there is often a lack of uniformity of view.

In some ways, the diversity of views regarding what art education should be may represent a tension between principle and practice. Principles that cannot bend are rigid. And what is rigid often breaks. Practice that is not principled has no compass; it does not know where it is headed. We need to be both practical and principled, creating the appropriate mix for the particular occasion.

## SOME PRINCIPLES TO GUIDE PRACTICE

What, at this point in time, should art education try to achieve? Taking into account the considerations of context I have just described, I present my view of art education in terms of five principles.

Principle One. In justifying its case, art education should give pride of place to what is distinctive about the arts. Art education should not get sidetracked or attempt to justify its primary educational mission by focusing its efforts on outcomes that other fields can claim to serve equally well. Nor should art educators make research claims about the effects of art education on, say, academic forms of performance for which there is little or weak research evidence.

The primary reason for fealty to this principle is that what is distinctive about the arts is itself of value. Few members of a school faculty are as concerned with the education of vision as are teachers of art. The visual arts make visible aspects of the world—for ex-

ample, their expressive qualities—in ways that other forms of vision do not. The ability to see the world in this way is no small accomplishment. It engenders meanings and qualities of experience that are intrinsically satisfying and significant.

Principle Two. Art education programs should try to foster the growth of artistic intelligence. The conjunction of art and intelligence is not common. Ability in art is assigned to talent, ability in "intellectual" subjects like mathematics and science to intelligence. For all the reasons I stated earlier, there has been a separation of art from intelligence. Yet as John Dewey pointed out in the William James Lectures he gave at Harvard in 1932, intelligent reflection is a fundamental condition in the creation of art.[27] Arts teachers help, or ought to help, their students get smarter about art in all its manifestations, including the arts in popular culture. Being able to compose the qualities that constitute a successful work is no trivial intellectual accomplishment.

There is no good theoretical reason to assign exclusive rights regarding the exercise of intelligence to those who use language or numbers well, or who shine on traditional academic tasks. Human intelligence takes many forms, and each of them serves important social and cultural purposes.[28] Such achievements should be acknowledged, if for no other reason than that not doing so creates significant educational inequities for those whose proclivities are in the arts. In the broadest of terms, art education might be said to have as one of its major missions the development of artistic intelligence, a concept rooted in Dewey's theory of art and qualitative thought.

Principle Three. Art education programs should help students learn how to create satisfying visual images, how to see and respond to what we call the arts and other visual forms, and how to understand the role the arts play in culture. Put simply, art education should help students learn how to create and experience the aesthetic features of images and understand their relationship to the culture of which they are a part.

In identifying these domains for curriculum development there is no implication that they need to be addressed as independent units. They can, and probably in most situations they will, be ad-

dressed in an integrated fashion, but that decision is one that is best made in light of the situation itself.

Principle Four. Art education should help students recognize what is personal, distinctive, and even unique about themselves and their work. There is so much in our schools that pushes for uniformity of response—standardized testing, for example—that one of the important contributions that art education can make to students is to help them become aware of their own individuality. The arts, if they are about anything, are about the creation of a personal vision. The teacher of spelling, assuming the same words are given to a class, seeks unity of response from his students. The same is true for most teachers of arithmetic. Even the teaching of writing puts a premium on teaching students to imitate prototypes. In fact the dominant climate of the early grades of schooling is one of highly rule-governed tasks and standardized expectations. For many tasks, such as spelling and arithmetic, uniformity of outcome is necessary. To communicate we impose and observe common rules regarding how words are to be spelled. We heed convention. Yet because the school curriculum is so heavily weighted toward rule-governed fields of study, what schools seem to teach best is rule following. The arts, however, march to a different drummer. In most of the arts we seek diversity of outcome. We are interested in the ways vision and meaning are personalized.

Outcomes of this kind are subtle. They require interpretation. They express themselves in the way forms are nuanced. Recognition of personal distinctiveness requires an ability to notice subtleties about one's own work. Noticing subtleties is something art teachers can teach. I believe we ought not to abandon such aims.

Principle Five. Art education programs should make special efforts to enable students to secure aesthetic forms of experience in everyday life. As one Chinese scholar is said to have commented, "First I see the hills in the painting, then I see the painting in the hills." After a while it is not art that imitates life; it is life that imitates art. The outcomes of art education are far wider than learning how to create or to see the objects populating museums and galleries. The world at large is a potential source of delight and a rich source of meaning if one views it within an aesthetic frame of

reference. It can be said that each subject studied in schools affords the student a distinctive window or frame through which the world can be viewed.

To see the world as matter in motion, the way a physicist might, provides a unique and telling view. To see it as a historian might is to get another angle on the world. To see it from an aesthetic frame of reference is to secure still another view. Each of these views makes possible distinctive forms of meaning. Education as a process can be thought of as enabling individuals to learn how to secure wide varieties of meaning and to deepen them over time. The outcomes of education can thus be said to diversify and deepen the kinds of meanings people know how to construct and to provide them with the appetite and ability to shift frames.

I expect that each of these principles will have different degrees of prominence in different settings. This is as it should be. But each commends itself as an important part of the overall agenda for arts education. A well-taught program that paid attention to these principles in its construction would enhance the education of the students it serves.

# 3 TEACHING THE VISUAL ARTS

*TEACHING THAT DOES NOT PROMOTE LEARNING MAKES AS MUCH SENSE
AS SELLING THAT DOES NOT PROMOTE BUYING*

Understanding competing conceptions of art education and the conditions that give rise to them, while important for an enlightened view of the field, is inadequate for making any of those conceptions real in the lives of children. For that to happen, one must address problems where the rubber hits the road: in the classroom. Two of the most important factors affecting students' experiences in the classroom are the quality of teaching they encounter and the quality of the curriculum provided. This chapter examines the teaching of art.

How shall we think about teaching art? More than a few think art can't be taught, only "caught." Others believe that even if it could be taught, it shouldn't be.[1] To try to teach art is to risk stifling students' creativity, blocking their imagination, thwarting their personal expression. In the arts, students need support, materials with which to work, and then they need to be let alone to explore on their own.

This view of nonteaching is not one that will withstand analysis, however appealing it might first seem. There are no complex tasks or forms of thinking whose mastery is best optimized by pedagogical neglect. The challenge to teachers is not to do nothing, but to act in ways that advance students' thinking. The advancement

of thinking, the promotion of competence in a field, the enlarge-ment of intelligence and expertise—it is called by many names—is the product of no formula. Good teaching comes in a variety of forms, and each may have distinctive virtues. Furthermore, good teaching cannot be "delivered." Teaching, like knowledge, cannot be shipped, pumped, or transmitted like the contents of a letter into the heads of students. In a sense, all that teachers can do is to make noises in the environment.

The teacher designs environments made up of situations that teachers and students co-construct.[2] Sometimes the major respon-sibility for their formation resides with the teacher, sometimes with the individual student, often with other students, but the pro-cess is never entirely independent; the student always mediates, and hence modifies, what will be received or, better yet, *construed* from the situations in which he or she works.

In this chapter we will look at the teaching practices of three art teachers in order to see what they do when they teach. But be-fore we do, there are some general ideas about the teaching of art that are important to share. The first of these I have already al-luded to: teachers cannot merely transmit information or skills to another, if for no other reason than that the student always medi-ates and hence modifies what is being conveyed. The implications of this idea are significant, for it implies that to some degree, for a teacher to enhance what students learn, the teacher needs to have some sense of where they are with respect to the ideas or skills to be learned. Given this sense, the teacher is someone who designs situations that build upon what students value or know. "Situa-tions" are qualitatively related conditions that students experience and within which they act. Thus, if the teacher's aim is to further students' understanding of the ways in which colors interact, the teacher has to decide how such understanding, given *these* partic-ular students, can be promoted. In this task the teacher needs to behave like an environmental designer, creating situations that will, in turn, create an appetite to learn. These situations will con-tain tasks and materials that will engage students in meaningful learning, learning that they can apply and that connects with other aspects of the world.

The design of such situations can take many forms. It is here, in the design of the conditions that students will engage, that much of what is important in teaching occurs. But it is not the only place. Plans need to be acted upon, and how a teacher acts upon them is critical. Wonderful plans can be scuttled by weak teaching. Conversely, good teaching has no virtue if the content students engage in is without value: if the ideas or skills being taught are not worth teaching, they are not worth teaching well.

When "manner" in teaching is brought under intelligent control and when it is sensitive and appropriate for the individual student or class, it is artistic in character. The tone of the teacher's language, the way in which the pace of a class is modulated, and, most important, the ability to improvise in the face of uncertainty, are critical. Canned scripts in teaching promoted by some who believe that teaching can be reduced to a formulaic "science" (which, ironically, is not what science is about) do not work, since what cannot be provided to make the teacher's script useful are scripts for students. When working with students, surprise is always present to some degree. Therefore, the need for improvisation by the teacher is always necessary. The surest road to hell in a classroom is to stick to the lesson plan, no matter what.

Although some researchers and policymakers have sought to discover "what works," that is, to get a science-based formulaic array of methods for effective teaching, I believe such an aspiration is ill conceived.[3] Interaction effects will swamp any formulaic "method." In addition, the values that people wish to realize through the educational process differ. But even if formulaic procedures were available, their wholesale use would certainly rob teachers of the opportunities for invention and the challenges that now exist. Externally defined routines might be appropriate for workers on an assembly line (and maybe not even there); they are not appropriate for teachers.[4]

Because the practice of teaching at its best may be conceived of as an art, an art informed but not controlled by the products of social science, we might speculate how artistry in teaching gets refined.[5] One place to begin is to understand how artistry gets re-

fined in the arts. *By artistry I mean a form of practice informed by the imagination that employs technique to select and organize expressive qualities to achieve ends that are aesthetically satisfying.*[6] Artistry—the artistic performance of a practice—is enhanced as artists of that practice learn to see and reflect upon what they have created. This process is enhanced as they receive informed criticism concerning their work from others. The function of such feedback is to enable them to secure a more sensitive and comprehensive grasp on what they have created.

The kind of critical and helpful feedback I am describing is not common fare in most schools. Most teachers face the arduous task of trying to figure out on their own how things went and what might be done better. The task is arduous because the ability to notice what one has done is often impeded by *secondary ignorance;* that is, by not knowing that you don't know. *Primary ignorance*— knowing that you don't know—is far easier to deal with. Secondary ignorance is almost impossible to address. The way to reduce its presence is to organize schools so that they allow colleagues to see and critique each other's teaching, a practice rare but becoming more common in American schools.[7] Good educational criticism illuminates what's happening. In other words, the promotion of artistry in teaching is more likely to be realized not by searching for a formula for effective teaching, but by finding out what one is doing and by imagining how it might be made even better. To indicate that feedback can improve teaching is not to imply that critical feedback must focus on what needs improvement; it can also help teachers recognize what is outstanding in their teaching. It can help them recognize their virtues.

Another important idea about teaching is that its most important effects are located outside the classroom. In most settings students are expected to display what they have learned on tests, in portfolios, and in their commentary about what they have studied. Most of the time these studies are fragmented into disciplinary forms that seldom have much to do with the world outside schools. Yet what we surely want is more than merely knowing whether students can perform well in school. To the extent to

which we are interested in their ability to use what they have learned in life outside school—the context that really matters—we must look to their behavior outside school.

We have not yet begun to use such evidence of student learning in American schools, where standardized tests still prevail.[8] And we seem to forget that standardized tests confront students with tasks the likes of which they will seldom encounter outside school. (One of the few other places that require us to take standardized tests of the kind encountered in school is the motor vehicle department, where we apply for a driver's license.) To make matters worse, we take the scores from such tests seriously, as if they were good predictors of what students will do outside school. What such test scores predict best are other test scores. There may be a large difference between what a student can do on a test or in a classroom and what a student will do when he or she has a choice. In education, the really important effects of teaching are located outside the school.

A third idea concerning teaching is related to the previous one, namely, that the effects of teaching may not show up until long after students leave school and in ways the teacher never dreamed of. The way we assess most learning in school is by asking students to perform at a certain time. Yet what students have actually learned may not come to the surface until years after they have finished the course. During the various stages of the life cycle, lessons learned years ago may emerge that one was not aware of learning. Maturity can promote appreciations never before experienced. These appreciations can sometimes be discovered only by looking back. What was learned may be the result of a comment made by a teacher at a particular point in a student's life. It might even be the result of a teacher's or fellow student's half-finished sentence.

When I was in the fourth grade my teacher, Miss Purtle, asked me to have a "one man" show of my paintings in the classroom. It was an experience that made a difference I will never forget. A nine-year-old having a one-man show of his paintings! What matters is that such occasions, occasions whose importance may be unknown to the teacher, do matter, and may continue to matter long after the child has left the classroom. Although one is not

likely to be able to form educational policy on such promissory notes, in our pursuit of evidence of effective teaching we would do well not to forget that our data will always be partial.

In reflecting on the effects of teaching it must be acknowledged, yet again, that students learn both more and less than what we intend to teach. They learn more because of the personal meanings they make of what we have taught. Since meaning is located in the interaction between the student and the rest of the situation, and since each student brings a unique history to that situation, the meanings made by each student will differ from those of others, sometimes in very significant ways. In this sense what students learn exceeds what the teacher intended to teach. But they almost always learn less, as well. Our educational aspirations for students are almost never completely realized. But as Robert Browning said, "a man's reach should exceed his grasp, or what's a heaven for?"[9]

The promotion of educational forms of learning is realized by helping students form purposes to guide their work. In the arts there is a tendency to encourage children to "be expressive," which sometimes means, in practice, to be utterly exploratory, with no purpose in mind—all in the name of creativity and freedom. Yet one of the important abilities artists employ in their work is the forming of purpose. Work in art is typically directed by an idea that is realized in the material and through the form that the artist creates. These ideas can be large or small, important or trivial; they can reveal what has gone unseen, or they can put the familiar into a context in which it can be re-seen in a new and vital way. The artist can comment on or celebrate a slice of the world. She can seek to reveal something "beneath" the surface of the image. For Monet, for example, it was the quality of light, for Dali it was the world of the unconscious, for Picasso it was the horror of war, and so it goes. Helping students understand that artists have something to say—and that they themselves have as well—is a fundamental aspect of learning in the arts. A narrow focus on the technical mastery of the material or a preoccupation with the quality of the form leads to a neglect of matters of intention.

To emphasize matters of intention is not to suggest that inten-

tions must be fixed; they should not be. That is the point of *flexible* purposing. But although purposes should be flexible, there are purposes that should guide the work nevertheless.[10] Work in the arts is purposive, and the character of those purposes should receive far more attention than they do.

Intentions or purposes are realized through the use of materials that achieve the status of a medium as they mediate the purposes that are or have been framed. It often helps the student for the teacher to restrict the materials or to define the criteria, that is, to create parameters within which the student's purposes are to be achieved. Designing a hand-held sculpture that feels good to hold is an example of such parameters.

Another important idea about teaching pertains to what might be called the entry points the art teacher can use to comment upon the student's work. These entry points provide a variety of locations at which to begin a conversation with the student. The teacher might, for example, want to comment upon the way in which the materials were handled, or upon the way the form of the work was crafted, say, the relationships among forms. The teacher might want to say something about the idea the student is working with or to call the student's attention to the relationship between her or his work and the work of others.

One thing is likely: the teacher will not want to try to say everything that can be said about the work in one encounter. What a teacher chooses to comment upon, and how those comments are made so that they are appropriate for particular students, no theoretical knowledge can prescribe. Knowledge of the situation of which the student is a central part must be considered, and often by the feel of what is likely to be productive. In the student's response the teacher finds cues—or, better yet, clues—for further comments. The arts have a wonderful open texture that leaves open the entry points for comments.

## WHAT ARTS TEACHERS NEED TO KNOW AND DO TO TEACH WELL

Much of what I have said about teaching applies as much, or almost so, to the teaching of any subject as it applies to the teaching

of art. Are there some aspects of teaching that are unique to the arts? Perhaps not entirely, but almost so. Let's look at teaching in relation to the kinds of knowledge and understanding that teachers of the arts need to teach well. One caveat: some of the skills and understandings teachers of art need are related to the orientation, the version of art education, if you will, that the teacher embraces. What a teacher is trying to accomplish is directly relevant to some of the pedagogical skills and understandings he or she needs. Keeping this in mind, now we will identify those more or less generically distinctive if not entirely unique skills and understandings the teaching of art requires.

Because so much of what is important in the arts depends upon the use of the imagination, the ability to engage students' imagination is a critically important skill in art teaching.[11] Teachers can do this in a variety of ways. One way is to ask students to put themselves into imaginative spaces. For example, if one were working with eight- to twelve-year-olds one might ask them to imagine that they are on a space ship traveling to Mars and feeling the vibrations in space and the thump of having landed, and watching the door of the space ship slowly open. What do the travelers see? What do they feel? And how will they portray what they have experienced to others when they return home?

Teaching situations of this kind perform important functions. They engage students in vicarious experience imaginatively generated, and in this particular example they provide a topic that makes the ability to draw realistically unnecessary. After all, Mars can look like what students want it to look like.

Another kind of knowledge that the art teacher needs is knowledge of the technical requirements related to the use of materials. Teachers of art who ask their students to use materials need to know something about how those materials can be handled. Let me offer two examples. When children are tearing up newsprint to make papier-mâché, it matters how the newspaper is torn. If it is torn against the grain, the tears cannot be controlled, and the paper strips will be uneven. If the paper is torn with the grain, the strips will be even and much easier to work with. Consider another example. If students are mixing wheat paste, it matters if the wheat

paste is put in first and the water added or if water is put in first and the wheat paste added. The first procedure will create lumps in the paste; the second will not. Now these matters may seem trivial. I assure you they are not; they can make or break a lesson.

Art teachers also need the ability to read the quality of the student's work and to be able to talk to the student in a supportive and constructive way about the work. To know what to say from an aesthetic perspective is one kind of reading. To know what to say from a personal perspective is another. The way a student is likely to interpret the teacher's comments is important. Thus, the art teacher has to walk a narrow line between constructive criticism on what is a personal form of expression and, at the same time, conveying what the teacher believes needs the student's attention. All these pedagogical moves need to be addressed in a way that is constructive. Constructive reactions mean inviting students to appraise their own work and to give reasons for their judgments.

Another pedagogical skill in teaching art is the ability to model the kind of language and skill students are expected to learn. Students might have never seen or heard someone use metaphor and simile to talk about a painting, a tree, or a building. The art room is a locale in which they can see and hear such language. The teacher can display these skills and provide opportunities to students to emulate what they see.

A similar case can be made for the modeling of skills; we sometimes call it demonstration. Much of what students can learn in an art room is the result of observation. Teachers and fellow students can provide models for others to observe.

Art teachers need to know when to back off and to allow the student to find out for him- or herself. Although this kind of pedagogical judgment is not unique to the teaching of art, it is especially important in the arts. When the material to be learned obeys strict conventions—how to spell or multiply, for example—a stronger case can be made for intervention by the teacher than when the work to be done places a high premium on personal interpretation and the expression of a personal view. Precisely because the arts are among the few fields in the school curriculum

that emphasize the importance of a personal view, providing space for it to emerge without undue intervention is crucial.

Another pedagogical skill needed to teach art well is knowing how to acquire and arrange the tools and materials students need to use without the congestion or scarcity that might undermine their work. How to distribute paint, how to collect drawings, how to shelve fragile clay sculpture, how to store prints to protect them from damage, how to ensure that tools will be secure are all a part of the pedagogical skills art teachers need to have their classrooms or studios run efficiently. Absent such knowledge, the classroom can border on the chaotic.

Still another pedagogical skill is knowing how to set up a problem so that there is both space for personal interpretation and clarity of focus. Students should know not only what they are being asked to do, but why. They need to understand the point of the lesson or project and have space for personal interpretation. Again, this is an important aspect of teaching in other domains as well, but it is especially important in the arts because in other fields, especially in high-status fields, the need for justification is less critical to students, if not less important educationally.

Why are students asked to paint on a static, eighteen-by-twenty-four-inch sheet of paper an image that conveys a sense of repetitive motion? Why spend the time? What's the point? In the arts the point may not be obvious, and when it isn't students may comply with teacher expectations without any understanding of what is to be learned from the lesson. Knowing how to make clear what is not obvious is a critically important pedagogical skill in teaching the arts.

Another form of pedagogical knowledge in teaching the arts involves making connections between earlier and current work and between current work and the world outside the classroom. Consider the matter of sequence. How does the teacher set up tasks so that what a student learned on earlier tasks is applied, developed, and refined on current tasks? That is, how does a teacher build on what went before and prepare the student for what is to come? Art teaching can be a collection of unrelated activities that

not develop the skills that lead to mastery and satisfaction. Cre-
g tasks in which what has been learned can be used and
ugh which connections can be made between what has been
learned in the classroom and the world outside it is one of the crit-
ical needs in teaching the arts.

## IMPEDIMENTS TO ARTISTRY IN TEACHING

There are several impediments to artistry in teaching. One is habit
nurtured by comfortable routine.[12] Experienced teachers develop
routines that simplify their professional lives. All of us who have
taught for several years have acquired ways of doing things. We
organize our curriculum in ways that are familiar: we know the
pedagogical moves we want to make, we have an idea of what we
want to cover and at what pace, and we know what the final ma-
terial to be turned in by the student is likely to look like. All this
experiential knowledge allows us to get by with the least expendi-
ture of energy. Perhaps what we actually do in our classrooms is
not what we would do from an ideal point of view, but the de-
mands of teaching are so great, and our routines have worked well
enough—so we get by when we might have been getting ahead.
We do what Horace Smith did; we compromise.[13]

Because the job of teaching is often insular, it is easy to fall into
familiar routines. Such routines are not conducive to professional
growth. For professional growth, we need, as I have suggested ear-
lier, feedback on our teaching. In even broader terms, *we need to treat
teaching as a form of personal research.* We need to use the occasions
of our performance as teachers as opportunities to learn to teach.

In saying to experienced teachers that we need to use the oc-
casions of our own teaching as opportunities to learn to teach, I am
really saying that, like any other art, learning the art form is an
endless venture. In the best of all possible worlds, it never ends
until we do.

Self-reflection on one's own teaching, though important, is
seldom sufficient, for the reasons I offered earlier. We often simply
don't know what we are unaware of. It is a phenomenon that per-
meates parenting and friendships as well. What we need is critical

yet supportive feedback from those who know how to *see* the teaching of the arts in practice. Elsewhere I have called this phase of the critical process *educational connoisseurship.*[14] Connoisseurship is the art of appreciation. We see it in the arts all the time, as well as in other areas of life where someone really knows by virtue of experience and study what he or she is attending to. But connoisseurship is a solo enterprise; one can appreciate something in private, without uttering a word. Making public through language what one has seen, interpreted, and appraised is an act of criticism. It occurs not only in the arts but in sports, in food preparation, in fact in any domain where there is qualitative variation about which people like to speak. Thus criticism, what in educational contexts I have called *educational criticism,* is applicable to teaching. Indeed, it may be the only way in which the subtleties in teaching can be revealed.

We have been talking about teaching as if it entailed action exclusively with students. It entails more. Teaching occurs as teachers decide on how an environment is to be designed. What examples will be shown? How will materials be distributed? How will work be organized? What form of classroom life will be promoted? What will the walls of the classroom look like? What role will students have in designing those walls? What kind of rules and regulations will prevail? In sum, the entire environment, to the extent that it is a means for fostering the students' development, is subject to the professional judgment of the teacher and constitutes a form of teaching. Put another way, the setting itself teaches and is subject to the teacher's design choices. Teaching is not restricted to the direct interactions between teacher and student.

In the midst of discussion of the factors that constitute teaching it is easy to forget that as important as the curriculum might be, as ingenious as the teacher's pedagogical moves might be, the teacher not only teaches a subject or a set of ideas or skills; the teacher also teaches him- or herself. How we as teachers treat ideas, the exhilaration we display in the company of good ones, how we relate to our students, how we handle conflict, how differences in perspective are reconciled—or not—also teach, perhaps more vividly and surely than anything we do.

A teacher of art who is not moved by art cannot teach it, at least not well. I wonder if anyone can teach anything well that he or she does not love. Discovering the emotions that inquiry evokes, experiencing the feel of paint, the aroma of linseed oil, the touch of wet clay—these are a part of what is learnable from art and collectively contribute to its meaning. What the process of painting means is rooted in such experience. How teachers experience painting is not lost on students. "The teacher teaches him- or herself as well as the subject" might be the most significant aspect of what is often referred to as the "hidden curriculum." Ironically, it's not hidden from students.

THREE ART TEACHERS AT WORK

To exemplify some of the complexities and artistry in teaching, we will now look at three art teachers at work. The first is a high school teacher of art, Mr. Harsh (his actual name), teaching aesthetics to a class of inner-city youth.[15] To help them recognize differences in the ways the world can be experienced, he asks them to distinguish between two types of activities they routinely engage in, one practical and the other aesthetic. In helping them grasp this distinction he wishes to show them that there are different ways in which the world can be experienced. He proceeds to illustrate this distinction not by resorting to an exotic form of fine art or philosophical theory, but by calling their attention to a common activity, pouring cream into a cup of coffee. He first selects a Styrofoam cup and pours a little coffee into the cup, adds a little cream, tastes it, and then points out that the primary function of pouring the cream into the coffee is practical. He then uses a transparent plastic cup and carefully pours a little coffee into it and then a little cream while observing the way in which the white cream seems to explode in the cup for a brief few seconds after it is poured. He delights in the beautiful burst of cloudlike formations that the cream in the dark coffee creates. *That* kind of an activity, he tells the class, is an activity experienced for its own satisfaction; it is an aesthetic activity, not simply a practical one.

The example is something that students are familiar with, but

not in the way Mr. Harsh addresses it. The larger point of the lesson is that perceptual attitude is a choice, that there is more than one way to see. This point is reinforced by giving the students terms—*practical* and *aesthetic*—with which to frame this distinction.

Mr. Harsh moves from the coffee example to the task his students are to engage in; this is no mere spectator activity. That task pertains to writing about what they see, but not just any old form of writing; he wants a form of writing that has literary qualities. He doesn't use the term *literary,* but that is what he hopes they will create, and to increase the probability that they will, he tries to make sure that they have a sense of what literary language entails. This is accomplished in two ways. First, he models the use of the language by giving them a picture of what it looks like. Second, he gives them examples of what their peers have written in the past, thus making it clear that the task is doable and that it does not depend on special forms of adult expertise. In addition he gives them a negative example, that is, what their language should *not* look like.

He moves on by giving examples of experiences they have had or could have had in their own life in which practical experiences were transformed into aesthetic ones—watering the lawn, being lost in the experience of beauty—again, not in some exotic material outside their experience, but within their experience. The examples he uses make empathic forms of thinking possible.

Mr. Harsh then introduces the materials with which they are to work. These materials, water and red ink, are significant. Not only does each student get his or her own cup of water, but Mr. Harsh comes around to drop the red dye in each person's cup; personal attention is being provided here. The red dye in the water invites projection. Its fluid quality, much like a cloud's, makes it possible to see in the unfolding burst of form images that will receive without difficulty the meanings each student wants to confer upon them. The unfolding clouds of red open the door wide to individual interpretation. Unlike many tasks in school, this exercise has no single right answer. The key word is *single.* Not just any response will do; the response needs to have a literary or poetic feel; that's what his talk about simile was about. Thus, what we have here is an open-ended task that invites an individual re-

sponse and yet is not simply an instance of "anything goes." Not everything goes here.

The heart of the problem resides for Mr. Harsh's students in the relationship between seeing and expressing. Seeing is necessary in order to have a content to express. Expression is necessary to make public the contents of consciousness, and so what we have here is an imaginative transformation of a perceptual event that is imbued with meaning whose features and significance the students try to transform into language capable of carrying that meaning forward.

This transformation is, of course, what writing is about. Somehow the writer must find a way within the affordances and constraints of a linguistic medium to create the structural equivalent of the experience. Often in the very process of representation new ideas will emerge that are then themselves the subject of expressive aims. This phenomenon is exemplified in a student's narrative about the destruction and contamination of the Native American population. When asked to write a brief reaction to the dye swirling in the water, this is what she wrote:

> The clear crystal water looks to me like the landscape the native Indians love to live in. The land that was given to them from the Great Spirit. As the dye drops, Columbus lands. The Europeans not only destroy it, but pollute their beautiful land with diseases. The red dye spreads throughout the pure souls of innocent Native Americans. The red dye destroys their people, their tribes, their culture, their beliefs. In good hearts, these beliefs will never die.

It seems likely to me that these ideas were close to the surface of her consciousness and were triggered by the color and form of the ink. But note that her narrative itself has a powerful expressive quality, not only because of its imagery but because of its form. Think about the coda she used to bring her narrative to closure. "In good hearts," she wrote, "these beliefs will never die." It is in the relationship of image to form, or, more precisely, the forms her images take, that we are moved, as Mr. Harsh was, by her words.

This situation is one in which students use qualitative forms of thinking to do a number of things. First, they use perception, not mere recognition; Mr. Harsh is asking the students not merely to look in order to categorize, but to see. Second, the students' imag-

ination is engaged, in part because of the supportive relationship Mr. Harsh has with the students, but also because the exploding forms the ink creates invite such a response. In a sense, the free-floating cloud of red dye in water becomes a Rorschach-like experience. Third, the students must find a form, a form crafted in narrative that conveys their experience. They become writers. Their writing begins with vision and ends with words. We, as readers or listeners, begin with their words and end with vision. The circle is complete. The artful crafting of language so that it expresses what sight has given birth to is what this short episode is about. Finally, they bring closure to the episode by sharing their work with each other.

Consider another example. The scene is an upper-middle-class high school in which an experienced art teacher, Mr. Wayne, works with a group of freshman students. The project is the creation of papier-mâché masks of the heads of animals that in some way either reflect the students' personal characteristics or represent animals that the students like. As I enter the classroom, the students are listening to the teacher explain the technical requirements for using a wire armature for making a papier-mâché figure, the project that will follow the animal masks. The students are attentive. Mr. Wayne illustrates the project and the use of the armature by drawing the ways in which the wire is to be bent and what its proportions between torso and legs ought to be.

Once released, however, students pursue their papier-mâché animal project independently. There is, in this classroom, lots of self-directed activity. Students are working at their own pace and in relation to their own purposes. I can't help but reflect on how it is that work becomes important to students. Do they know the point of what it is that they are doing? How do they regard their work?

Mr. Wayne moves gracefully around the classroom. Help is provided individually; it is customized to fit the student. The work is there to see, and the problems that need to be addressed reside in the work or in the comments that students make about their own work. How do students learn to see what they have created? How do they develop the sensibilities, the refined perception, the attention to detail that mark aesthetic perception? Is this one more

project having little personal meaning, a normal part of the high school's scheme of things? It's hard to tell, but it is a question that should be raised in all classrooms. On the whole, students here do academically impressive work. They are accustomed to getting good grades.

On the wall of the classroom is a chart listing each student's name and the projects undertaken during the semester, with the grade assigned to each project. Each student's name is represented by a numerical code to keep performance levels private. I can't help but wonder if the press toward standardization and high-level performance in this upper-middle-class school district has created procedures designed to manage student behavior and to provide the illusion of serious business.

As students get into their work, concentration increases. The art room provides a context in which students interact and in which mobility is possible, although relatively few students move about without seriousness of purpose.

The kind of assistance that the teacher provides is largely technical. Students ask: How do I fix this problem? How can a wire be bent? How can the colors on this animal be improved? At this point in the project aesthetic considerations seem to be subordinated to the technical demands of the task. This is what students seem to expect, and it is probably what they need. The teacher suggests that the students use white paint first, because it can be covered, and then use a dark color. A practical and no doubt important piece of advice.

Students experience the qualities of the material they work with themselves. In some sense, the art room provides an opportunity to experience a sensory buffet. Wheat paste is used on papier-mâché, paper is torn into strips, the smell of paint is palpable, as is the drag of a brush on a surface. Unlike in most other classes, especially academic classes, the sensibilities are engaged. Yet I wonder how students connect with the project. What meaning does it have for them? I am impressed with their maturity, their demeanor, with the fact that they do address in their lives problems of great moment to them. Is an animal head in papier-mâché of the same order? Some students might be immersed in what for them is a non-

challenging routine, making it possible for them to converse with their neighbor while working on the project. I have a sense that for some students this *might be* an exercise in compliance, which the roster of grades on the wall may inadvertently encourage.

Mr. Wayne has some very interesting and imaginative requirements for the class. Perhaps the most important is that student work be sent home for parents to view and that they write a response to their child's artwork. It is a way to get them involved. And Mr. Wayne seems very satisfied with its effectiveness.

I am impressed by the fact that adolescents seem to fluctuate between being children and being adults. The amount of time needed to take this trip is very brief indeed. I am also impressed by the fact that these students do a lot of multiple processing: they pay attention to several things at one time, including conversations, painting their animal head, getting additional materials, listening to instructions.

Although the dominant lesson that appears to be taught is technical, a variety of other lessons are also taught and learned: how materials feel, how to assess the work they have done, how to work independently in the presence of others, how to work with tools. The activity in this room is largely individual; how could group activity be used? Would it be useful? How could the aesthetic aspects of the work that they produce or look at become more salient?

Mr. Wayne's relationship to the students is skilled, sensitive, and supportive. He moves about, providing individual attention. He displays a kindness that creates warm relationships with students. At the same time, students have a tendency to drift in and out of concentration on their project. Childhood emerges in the context of adolescence. However, a handful of students, perhaps five or six out of thirty present, seem to isolate themselves psychologically in the midst of social activity, remaining entirely focused on their work.

A substantial portion of the students are engaged in forms of thinking and activity that can be regarded as experimental; even when they are not consciously engaged in imaginative activities, they explore the potential effects that action on material makes

possible. In fact their unfamiliarity with the material invites an experimental attitude. It is the way they learn. Teaching here entails being supportive to students and yet providing guidance that sometimes implies criticism. The teacher negotiates this delicate relationship quite well. Through what kind of activities do students learn to see visual form and to talk about it? These are some of the questions that struck me as I watched a skilled and experienced art teacher and thirty high school freshmen spend an hour together.

Consider yet another example, this time an account by a Chinese art teacher, Miss Chan, in a middle school in Macao, describing her curriculum planning.

> I was conscious that advances in today's technology and the affluence of the society had enabled the majority of my primary five students to know how to take pictures with an automatic camera. Sometimes it could be by using a camera with an automatic zoom lens. I was also aware that the students were strongly affected by the widespread visual culture, especially TV programs (including kids' cartoons, gag shows, and the family soap opera series) and TV advertisements. In addition, there were movies and commercial videos. In other words, my students encountered close-up shots in one way or another. Therefore, I intended to make use of their knowledge of camera perspectives to teach the visual arts concepts of objective, non-objective, representational, and abstract.
>
> In the past I had observed that many students, especially those who happened to have an authoritarian class teacher and those who themselves had a soft character, would be inclined to draw figures and objects small and whole, all within the frame of the drawing paper. Very often they left a narrow margin on all sides, no matter how small the sheet of paper. One of the common features of their drawing was that the branches drawn near the edge of the paper would suddenly take an irrational change of direction just parallel to the sides of the paper.
>
> In order to break their limitation and psychic boundary and to enhance their sensitivity to the subtle qualities of colours as well as their knowledge of composition, I selected Georgia O'Keeffe's work *Red Poppy* [Plate 1a] as the teaching resource of the curriculum unit. Normally the lesson took place in the first quarter of the academic year. . . . This year this lesson was implemented after Easter, as a part of a series of learning ac-

tivities. The slides of the children's work were reproduced from the students' drawings of that academic year. As you can see in [Plates 1b, 1c, and 1d], the children captured the expressive content of O'Keeffe's painting, an accomplishment that required them to see the flower, in a sense, in the way she did. It required them to create a composition that reflected the qualities in O'Keeffe's image and to use the material, in this case oil-based pastel, so that the intensity of color was present. In the process, it is likely that they learned some important lessons about the construction of the image.

For the primary five students, the opaque oil pastel was an ideal dry medium since it could be easily handled. The 12-colour and 24-colour packs were very common in the market. With them, the children found less difficulty in achieving the richness of colours. Taking into consideration the fact that the tint of the paper could be seen where it was thinly coloured increased the complexity of the visual qualities. I prepared a few low-toned colour papers and asked the students to choose their preference. They were also required to collect large colour photographs of natural flowers, insects, or animals from magazines, postcards, calendars, or books.

My procedures for teaching were as follows:

1.  *VISUAL THINKING SKILL AND INTRODUCTION OF THE ART CONCEPTS*

I asked the students to imagine and to tell me what they could see from the viewfinder of the camera if they were taking a photograph of me from afar, at mid-distance, and as near as a few feet apart from me. They were encouraged to think boldly about how the images on the screen were changed when they kept moving close to me, as close as the focus was on a certain part or certain feature of my face, say my cheek or my eyebrow.

Then I introduced the concepts of objective, non-objective, representational, and abstract. Next, I asked the students the purposes of using a close-up shot and a super close-up shot.

2.  *ART APPRECIATION: GEORGIA O'KEEFFE'S* RED POPPY

I posed the following questions:

a.  What do you think about this artwork? How does it impress you? What can you see there? What is the artist's purpose then?

b.  What is the main colour of the picture? How many shades and tones of red can you find there? Point out and describe the colours (e.g., red, red-orange, between red-orange and orange, etc.).

Students were asked to compare the tones as close as even a very slight difference. (Most of them neglected the very low tone near the centre of the picture.)

**c.** How many petals are there? How are they positioned? How did the artist place the two front petals, of which the outside is facing you? Demonstrate it with your hands. Guess the purpose of the artist. Why didn't the artist draw these petals closer and wider apart? Is this a blossoming flower or one in full bloom?

I wanted the students to become aware that the positions of these two front petals help to shape and increase the mysteriousness of the inner centre of the flower, making it the centre of attention. As in everyday life, we usually have a higher interest in something that we partially know. This is because it arouses our curiosity. An example of this phenomenon can be found in Chinese landscape painting—mountains shrouded in mist and clouds.

**d.** Are all petals within the frame of the picture? Why? Imagine you were panning the camera across a city scene and took a standstill half way, what sort of a picture could you see from the viewfinder? What could you tell if you started panning again?

**e.** Which part of the picture attracts you most at the first glance? What do you look at next? (Get the students aware of their eye movement. Most students were attracted by the brightness of the red petals first, others found the darker shade of red the centre of interest.)

**f.** Look at the darker shade of red in the centre. What will you look at next? Can you tell the relations among the four darker shades in the centre of the lower half of the picture?

**g.** Look at the four corners of the picture. What is the purpose of the darker shades there?

**3.** *ART MAKING*

Students moved their viewfinder across the colour photograph to find a composition. It could be representational or abstract. However, if it was a representational one, the composition had to illustrate a sense of continuity. Students were reminded to study carefully the colours of the subject depicted.

Let us take a moment to reflect on what this teacher has to say about her curriculum planning and what we can infer from her teaching practices as she describes them.

First, she tells us that she recognizes the kind of experience her students have with modern technology. She uses their experience with cameras, video, and film to expand their awareness and sensitivity to visual form by asking them to imagine her appearance from close up, mid-distance, and afar, and thereby to experience vicariously differences and the impact of these differences among those images. She then uses this experience to make a connection to the work of Georgia O'Keeffe and O'Keeffe's preoccupation with very close-up images of flowers—in this case, "the red poppy."

Several things here are particularly impressive—not only her willingness and ability to recognize her students' experience with technologies that are related to vision, but also her ability to pose questions that activate their own cognitive processes in order to see what is normally recognized but not really seen. In other words, she poses questions that invite them to search for the visual qualities needed to respond to the questions she poses. She promotes inquiry of a visual kind into the work.

In addition, she affords them an opportunity to create their own images, images influenced by O'Keeffe's work but intended to concretize their experience. Finally, she selects materials for them to use which they can manage. She does not ask them to use watercolor, which would pose formidable technical difficulties, but oil-based pastels, which are intense in color but comparatively manageable. Thus, in the context of her lesson there are a multitude of judgments and decisions being made by her, all instrumental in promoting the learning in which she is interested.

What is there to learn from these observations?

One of the things that we can learn is that art teachers design tasks which invite students to pay a kind of special attention to visual qualities. Mr. Harsh directed attention to the forms created by red ink as it exploded in water. Mr. Wayne directed attention to the expressive features of the animals they were constructing. Miss Chan encouraged her students to explore images by zooming in on them with a camera and then transforming the experience

they secured in this process by representing it as Georgia O'Keeffe did in their color drawing. In all three cases the teacher's intention was to help the students escape the traditional habits of daily perception, namely, to avoid the rapid classification process that we all engage in so as to get on with our lives. This attitude toward perception is what Dewey referred to as "recognizing," in contrast to "perceiving," the slowing down of perception in order to explore and savor the visual qualities of form. It is in the process of perceiving that the nuances which inevitably constitute all form are apprehended and the qualities of life that their patterns engender are experienced. For example, Mr. Harsh invites students to transform practical activities into aesthetic ones, to re-see, to recognize a visual field. In effect, visual arts teachers are trying to help students learn how to participate in a new world. They are trying to help students reframe a visual world that they ordinarily treat instrumentally and as efficiently as they can. Efficiency, in the activities we particularly enjoy, is no great virtue. Inefficiency in such matters is usually preferable; slow is good.

But there is more to art teaching than discovering a new orientation to the perception of the visual world, as important as that might be. The "more" that I speak of pertains to the development of those forms of cognition that activate imaginative possibilities and eventuate in the use of technical skills for transforming what the imagination has given rise to within the possibilities of the material one has at hand. Thus, Mr. Harsh invites his students to transform their experience with the exploding red ink into literary and poetic language; and they do so. Mr. Wayne invites students to transform their image of themselves into its animal equivalent within the possibilities of a three-dimensional sculpture; and Miss Chan invites students to express what their eyes have seen close up through the use of opaque oil pastel.

What this process represents is a cycle that moves from the differentiated perception of nuanced unfolding qualities into the generation of imaginative possibilities. These imaginative possibilities are then expressed through a medium controlled by the technical skills the individual student possesses. Again, the work starts with vision and ends with a form of representation. Those of us

who encounter their work begin with representation and end with vision. What we see or read of what the students have created helps us re-see phenomena that we might not have considered or noticed before. Artists, whether teenagers or adults, feed our consciousness.

Not only do artists feed the consciousness of others; the work artists engage in feeds their own consciousness. Coping with materials, making judgments about formal relationships, appraising the features of various qualities in the work are activities that can powerfully heighten our awareness not only of the work acted upon, but of qualities related to those upon which we work. It is in this sense that the fruits of one's labor in the arts generalize. Learning to see one of Georgia O'Keeffe's poppies illuminates not only the poppy in question, but a whole other visual world sharing features similar to the ones O'Keeffe created.

The features of teaching and learning that I have been discussing are related rather directly to the arts themselves. However, it should be remembered that students never learn one thing at a time. Students live and work in a context, a milieu shaped by a wide variety of activities and events. The art room affords students an opportunity to develop their persistence, to explore their individuality, to share what they have learned with others, and to learn from others what they themselves do not yet know. It gives them opportunities to be mobile and to pursue their individual visions. It also gives them opportunities to learn to use a wide variety of tools and to learn how to care for them. The art room, like the concert hall and the dance floor, is a complex and changing nexus in which a wide variety of forms of thinking and learning are made possible. To provide a replete picture of what is taught and learned in the context of an art class, the sources of teaching must be extended well beyond what human teachers teach; the context also begs for a pedagogical analysis.

# 4 WHAT THE ARTS TEACH AND HOW IT SHOWS

*STUDENTS LEARN BOTH MORE AND LESS THAN THEY ARE TAUGHT*

What the arts teach is influenced by both what and how something is taught. That is, the arts, like other fields, can be taught in different ways for different ends. The aims of any field are not determined solely by its subject matter; they are also determined by policymakers and teachers who decide what is important to teach.

But regardless of intended aims, students learn both more and less than they are taught. They learn less, for seldom are all the hopes and expectations held by those who teach realized in practice; goals, in some sense, are always out of reach. But students also learn more than they are taught. Students bring with them individual life histories that interact with what is taught, and the meanings they construct from these interactions inevitably both exceed and fall short of our educational aims. Learning what the outcomes of curriculum and teaching have been for a student requires a form of open-ended clinical assessment that enables what is personal as well as what is common to come forward. *Outcomes* are what actually occur as a result of intervention, not necessarily what are intended to occur. If evaluation focuses only on what was intended, it is likely to miss outcomes that were unintended.

We are accustomed to asking, "What has the student learned?" The question is operationalized to mean, "What does the student

know or is able to do as of, say, May 12?" This conception of learning does not take into account the fact that what a student has been exposed to may interact in significant ways with what he or she will be exposed to in the future. Future experiences may confer a significance upon earlier learning that it did not initially have. Look at it this way. Seeds that are planted do not come to fruition until they are watered. In education the water the seeds need may not be provided until after the assessment has been made. The fact that the seeds have been planted is the first crucial move. Planting the seeds is one of the contributions teachers make to their students' development; when those seeds actually flower can't always be predicted.

Despite these complexities, we need to do what we can to identify the ways in which the arts influence the experience students have in working with them and thereby the cognitive abilities that they are likely to develop. One way to address the matter is to recognize the forces that affect what students learn in the arts. Let me identify four: there are the constraints and affordances provided by the activities and the materials with which students work; there are the prompts, cues, and scaffolding that the teacher provides to enable the student to succeed; there are classroom norms, the kind of thinking and behavior that is encouraged and discouraged in the setting; and there is an ambiance we can refer to as the classroom milieu. What is the *modus vivendi* in the classroom? What is its sense as a community of practice, and how does it relate to what students experience and learn? Let's look at these one at a time, although in any classroom all four interact.

The curriculum as it is used in a classroom or in any other setting is, at base, a series of activities in which students will engage. The activity may take the form of a project to be framed or a well-defined problem to solve. Each of these activities takes shape within the constraints and affordances of some material; if the class is an English class, tasks related to the uses of language are likely to define the activities provided. If the class is a choral group, music, specifically vocal performance, will define the tasks to be performed. If it's a math class, the use and comprehension of numerical relations will be the focus. Each of these curriculum activ-

ities imposes on students different constraints, and each provides different affordances; attention to the use of metaphor is much more likely in the English classroom than in a math class. The behavior of color is more likely to be addressed in a painting class than in a history class. Each class, devoted as it is to a subject matter whose aims and materials differ from those of others, defines the resources within which students must think and resolve some problem or complete some project.

I alluded in the preceding chapter to the constraints and affordances of watercolor painting. Constraints and affordances emerge in *any* selection of tasks and materials. These tasks and materials constitute what it is that the student will need to "get smart about." Getting smart, in this context, means coming to know the potential of the materials in relation to the aims of a project or problem; and since each material possesses unique qualities, each material requires the development of distinctive sensibilities and technical skills. From this perspective the selection of a material or activity is also the selection of an array of forces that will influence how students will be challenged to think.[1] It is this realization, the realization that the curriculum is a means for developing the mind, that makes the planning of curricula so critically important. When we decide what will be taught and how it will be taught, we influence, but do not determine, what students will have an opportunity to learn.

A second force influencing what students experience is the array of prompts, cues, and scaffolding the teacher provides as students work on projects or problems.[2] What a teacher says to assist a student can either advance or undermine the student's ability to solve the problem at hand. For example, in the visual arts some teachers may inadvertently take over a student's project, not by providing options the student can consider to determine how the problem might be resolved, but by determining what the student should do—perhaps with a suggestion such as "You need a little more green over here." In the process the teacher assumes the role of an art director responsible for making the aesthetic decisions and the student the role of technician who executes the decisions made by the teacher.

Teachers can advance their students' ability to see what has been done and to consider alternatives, to suggest connections with the work of other artists, and to assist in the development of necessary technical skills. In short, the teacher can help the student move along on a journey that fosters both independence and self-confidence in dealing with problems in the arts.

In many ways, the creation of a scaffolding that optimizes what students are able to learn in particular circumstances is much like what good parents do to help their children learn. Such learning culminates in the child's achieving mastery, a form of learning that promotes independence. *When* parents decide to intervene when a young child is having a bit of difficulty learning to tie her shoes is an important tactical decision. If the parent intervenes too soon, the child may become dependent upon the parent. If the parent provides too little help too late, the child may become frustrated. The parent's task—like the teacher's—is to be tuned in well enough to make the right decisions about when, how much, and how.

This process, one that parents around the world have negotiated successfully for millennia, is what the Russian psychologist Lev Vygotsky has called the "zone of proximal development."[3] This zone is the space within which tasks need to be set to be, on the one hand, challenging and, on the other, capable of being successfully negotiated by the child with a helper, peer, or adult. No challenge, no growth. No success, no growth. Finding the child's zone of proximal development is the way to keep growth moving.

A third force affecting what students learn is the classroom norms that pervade the setting in which students work. Every classroom possesses norms that define acceptable behavior. For example, in many classrooms looking at your neighbor's work is prohibited; it's called copying. In some classrooms students are not to leave their seats without having asked for and received permission. In other classrooms, especially art rooms, looking at fellow students' work is not only permitted, but encouraged; it's a way to learn. Furthermore, student work is not only looked at, but discussed by both students and teachers.[4] In this setting classroom norms encourage cooperation, autonomy, and community—students can

look at the work of their peers and at the same time become increasingly independent. Movement in the class is not prohibited; if students need something, they are expected to get it. It is also expected that the teacher will be able to distinguish between "goofing off" and the necessity of moving about in order to meet real needs. It is expected that students will come to the classroom to work, that they will have the materials they need to work with, that they will initiate their work as they enter the classroom and not feel the need to wait for a signal from the teacher before they begin.

These norms aim at creating an environment that approximates a studio's and at establishing expectations that students will help one another. In this environment comments made by the teacher are both private and personalized when it is time to talk about the qualities of individuals' work. Comments are public when it is time for group critique. It is an environment in which students are learning to think and behave like artists.[5]

Task demands, teacher prompts, and classroom norms considered collectively constitute the fourth force that affects what students learn in the arts. That collective force is the creation of a classroom milieu. Classroom life in the arts does not usually resemble life in academic classrooms. In the choral setting, students are collectively engaged in a common enterprise. In the art room, students are given permission to direct their own activities in settings that provide much more space for personal initiative than is normally found in most academic settings. In dance class, students focus on the development of aesthetically shaped movement but then work with other dancers to put aspects of their individual performance together with theirs. Similar factors are at work in theater; lines may be learned solo, but performance is seldom effected alone.

These interacting forces create a cognitive culture that has as much to do with developing dispositions as with developing aesthetic and analytic abilities. It is a culture that, at its best, models what adults do in those realms. What the milieu teaches is seldom on the list of aims for the arts, yet what the milieu teaches can be of prime importance in helping students learn what it feels like to

function as a budding artist, to be really engaged in one's work, not for extrinsic reasons but for intrinsic ones.

Given this backdrop, let's turn to what the arts teach as students engage in them in class. Up to this point I have been talking largely about lessons learned in classroom settings. But what is it that students learn when they are engaged directly in art activities? Several caveats are in order here. First, everything that I have to say about the educational value of the arts is predicated on the provision of excellent teaching. Poor teaching can scuttle the potential contributions of any field. Second, because my own background is in the visual arts, I will focus upon the visual arts, but I believe that the general factors I identify have their counterparts in the other arts as well. Third, I said earlier that the arts can be used to move students toward a variety of destinations. I am choosing here to focus on two domains in which learning about the visual arts can be fostered because I am interested in furthering the modes of thought that make it possible for students to use materials as media for artistic expression: learning to think aesthetically about images and their creation and helping them advance their ability to see the world aesthetically and to describe it in artistically sensitive ways.

## WHAT THE ARTS TEACH

### Attention to Relationships

A fundamental concern of anyone working in the arts, whether painting, composing music, writing poetry, or engaging in dance, is to create satisfying and expressive relationships among the "parts" that constitute a whole. Composing, the putting together of elements, can be resolved in the arts only by paying attention not to literal matters, not to matters of reference or to logic, but to qualitative matters. How do the parts of the composition hold together? Do some parts dominate? Is there, as Nelson Goodman calls it, "a rightness of fit"?[6]

The creation of such relationships, relationships that display rightness of fit, require careful attention to highly nuanced quali-

ties; very subtle differences in the temperature of a color or in the strength of a line can make all the difference between achieving a satisfying array of relationships or an array that doesn't work.

Learning to see these relationships requires use of a new form of vision. Most perceptual activities are essentially efforts to recognize rather than to explore the particular expressive qualities of a form. In typical circumstances, seeing stops when a label can be assigned to a quality:[7] That's my house. That's a stop sign. That's my Uncle Harry. Other forms of perception attend to component qualities but do not explore the relationships among them. In Piaget's terms, perception is "centrated" rather than "decentrated."[8] In Arnheim's terms, the solution is "local" rather than "contextual."[9] The viewer looks, but looks at parts rather than at the ways those parts interact with each other. Teaching in the arts is very much concerned with helping students learn how to see the interactions among the qualities constituting the whole. This lesson is, of course, a major lesson art students learn in life drawing classes. It is here that not only must the configuration of the figure be addressed; the student must also see the figure in relation to the ground on which it is to be placed. If the figure is, for example, off-center, the balance needed to achieve a satisfying image will be lost. If one wants an unbalanced image, fine. If not, there is work to be done.

One of the techniques people use to heighten awareness of these relationships can be seen in an art museum as people move close to a painting and then step back several feet. Move up, and then step back. What is happening here is a kind of visual analysis–synthesis relationship. The person is trying to see the details or nuances of the part and then, by moving back, how those qualities influence the whole. One might say that it's a kind of dance in the service of sight.

In the kind of perception I am describing, sight alone will not be adequate for resolving problems of fit. Problems of fit must be addressed not only through sight but also, as I indicated in Chapter 1, through *somatic knowledge,* through being tuned in to the work and being able to make adjustments to the image on the basis of what is felt emotionally.[10] Body knowledge comes into being as

the individual learns how to use sight to inform feeling. In this sense, each modification of the image in the course of doing a painting or drawing and its emotional consequence can be likened to a personal experiment. The efficacy of the move is known by its effects on our experience. These effects then become cues for further adjustment. Over the years artists in all fields have become extremely sensitive to these embodied effects and depend upon them to make choices about emerging forms.

The sensitivities I have described come into play in the entire painting process. A painter, for example, must make choices that depend upon "feel" well before the finishing touch is applied to the work. The artist regards preliminary moves as leading to the creation of qualitative relationships that are necessary if the creation of later qualities is to be possible. For example, an underpainting having particular qualities may need to be achieved before the overpainting can be applied; unless the underpainting possesses the necessary qualities, the overpainting will not have the desired effect. What we have here is more than technical expertise—although it is surely that; it is also the creation of a somatic connection with the work, a connection secured through refined sensibilities. What such choices depend upon is judgment in the absence of rules. Indeed, if there were rules for making such choices, judgment would not be necessary. As in the scoring of multiple-choice tests, judgment would be superfluous; the optical scoring device scores without considering alternatives. Work in the arts, unlike many other rule-governed forms of performance, always leaves the door open to choice, and choice in this domain depends upon a sense of rightness, a form of somatic knowledge that allows the maker finally to arrive at that most difficult of artistic decisions: "It's done."

## Flexible Purposing

The term *flexible purposing* is Dewey's.[11] In the context of this book, flexible purposing pertains to the improvisational side of intelligence as it is employed in the arts. The intelligence I speak of is the ability to shift direction, even to redefine one's aims when better options emerge in the course of one's work. In many ways this

willingness to treat ends flexibly and temporarily flies in the face of our dominant view of rationality. According to the standard view, ends are supposed to be well defined, firmly held, and used to formulate means, which are theoretically related to the achievement of those ends. Once means have been employed, evaluation is to follow. If means are found wanting, new means are conceptualized and implemented, and their effects evaluated. Again, if means are ineffective, even newer means are implemented. Ends are held constant in the standard view of rational behavior. Means follow goals. It's all quite neat.[12]

The problem is that it's too neat. Life does not proceed that way, and for good reason. The implementation of means might lead to unanticipated effects that may be more interesting, promising, or problematic than the ones originally sought. In such cases, and especially so in the arts, the individual takes his or her lead from the work. The work, so to speak, also speaks, and at times it is the artist who listens. The work in progress begins to look more like a conversation than a lecture. This conversational quality is almost literally true in jazz improvisation, in which musicians do not know prior to performance what their musical conversation will consist of, at least not in precise terms.[13]

Of course, improvisation occurs in the other arts as well, including the performance of music when a score is available. Even in such cases performance is never mechanical routine. Within the constraints of the score the musician improvises by choosing to modulate sound in ways that are innovative. The same holds true for the visual arts. Not all the consequences that flow from the process of painting or drawing can be predicted, and when what emerges is found attractive, the artist may very well take his or her lead from the work. "This passage of color looks promising." "I think I will alter this so that it works with that." Part of the joy of painting consists in the microdiscoveries that the work in progress makes possible. As I mentioned in Chapter 1, these microdiscoveries provide for surprise, and surprise is one of the rewards of work in the arts. The kind of flexible purposing fostered in the arts might develop forms of thinking and attitudes toward problems that

emerge in other fields, but such outcomes are never the arts' primary educational justification.

To pursue surprise requires the willingness to take risks, for while surprise itself may emerge, its pursuit is a choice. In choosing to pursue surprise one selects an uncertain path, and it is here that familiar schema and customary techniques may prove ineffective. One of the challenging features of work in the visual arts is the tendency to revert to familiar routines in order to resolve a visual problem, and this tendency can become even more severe when the artist has been successful in previous work. The easiest road to follow is to try to repeat past victories. When the arts are well taught, flexible purposing is encouraged.

## Using Materials as a Medium

Close your eyes and imagine you are driving in an open car on a beautiful country road on a sunny day in May. The sky is blue and punctuated by large white cumulus clouds overhead. As you drive down the road you see a green field with a dark brown horse far in the distance. You slow down, stop the car at the side of the road, and get out to get a better view. As you stand by the fence the dark brown horse begins to move, slowly at first, but as it moves it picks up speed, from a walk, into a trot, into a canter, a gallop, and a full run; and as this happens, with each increase in speed the color of the horse begins to change, from dark brown, to gray, to a deep dark blue. And while this is happening white wings on the back of the horse appear, and as they appear they begin to move, lifting the horse into the blue sky. The image gets smaller and smaller as it rises, and as you stand there slack-jawed, it disappears in a large white cloud.

I have no doubt that you were able to envision the scene I have described. Now suppose you were asked to represent that scene in a painting, next in a dance, then in a musical score that you will compose, and, finally, in a short story. Each material and each art form imposes its own possibilities. In dance you must think in terms of bodies in motion that somehow "capture" the scene or express the emotion you experienced or wish the viewer to expe-

rience. Painting, a physically static product, requires other modes of thinking. In dance, movement is actual. In painting, movement is virtual. Furthermore, dance need not deal much in color. In painting, color is likely to be important. The way composition is shaped in each of the materials differs. In dance, composition is in constant change. In painting, it is stable. What you are able to achieve will depend on what you are able to do with the material. This doing represents a transformation of a material into a medium. Materials *become* media when they mediate. What do they mediate? They mediate the aims and choices the individual makes. In this sense, to convert a material into a medium is an achievement. A material becomes a medium when it conveys what the artist or student intended or discovered and chose to leave.

If a material is to be used as a medium, techniques for working with the material must be developed. For children of different ages the level of skill development will differ. But always, to some degree, skills must be at hand. Young children given a ball of clay and asked to make a tree will make quite a different form than they will if asked to draw a tree.[14] The characteristics of the materials call up different conceptions and skills that function within the limits and possibilities of the material, and it is within the limits and possibilities of the material that cognition proceeds. As they mature, children's recognition of the material's potential expands, and when their technical skills live up to their expanding conceptions of what they want to create, the quality of their artistry increases.

Now it is easy to think about skills and techniques as rather mechanical processes. They can be. But they need not be. To think skillfully is an act of intelligence, and to modulate technique so that it serves one's purposes requires sensitivity to nuanced qualities. Thinking well within a medium requires an understanding of the potential possibilities and limits of the material with which one works. But it also requires more. If sound in the context of music is to be the medium, attending to the patterns of sound is the mode of cognition. If paint in the context of the visual arts is to function as a medium, thinking needs to focus on the organization of what is visual. Seeing or imagining how something will look is crucial.

To point out that each material imposes its own limits is not to say that thinking in modalities that differ from the one in which the material resides does not occur. It does. As one works on a sculpture, language may come into play to help think through the problem, to consider alternatives, to reflect on what has been done and what needs to be done. Internal monologues—inner speech, a form of self-regulation—are ways of dealing with complexity in the safety of one's private cognitive life. The cost of an empirical try-out may be too high, given the lesser cost of trying out ideas in one's mind.

## Shaping Form to Create Expressive Content

The hallmark of the aesthetic is perhaps best known by contrast with its opposite, the *anesthetic*. An anesthetic suppresses feeling; it dulls the senses. It renders you numb to feeling. What is aesthetic heightens feeling. What is aesthetic is pervaded by an emotional tone made possible by the process of being engaged in a work of art. The phrase "work of art" can have two meanings. It can refer to work of *art*, or it can refer to the *work* of art. The former refers to the product created, the latter to the process of creating it. Aesthetic experience can be secured at each location.

We may ask what it is about the work that causes us to be touched or moved in its presence. The answer can be found in the value that aesthetic experience has for us. The experience of a powerful play, a moving symphonic score, a jazz trio at its best, or an architectural masterpiece like Frank Lloyd Wright's "Falling Water" provides an emotional yield that is, for some, well worth a trip to the ends of the earth. If the payoff weren't there, the effort would not be made.

But what is it about these and other such works that evokes in the receptive viewer the experience I speak of? In one sense the answer seems plain: it's the way forms are crafted. It's the shape they take. It's the relationships they display. *Artistry consists in having an idea worth expressing, the imaginative ability needed to conceive of how, the technical skills needed to work effectively with some material, and the sensibilities needed to make the delicate adjustments that will give the forms the moving qualities that the best of them possess.*

Artists have learned to create forms that are intended to move us. The incarnations these forms can take are various. Even more, different forms appeal to different "parts" of ourselves. For example, the optical illusions of Josef Albers's or Bridget Riley's work appeal to the visual parts of our selves; the flowing nudes of Peter Paul Rubens and Pierre-Auguste Renoir appeal to our tactile selves; the fantastic Surrealist images of Salvador Dalí and Yves Tanguy play games with our mind and our sense of what is real; the Abstract Expressionism of Franz Kline and Jackson Pollock appeals to the swift power of gesture. Our involvement in these works speaks to us in different ways, and their messages evoke responses in different aspects of our being. In a sense, their form finds its echo in our soma.

Another quality that characterizes work of high artistic quality is that a percipient can return to the work over and over again and still find qualities and relationships that continue to nurture; the work is not exhausted in a single glance. Of course, what nurtures is also dependent on who is dong the reading and looking, but, in general, the work's capacity to delight, move, and surprise is a telling index of its artistic merit.

For children, the conscious realization that form can be managed to express feeling comes late in childhood. Although some scholars believe that very young children are naturally tuned in to such expressive qualities well before they enter school, there is no evidence that preschoolers can produce such forms on demand or that they know at a conscious level what they are doing when they do so. The development of the imagination, the technical skills, and the sensibilities needed to create aesthetic form is much—but not all—of what arts education is about.

### The Exercise of Imagination

One important feature of the arts is that they provide not only permission but also encouragement to use one's imagination as a source of content. Unlike in the sciences, where imagination is also of fundamental importance, in the arts there is a tradition that does not hold the artist responsible for "telling it like it is." In the arts children, like adult artists, can pursue whimsy if they wish— the man's hair can be blue; they can tell it like they want it to be.

Put another way, in the arts the individual can use materials to confer upon forms whatever suits his or her purposes without being accused of "distorting reality."

It is ironic, but the enlargement of life through the arts is a powerful way to see what is lifelike. By making things larger than life or by recontextualizing them, reality, whatever it is, seems to be made more vivid. We sometimes say of a character in a play or film that he seemed larger than life. The imaginative image in such situations functions as a template by which we reorganize our perception of the world. We acquire new schemata. That, I think, is one of the reasons despots have regarded the arts as dangerous. The arts provide a platform for seeing things in ways other than they are normally seen. In so doing they help us wonder, "Why not?"

Writing about the power of the imagination to effect social change, Maxine Greene has this to say:

> It may be the recovery of imagination that lessens the social paralysis we see around us and restores the sense that something can be done in the name of what is decent and humane. I am reaching toward an idea of imagination that brings an ethical concern to the fore, a concern that . . . has something to do with the community that ought to be in the making and the values that give it color and significance. My attention turns back to the importance of wide-awakeness, of awareness of what it is to be in the world. I am moved to recall the existential experience shared by so many and the associated longing to overcome somnolence and apathy in order to choose, to reach beyond.[15]

For those who want no change the arts and the imagination can cause trouble.

## Learning to Frame the World from an Aesthetic Perspective

The world we live in can be seen in a variety of ways. Indeed, the process of socialization is, among other things, a means through which we learn to see the world within a common frame of reference; our frame shapes what we see. As I indicated earlier, most perceptual activities are instrumental in character; we see in order to use the content of sight to get somewhere else or to bring closure to an activity. We look for our house in order to know that we

have arrived home. Our seeing is practical, and practical perception is not usually designed to provide delight in what is seen, to challenge our beliefs, or to generate questions that lead to productive puzzlement. Most of what we do when we see does not have as its primary outcome a new way to view the world. The arts, however, do this with regularity.

What does it mean to view the world within a frame of reference? A frame of reference is a frame that defines a point of view. We see what we see within the terms the frame provides. Consider seeing not simply as the exploration of qualities, but as a "reading" of those qualities. A geologist looking at the Grand Canyon sees the striations of rock as proxies for evolutionary forces for which the color changes provide information for making geological inferences. It is by virtue of these differences in rock formation that the geologist is able to read the geological surface. Seeing is epistemic; the geologist sees in terms of geologic interests.[16] But the "same" rock formations are quite a different form of experience for the real estate agent, the poet, and the painter. The real estate agent reads the rock formation in terms of its property potential, the poet with respect to its lyric possibilities, the painter in terms of its potential for painting. Each person bringing a different frame of reference reads the so-called same image differently. Each reading is an interpretation that influences the kind of experience the individual will have.

The image for each of these people is not the same. What the rock formation is for each of them is determined not only by the rock, but by what they bring to it. Their frame of reference shapes what they will make of the rock. Part of what the arts provide are new ways of experiencing the rock.

Seeing the rock aesthetically, or hearing a wonderful piece of music, or experiencing a fine play is more than becoming aware of its qualities. It is a way of being moved, of finding out something about our own capacity to be moved; it is a way of exploring the deepest parts of our interior landscape. In its best moments it is a way of experiencing joy.

*Joy* is not a term that is used much in the context of education, but if the arts are about anything, they are about how they make

you feel in their presence—when you know how to read their form. The arts, when experienced in the fullness of our emotional life, are about becoming alive.

I suggested earlier that frames of reference make a huge difference in what we see. But even here there is a caveat. Although frames of reference provide an aperture through which we can secure a focus, every frame excludes as well as includes. To see the rock formation as a poet might mean that one will not be likely to see it, at least at the same time, as a geologist, painter, or real estate agent. As I said, a way of seeing is also a way of not seeing. Sense is made; it is not provided or discovered. What students are able to do with a situation is affected by what they bring to it, their frame of reference. And this brings us to the function of the curriculum and, more specifically, the function of the arts within the curriculum.

One such function is that the curriculum provides frames for reading the world. These frames, theories, concepts, images, and narratives parse the world in particular ways. Becoming socialized within a culture means acquiring these frames, for they allow you to join and participate in a discourse community, where discourse refers to the sharing of any form in which meaning is encoded and can be decoded. Common frames make a shared way of life possible.

Students acquire tools in the courses taken for making sense of the world. Educational programs that are effective both provide a variety of frames *and* develop the student's ability to shift frames. But what of the arts in this scheme? Specifically, what does work in the arts contribute to these frames?

The arts help students learn to pay attention to qualities and their expressive content. Attention to the particular qualities of, say, a rock is not a customary mode of perception, yet there is more beauty in a rock than any of us is likely to discover in a lifetime. Learning to see in the sense in which I am using the term here is learning to use a particular frame of reference. It requires, in some cases, a disregard for the label or function of the thing seen in order to pay attention to matters of form, that is, to the way qualities are configured.

But it is not only the formal elements or qualities of the thing

itself that need to be addressed, but the way these qualities generate expressive content. Put another way, it requires a willingness to allow the form to inform the way we feel when we see it. Sight, in this case, is put in the service of feeling. No teachers on the faculty of a school are more likely to address such matters than teachers of the arts.

## The Ability to Transform Qualities of Experience into Speech and Text

Up to this point I have been speaking of forms of cognition that have to do with either the creation or the perception of visual form. Now I shift to another dimension, the forms of thinking that make it possible for the student to perform a feat that is usually so apparent that it is taken for granted. This feat is the ability to transform experience into its linguistic counterpart. This task—talking about art—is the job of critics and art historians, but it is done by all of us who wish to converse about what we have experienced. I use the word *experience* in this context rather than *see* because experience is wider than sight and because many visual works of art may begin with sight but can be rapidly transformed into nonvisual forms of experience. For example, we can have tactile experience by looking at visual form. This process of experiencing in one sense modality qualities that are found in a different sensory modality is called synesthesia. For example, we can look at certain shapes in a painting and regard them as sharp or see an array of colors and describe them as soft. We can feel rhythmic sensations of a muscular sort in looking at paintings that seem to pulsate. In fact much of our experience is multisensory even when there is a dominant sensory modality. Music is not only auditory; it is tactile, sometimes visual, and it is tactile and visual in particular ways depending on the particular musical score we are listening to.

The transformation of what is experienced into speech or text can be addressed in different ways and at different levels. A student might see a painting, recognize the artist or genre, and assign it a date. A student might speak about the technique or materials used to make the work. Someone might discuss the theme that the work displays. All such aspects of the work are routinely addressed by critics, who in one way or another speak and write about works

at different levels of specificity and who focus on some (but not all) of what can be experienced. Knowing what to say, in part, requires knowing what to look for. However, for our purposes, I wish to focus on an aspect of speech and text that addresses a particularly elusive aspect of a visual form: its expressive content.

You will recall that I said that expressive content, a property that all form possesses, relates to the emotional character that pervades a particular work. To encounter a work and not to experience its expressive content is to miss the aesthetic features of the work. This does not mean that experiencing the expressive content of any particular work will be identical for all individuals. It cannot be, since experience is shaped not only by the work, but by what an individual brings to the work. Nevertheless, if the individual is open to the work, that is, if the individual allows himself or herself to "surrender" to the work, there will be some emotional yield. Experience will have some feelingful quality. It is this quality and the expressive character of the component qualities that are subject to linguistic transformation. Consider the following critical account by Harold Rosenberg as an example of a skilled critic's attempt to render the qualities of a work through language.

> Rothko had reduced painting to volume, tone, and color, with color as the vital element. His paintings, many of them huge and intended for display in public places, range from floating masses of tinted air, like influxes of breath, to closely packed slabs of dense, glowing pigment, resembling segments of metal or stone tablets that once carried inscriptions (the latter canvases reawaken the archaic overtones of Rothko's submerged cities of the early forties). With the overall figuration kept intact from canvas to canvas, emotional content is determined by the hue, pitch, weight, and expansion and contraction of his oblongs of color, as these are affected by the shape and size of the whole. The psychic tensions evoked by Rothko are at once extreme and featureless, mythical without mythic personages or events. An upward drift, as of levitation or the weightlessness of grace, stimulates a flux of inhalation and opening out, and draws the spectator into the orbit of the artist's inward flights. Materiality is overcome—at least, until the walls reassert their presence—an effect that has led some observers to speak of Rothko's paintings as enveloping the onlooker or transforming his environment. In contrast, his brooding, dark, reddish-brown canvases,

which had emerged as early as the fifties but appeared more frequently, and growing blacker, in his last years, tower over the spectator in a blank foreboding, like ancient testaments kept intact in a shrine or a grotto of some dour barbaric cult.[17]

This critical discourse is riddled with innuendo, metaphor, and simile. The critic tries to get at the expressive character of the work through suggestion. The linguistic transformation finds its roots in the neologisms that infants and preschoolers regularly concoct. "Ickey!" is in no English dictionary but leaves no doubt about the child's attitude toward what is placed before him. From neologisms, we move to vernacular poetry called slang. Slang is a way to use language so that it captures attention, marks one as a member of a particular group, and captures and conveys meaning that could not be expressed as well in ordinary vernacular.

In the context of art, language must at times be used in ways that express the ineffable. For example, when qualities that have particular expressive characteristics must find a poetic or metaphorical equivalent, language is used artistically. The way colors are laid on in a painting by Pierre Soulages might be described as "slurpy"; the word itself suggests an experience secured in other settings, and in so doing helps others experience a quality of Soulages's work that they might not otherwise see. Of course, to do this the student must first be able to experience the "slurpyness" in the painting and then be able to use language that captures its quality. This linguistic act is the product of a linguistic imagination. The attitude required to use language of this kind is one that eludes the limiting constraints of literalism in perception and allows one to enter the work emotionally. Again, in many ways it represents the ability to surrender to the qualities of the work one beholds.

This willingness to surrender to the work is an attitudinal characteristic of writers. The phenomenon surrendered to need not be a work of art. It can be a family, a city street, a carnival, in fact anything that one cares to address aesthetically. The writer starts the process of writing by seeing and by having an emotional response that is then transformed into words intended to capture the flavor

of that response. Thus, as I indicated in the previous chapter, the writer starts with vision and ends with words. The reader, however, starts with the writer's words and ends with vision. The circle is complete. Both painter and writer enlarge our awareness within the frames their work provides, and, I would argue, it is this expanded awareness that in turn enlarges our understanding of what the work addresses. If understanding can be conceived of as the enhanced experience of qualities so that relationships are noticed, relationships that confer upon component qualities a pervasive quality, then the arts, to the extent to which they expand such awareness, also enlarge human understanding. To be sure, the understanding I speak of is not theoretical understanding. It is a grasp of interacting relationships among distinctive qualities. When such seeing occurs it is epistemic.[18]

Thus, work in the arts, when it provides students with the challenge of talking about what they have seen, gives them opportunities, permission, and encouragement to use language in a way free from the strictures of literal description. This freedom is a way to liberate their emotions and their imagination. The opportunities to speak or write as I have discussed them are not only ways to describe what has been seen—though they are surely that; they are also a way of searching in order to see. The opportunity to talk about a visual field is also to imply a need to have something to say. It is this need that motivates search patterns in the work. Having a need to say, one looks more intently.

My focus thus far has been upon the use of speech and text as avenues to sight and as a means by which students learn how to use language imaginatively to describe felt qualities and to promote vision and advance understanding, their own vision and the vision of others. But language also has other, more conventional functions when it comes to the arts. One of those functions is to enable students to acquire an understanding of the relationship between the arts and culture over time.

One of the outcomes of arts education is the development of students' ability to understand art as a cultural artifact. How do the technology of a culture, the values that pervade it, the forms of art that preceded it influence the art at hand? How, for example, did

the return to the natural landscape by the Barbizon painters in the mid-nineteenth century in Europe influence the work of the Impressionists, and how did the work of the Impressionists influence the work of the Nabis, the Fauves, and the Cubists? Work in the arts—in any art field—should help students grasp general principles regarding cultural influences on the arts. This is not to suggest that students must come away from study of the arts with an encyclopedic grasp of the details of each period, but the principles are understandable, and the questions that give rise to them are powerful heuristic devices for putting art in context. These principles are teachable, learnable, and conceptual in form. In my view they ought to be a part of the curricular agenda.

Understanding art as a cultural artifact is by no means limited to historical material. Contemporary motorcycles and the features of a laptop computer are also influenced by cultural values, the technology that has been developed, and the way business is conducted. To understand why computers look the way they do, the impact of these factors must be taken into account.

So far in this chapter we have focused on *what* the arts teach. Now it is time to focus on *how* it shows. How shall we know if learning in the arts has occurred? What evidence do we look for? Where might it be located? Although in Chapter 8 we will be considering some of the methods through which the assessment of learning in the arts can occur in depth, there are some things we can say now.

## HOW DOES LEARNING IN ART SHOW?

The most significant kind of learning in virtually any field creates a desire to pursue learning in that field when one doesn't have to. In this sense, the really important outcomes in education are located not within the school, but outside it. After all, schools will never have the time to do a comprehensive job of teaching all that can be known about any field of study. In any case, that is not the job to be done. The aim of the educational process inside schools is not to finish something, but to start something. It is not to cover the curriculum, but to uncover it. What one starts is an interest

that is sufficiently powerful to motivate students to pursue that interest outside school.

The dilemma for educators is that although this may seem a worthwhile aim, the likelihood of being able to observe students in nonschool settings using what they have learned in school is small. Hence, we make inferences from in-school behavior to how students behave elsewhere. How do students react to the visual world around them? With what level of interest do they take on tasks in the arts? Are they engaged? Do they seek out qualities in the environment in order to enhance their aesthetic experience? Arts education, when it is effective, has dispositional outcomes. It stimulates appetite. And it is appetite that ensures, if anything can be ensured, that what was begun in school will be continued outside it. All of this adds up to the importance of intrinsic satisfaction as an educational outcome. As long as extrinsic rewards provide the motives for action, action is likely to cease when the extrinsic rewards stop.

Another outcome of effective art education is the refinement of perception. Students who have been in an effective arts education program should have had their sensibilities refined. When it comes to visual qualities and their relationships, they should be able to see more, aesthetically speaking, than their peers who have not had the benefits of such a program. As I indicated earlier, arts education is about the development of sight in the service of feeling. One might say that arts education should foster the ability to carry on those fine-grained discriminations that constitute qualitative forms of inquiry.

But how can we know what such inquiry yields in the form of experience? We have no direct access to experience. We must use proxies for experience, and one such proxy is language. What are students able to say about what they look at? Or, put another way, what does their language tell us about what they see? Assessing the features of their language in relation to the work they comment upon is one avenue for learning what they have seen. This kind of assessment requires us to look at their language, the kind of similes and metaphors they use and, most important, the incisiveness of the comments they make to get at what appears essential to the work.

Related to the use of language I have described is the presence of another kind of language, a technical language, that provides an indication of the depth of the student's understanding of the work. To talk about "dry point," "underpainting," "chiaroscuro," "picture plane," or "negative space" is to reveal, when used appropriately, a grasp of features both technical and formal that the less well informed might not notice. Such cues give us some insight into the range of what students have learned.

An important data source for determining what students have learned is the artwork that students create. These works are potent sources of evidence regarding the outcomes of effective arts education when competence in qualitative reasoning is an educational aim.[19] The works that students create can serve as proxies for their ability to think within the affordances and constraints of a material, to employ their imaginative abilities, to apply technical skills and, indeed, to use the various forms of thinking I have already described. The work is an expression, a representative of their ability to think intelligently about the perception and creation of the visual arts. If you want to know what students have learned in the visual arts, one way to find out is to look at their artwork and to compare it with their earlier efforts.

What about their aesthetic preferences? Can students give reasons for their appraisals and preferences of works they see and are invited to discuss? When they make comments about a work, how relevant are their comments to the work in question? What grounds do they use to support their judgments? What the arts teach shows when students are able to comment upon work that they experience and give reasons for the appraisals and interpretations they make. A program in arts education that nurtured such competencies would make it possible for students to provide experientially grounded justifications of their observations. Now we turn to an examination of what children learn when they engage in the visual arts.

# 5 DESCRIBING LEARNING IN THE VISUAL ARTS

*CHILDREN, OF NECESSITY, DEVELOP FROM BOTH THE INSIDE OUT
AND THE OUTSIDE IN*

If children's artwork is examined in social rather than in individual terms, it becomes apparent that what they learn when working on a painting or sculpture is not simply what they learn about dealing with a material; it is also a function of what they learn from others as they become members of a community. Social norms, models for behavior, opportunities to converse and share one's work with others are also opportunities to learn. This broad social conception of the sources of what, where, and how children learn, not only in the arts but in all areas, is referred to as *situated learning;* the child is situated in a social and material context, and this context, viewed as a culture, teaches. The cues students attend to and the priorities that guide them are influenced by that culture. The child belongs to a community of learners, in some ways like a member of a team, say, Little League, but without the pressured competitive climate that Little League suggests.

The situations in and through which children learn can be crafted by the teacher. When the situation *as a whole* is conducive to learning in the arts, positive outcomes are strengthened. This view of learning gives learning a social character; it departs from the more individual and often atomized conceptions of learning that have dominated much of educational psychology.[1] The theo-

retical roots of this social view of learning are thought to reside in the work done by Russian psychologists Lev Vygotsky and Alexander Luria, who were writing in the 1930s.[2] Although their research on the impact of the social context on the cognitive skills Russian peasants acquired was significant, even brilliant, they were not the first to discuss the importance of context. John Dewey preceded them. In 1901 Dewey wrote an article titled "The Educational Situation," in which he discussed the constructed character of experience.[3] That construction was not only activated by the prior experience the child brought to the situation; it was also the result of the child's interactions with the social and material conditions in which he or she worked. In this view, learning and culture were inseparable.

Dewey's emphasis on the importance of creating communities of learners so that children could learn from each other was one of the hallmarks of good progressive education practices.[4] Indeed, the opportunity to work in a group on common tasks was a way to help children not only to find practical meaning in academic ideas but also to learn what democratic life entails. Discussion and deliberation and consensus were a part of that life.

A vivid current example of situated learning is the Reggio Emilia program for preschoolers in Italy.[5] The remarkable graphic work children in this program do is, in part, the result of what they call "work projects." These projects are thematically organized group investigations of, say, the construction of a building that they have visited, discussed, and then graphically portrayed. The drawings made then become the subject of further discussion. Discussing them prompts reflection, which leads the children to elaborate on what they initially created. In this process preschool children become members of a community effort in which this mode of collective and elaborated visual work becomes comfortable and familiar, one that the children know is taken seriously by their teachers.

In this view of the sources of learning, group activity is multisensory. Activities are diverse and dynamic in character, conditions change in unpredictable ways, and multitasking is common: there is more than one activity going on at a time, and students

learn to cope with this multiplicity of events, activities, and opportunities as a normal part of their school experience. Put another way, life in classrooms looks more like life in life! Learning situations are, one might say, "more real."

One of the potential virtues of situated learning is that it increases the probability that students will be able to apply what they have learned. When the conditions of learning are remote from the situations or tasks in which what is learned can be applied, the likelihood of application—or some would say transfer—is diminished. Although some students might be able to make connections on their own despite the remoteness of the relationship between what was taught and where it may be applied, that restricted reference group is not a good one on which to base curriculum design; what one wants is to increase the probability that connections will be made by all students. Teaching can facilitate such learning. The insular and often artificial circumstances of so many classroom activities decrease the likelihood that what is learned will be applied; and when what is learned cannot be applied, the meaningfulness of what is learned is diminished.

Taking this conception of learning seriously has substantial implications for teaching. Classrooms would look different than they do now, roles for students would differ, and students would use one another as resources. There would be a sense of community and cooperation, a shared enthusiasm in which the language of the field—in this case the language used to discuss the arts—would become the educational coin of the realm. The technical language related to the arts would become a shared mode of discourse. In some ways the climate and the discourse would be closer to the climate and discourse of groups that share a hobby or interest; discussion with peers around a common interest is a source of pleasure and a demonstration of competence. Students would take pleasure in sharing enthusiasms.

As important as this view of the conditions of learning in the arts may be, it is only one of the conditions that need to be considered to understand what and how children learn in the arts. Another of these conditions centers on what might be referred to as "the problem." By problem I mean a situation in which stu-

dents' existing conceptual and technical repertoires are inadequate for coping with what they confront, and as a result they are challenged to think in new ways about how to grapple with the problem. The students' inability to deal with the problem to their satisfaction motivates attention and experimental trial; they need, for example, to look hard at what they have created in order to see what is there, to make judgments about it, to use their skills to address it and to assess the results. It is in coping with the resolution of a dissatisfaction—the conversion of something less than satisfying into something that satisfies—that children learn from the activity. When there is no challenge, when everything is satisfactory, there may be little motivation to stretch one's thinking, to try something new, to experiment, to revise, to appraise, and to start again. Creativity profits from constraints. The problem is a major centerpiece by which learning is promoted. It is embedded in a social structure that can facilitate or impede its resolution.

Problems are nagging, they call for attention, they stimulate and motivate when their resolution *from the student's perspective* is possible. This qualification is important. If students believe their ability to address the problem successfully is nil, they will feel discouragement. If the problem is too easy, there is no problem. The art of teaching consists, in part, in knowing how to set problems within Vygotsky's "zone of proximal development," that cognitive space in which the problem posed is not so simple that the student feels no challenge nor so complex that the student feels there is no hope. Like attentive and intelligent parents, the good teacher knows when to intervene, how much guidance to provide, and when to back off.

But learning is seldom significant when it is limited to a one-time affair. The teacher who gives students clay one week, watercolors the next, wire for sculpture the third week, and linoleum printmaking the next, all in the name of providing a rich art curriculum, does those students no favor. What are needed are sequential opportunities to work on problems with one material, time to get a feel for that material, and time to learn how to cope with problems engendered by the material so that mastery is secured. Of course, mastery as such is eternally elusive—we never

really "master" anything—but developing sufficient skill that one's work can be brought under intelligent control is possible. Such a state of mastery is fostered by programs that not only expose children to a material but also provide the continuity children need to learn so they can use a material as a medium. This continuity is made most apparent in activities that promote the development of particular skills.

Consider once more how children become competent in Little League or in playing the piano. Competence in these activities is never treated as a one-shot affair; children work at them, they try to move up on the scale of performance, they are not treated casually, and they have models of excellence to guide them. In the visual arts in the context of schooling this continuity is all too rare. The richness of a visual arts program is too often equated with the number of different projects children complete. But even three- and four-year-olds are capable of sustained attention and elaborated work if adults show interest in what they do and provide opportunities for them to do sustained work. Sustained work promotes attention to the work in depth, taking the work seriously.

I have been talking about the need to provide sufficient time to students that they can develop the skills and the "feel" needed to work with a material intelligently. Time on task is not only an index of students' attention; it is also an index of the opportunity provided to learn how to deal with the problems they wish to address.

But there is another conception of time that needs to be recognized in the course of, say, painting, and that conception refers to matters of sequence. Recall our example of watercolor painting. Watercolorists think about their painting in terms of what must come first, what needs to be addressed before moving to a second layer of action. For example, light-colored backgrounds need to precede what will be painted over them. In creating a sculpture an armature may need to be made first so the rest of the sculpture can be built upon it. In the domain of cooking certain ingredients must be added before others, and so forth. Competence in a task often requires such sequential thinking. It makes intelligent planning possible, and often the sequence of such planning is so internalized by experienced workers that little conscious attention is devoted to it.

How shall we think about the modes of thought and the array of skills needed to work in artistically intelligent ways with a material? One way to think about the processes is to begin with sensory experience. I speak here of students' ability to experience and to interpret some aspect of the phenomenal world in which they live—the ability, for example, to notice the patterns of sunlight on a wall, or the countenance of a homeless person pushing an overloaded shopping cart down the street, or the cacophony of an urban thoroughfare. These subjects require awareness and interpretation to become candidates for artistic expression. They need to be seen or noticed, and they need to be interpreted. Sense, in both its meaning of qualitative experience and its meaning of making something meaningful, is the initial basis upon which a motive for a painting, poem, story, or dance might be created.

But experiences with phenomena that are meaningful in these two senses are necessary but not sufficient for doing meaningful work in the arts. For that to happen an idea must be framed: What does one want to "say" about what one has experienced? What is the point from which the work builds? Attention to such matters in classrooms is often neglected. One of the most important pedagogical tasks is to help students formulate something to say that matters to them. This "something to say," paradoxically, may not be literally sayable. That is, it may not be translatable into words; but it can be felt, it can be experienced as an urge to express a feeling or emotion that gets clarified through the process of expression itself. Again, we return to Susanne Langer:

> Whatever resists projection into the discursive form of language is, indeed, hard to hold in conception, and perhaps impossible to communicate, in the proper and strict sense of the word "communicate." But fortunately our logical intuition, or form-perception, is really much more powerful than we commonly believe, and our knowledge—genuine knowledge, understanding—is considerably wider than our discourse. Even in the use of language, if we want to name something that is too new to have a name (e.g., a newly invented gadget or a newly discovered creature), or want to express a relationship for which there is no verb or other connective word, we resort to metaphor; we mention it or describe it as something else, something analogous. The principle of metaphor is simply the principle of say-

ing one thing and meaning another, and expecting to be understood to mean the other. A metaphor is not a language, it is an idea expressed by language, an idea that in its turn functions as a symbol to express something. It is not discursive and therefore does not really make a statement of the idea it conveys; but it formulates a new conception for our direct imaginative grasp.[6]

Awareness and idea are part of the process of meaningful artistic activity, but an idea needs a vehicle that will carry it forward, that will make it into an object or event that has a place in the world. To do this requires an imaginative leap into a form in which that transformation is to occur. What means, what form, what structure will convey or express the idea that has animated this process? Ideas that cannot be embodied through a medium are destined to remain in the cortex, a locale that is inaccessible to others and evanescent for oneself.

To say that an imaginative construction must be formed is to embody a purpose. Imagination provides the initiating conditions that make genuine purposes possible. But imaginative constructions and the plans developed from them should not be regarded as specifications or scripts; the act of expression is also an occasion for revising, even discovering and altering purposes. Put another way, purposes represented imaginatively are held flexibly. The worker not only speaks to the work; the work also speaks to the worker.

Talking about the need for an imaginative construction of an idea leads to another aspect of artistic expression, namely the need for technical skills. Even an imaginative construction held clearly in the mind's eye has no empirical life unless the student has the technical means for expressing it. As Dewey once commented, ideas need to be *com*pressed if they are to be *ex*pressed.[7] The artist distills the idea within the constraints and affordances of a material and in the process converts that material into a medium, a vehicle that mediates what the individual wishes to say. The use of technical skills is a way to treat a material so that the form created has an effect. No technical skills, no treatment. No treatment, no effect. Artists in any field work assiduously to acquire the techniques they need to create the effects they desire.

I have spoken of the various modes of thought and work in

artistic activity in discrete terms. In actuality, they are not discrete. Language is a way of making distinctions, and distinctions promote differences and separation. It is important to remember that these modes of thought are empirically inseparable. The senses feed ideas, and ideas focus one's senses. We find what we seek—and often more than we seek. At the same time imagination is moderated by what we believe we have the skills to create.

What we have is a complex, integrated, and mutually determining array of cognitive processes interacting. Language and the theories that are used to describe them are ways of highlighting these processes so they are inspectable. They are not intended to assign them an independent existence.

But what counts as learning in the arts? I wish now to focus on children's performance in the making or creation of an art form, in other words, doing the work of art.

## WHAT CHILDREN DRAW AND WHY

What is going on when we see the changes in the images children draw? How do we account for them? Are they scribbles that have no intent? Are they marks that represent efforts to communicate? Are they the result of an unfolding genetically determined program? Are they the consequence of what children have learned by working with media? What do children's drawings mean? Indeed, do they mean anything?

These questions have different answers depending upon the theorist you read. For example, John Matthews believes that even infants have communicative intent and that this intent is partly the result of the bonding created in the parent-child relationship.[8] Furthermore, Matthews believes the child's intent is expressed in a variety of ways: the medium for the child's expression may be graphic, or verbal (through cooing and other forms of infant "speech"), or manifested in body movements. In short, the expression of the child's intent is mediated by the medium. For young children the media are diverse. Matthews believes the expressions of infants are no less articulate than the expressions of those who have mastered speech. Looked at this way, the marks

and other images very young children make are forms of repre-
sentation that Matthews believes need to be regarded as having
content. Put another way, even infants are trying to say something
through the actions, marks, and images they create.

Others look at the matter somewhat differently. For Rudolf
Arnheim the course of children's graphic development is the result
of a growing ability to perceptually differentiate the visual quali-
ties of the world.[9] As visual differentiation increases, children no-
tice more and more within the visual field to which they attend.
The growth of perceptual differentiation is accompanied by an in-
crease in the differentiation of the drawings they create. Children
create visual images within the constraints and affordances of the
material with which they work. According to Arnheim children
ingeniously create a *structural equivalent* in the material, one that
corresponds structurally to what they are trying to portray. Thus,
a tadpole figure that shows a body (which contains or encom-
passes a head) with two lines attached is for many three- and four-
year-olds a satisfactory way to represent the human figure; it con-
tains the essential elements, a head, a body, and legs. However, as
children mature the pictures they draw become more differenti-
ated, and in Western culture the desire to create convincing illu-
sion sets in. The child of ten often wants to make a drawing of a
cat so that it looks like a cat. What we have according to Arnheim
is a gradual progression of perceptual differentiation as a normal
aspect of the biocultural process and a corresponding inclination
among children in the West to master illusion. The elementary
school–aged child who has learned how to do that very well is
often regarded as the class artist.

Arnheim is not suggesting that young children see the world
in the way they draw it. What he is saying is that children's repre-
sentations of a house, tree, or person are schematic, and these
schematic images are not as differentiated as they will become as
the children mature. As maturation proceeds, both perception and
representation become refined. With experience using materials,
technical controls are refined so that drawings reflect children's
ability to create illusion. With these developments children ac-
quire further tools for artistry.

Other theorists such as Rhoda Kellogg believe that in children's collective unconscious there reside a variety of symbolic forms, the mandala being a prime example, and that children intuitively create echoes of these forms in their graphic work.[10] Following Jung's theories, Kellogg presents a picture of children's artistic development as an unfolding of a historical process that resides in their collective unconscious. The process of making art is one that unlocks the content of this collective unconscious.

Others such as Anna Kindler approach the graphic development of children from a view based in a postmodern conception of art. In this view modern aesthetic values, as contrasted with postmodern values, are brought into question as arbitrary values that need to be superseded by less prescriptive conceptions of what art is. For Kindler, the liberating features of postmodernism offer the possibility of a new agenda for art educators. The aim should be, according to Kindler, to take into account all of the representational forms children might employ, from maps, to drawings, to graffiti, to rap; the demise of art has created a new opportunity to redefine both development in art and the aims of the field of art education. Kindler writes:

> The situation [today] clearly poses a challenge to the field of art education. It necessitates a reexamination of what art education should be in the "after the end of art" era to account for a variety of pictorial repertoires and visual languages reflecting the open texture of the concept of art. It offers opportunities to incorporate in art education realms of pictorial representation that have traditionally remained outside of its boundaries. It calls for re-evaluation of our understanding of the notion of artistic development and ways in which such growth should be encouraged and supported.[11]

Kindler's argument opens up the content of art education, but while she has much to say about the semiotics of the image, the aesthetics of the image and what people have valued most about the arts get less attention.

What we see in these interpretations of the course of child development in the arts is that some theorists emphasize the connection they believe to exist between mark and meaning. For them, even newborns are purposive and create marks expressive

of their purposes. Others conceptualize children's art as a result of a process of differentiation in terms of both perception and representation. Still others believe that in the child's deep unconscious resides the intuitive knowledge of our cultural forebears. We all have a collective unconscious, and its manifestations are to be empirically found in the arts. Finally, there are those who emphasize the influence of our unexamined cultural values and assumptions in shaping our conception of children's art. They regard traditional conceptions as limiting and advocate a different perspective, one far more inclusive of what children can do with a wide variety of materials and gestures in the process of representation.

Just what do children create when they paint or draw? Are there age-related patterns or commonalities in the images they make? If so, what do they signify?

Let's start with an empirical description of the image making of very young children. Consider the five images shown in Plates 2 through 6. Plate 2 was made by a boy twenty-three months old. What is probably most striking about this image is the speed with which it was created. Children of this age often secure what might be called "action pleasure," a form of pleasure derived not only from the rapid movement of hand, arm, and wrist, but also from the visual properties that emerge from the action. In a sense, drawing becomes an event rather than an intentional effort to delineate the features of some object, situation, or person.

Although there is a vast conceptual difference between the work of the Abstract Expressionists and that of a twenty-nine-month-old, in both cases the surface to receive the paint, shape, or line is conceived of as an arena on which to act; the large gesture leaves its mark. In both cases the image may not convey any intentional content. In a certain sense, what emerges is another type of "found object." The act yields conditions for visual discovery.

Plates 3 and 4 show images drawn by the same child at twenty-nine months. Both display a tendency to slow down action a bit and to bring some degree of visual closure to the images drawn. The small arrowlike point at the top of the bottom left quadrant of Plate 2 was the starting point of the drawing. This response to a request to draw Mommy started out with focused attention on the

arrowlike beginning and then rapidly shifted into the broader armlike strokes that created the image as we see it.

The same conditions existed for the creation of Plate 3. In the left quadrant of the picture there is a heavier line, the starting point of the drawing. The child started slowly but then moved into broad quick strokes. It is likely that this child had not yet developed the schemata to create a structural equivalent for greater verisimilitude in the human figure. There is no necessary virtue in being able to produce images on paper that re-present the structural features, say, of a person, a house, or a tree. Yet the drawings that children make do provide an indication of the extent to which the ability to do so has developed at a given age.

Plates 5 and 6 are also responses to requests to draw a picture of Mommy and a picture of Daddy. Both drawings were made by a child four and a half years old.

What is telling is the similarity between the drawings. The shapes, the location, and the colors are virtually identical. In both cases the sky is up, the ground is down, the sun has five rays emanating from it, and the individual portrayed has a smile on his or her face. In both cases the proportions are approximately the same. The telling difference is located in the hair. This defining feature differentiates the image from its counterpart. Mommy clearly has long hair.

Whether Mommy actually has long hair is not the point here. This child has acquired a set of more or less standardized visual conventions for rendering people and up and down. She anchors the figures to the ground and puts the sun in the sky. Over time these images will become increasingly more differentiated. We shall see how these developmental features are rendered as we examine additional drawings.

If we look at the drawings—and, by analogy, the paintings—of children from birth to age fourteen, on average we will see a progression of images from marks to shapes, to the use of a baseline to anchor figures, to the use of location and the overlap of figures to portray depth, and, for some children, to the use of light and dark to create a sense of volume or roundness. Among the aims that interest children in our culture is the mastery of illusion,

a longstanding aspiration for Western artists, from Giotto in the fourteenth century to the beginnings of Impressionism around the third quarter of the nineteenth century, when what we call a self-conscious attention to abstraction began to emerge in the work of Cézanne, the Fauves, and, after the turn of the century, especially in Picasso's and Braque's Cubist paintings.

To say that an interest in abstraction began to develop in the 1880s with Cézanne is not to suggest that artists before that time were not interested in the abstract character of the forms with which they were working; the fact of the matter is that all artists must be concerned with such matters to do anything artistically worthwhile. What I am saying is that with the fourth quarter of the nineteenth century Western artists freed themselves from a concern with verisimilitude and redirected their efforts to exploring forms abstracted from the reality they had been interested in portraying in previous years.

Do preschool children display the same interests as, say, Jackson Pollock, or Pierre Soulages, or Mark Rothko? It seems to me that they do not. The work of abstract artists is directed by aims that preschool children are not developmentally able to conceptualize. This does not mean that preschoolers do not enjoy the viscosity of paint, or the brilliance of color, or the feel of moving a brush over a surface. Observations of their behavior while drawing and painting suggest that they do. But artists use abstraction to realize an idea, to resolve a visual image, to express an unspeakable notion. Artists are not simply movers of paint; even action painters like Franz Kline used action to serve an idea. The canvas was both an arena for discovery and a means through which their animating idea could take shape in public terms.[12]

Perhaps the most popular view of children's art is found in Viktor Lowenfeld's ideas about the stages through which children pass in the course of their graphic work.[13] For Lowenfeld these stages, which are modal, age-related features, are the result of a genetically defined program that unfolds over the course of the child's life. Lowenfeld regards these stages as natural and believes that the function of drawings differs for children of different ages. The pedagogical implications of his views of children's art as an unfolding

process is for the teacher to play primarily a supportive role to the child and to let nature take its course.

Lowenfeld also points out that as children move into adolescence, personality factors or dispositions toward the expressive character of artwork begin to appear. He identifies two types of personalities or emphases in visual expression. One he calls *visual,* the other *haptic.* The former leads to work that emphasizes verisimilitude, the latter to work that emphasizes emotional expressiveness. In a sense the former is represented by visual realism, the later by Expressionism. The disposition to one or the other is a consequence of the child's biological endowment rather than, say, the models of visual art the child has encountered or the expectations held for the child by significant adults. Lowenfeld writes:

> We can now clearly distinguish two types both by the end products of their artistic activities and by their attitude toward their own experiences. When we investigate the artistic products of these two types, we find that the visual type starts from his environment, that he feels always a spectator, and that his intermediaries for experience are mainly the eyes. The other, the haptic type, is primarily concerned with his own body sensations and the subjective experiences in which he feels emotionally involved. . . . Furthermore, it was shown that the inability inspectively to notice visual objects is not always an inhibitory factor in creative activities. On the contrary, the very fact of not paying attention to visual impressions may become the basis of a specific creativeness of the haptic type. This is of greatest importance for art educators, especially for those who still are concerned with visual stimulations only.
>
> A visually minded individual would be disturbed and inhibited were he to be stimulated only by means of haptic impressions—that is, were he asked not only to use sight, but to orientate himself only by means of touch, bodily feelings, muscular sensations, and kinesthetic fusions.[14]

What we have as we read the literature are theories of children's art that regard artistic development as directly related to children's desire to convey meaning, even for infants. We find theories that regard development as a product of the situations in which children work. We encounter theories of artistic development that hold that the images children generate are rooted in

their collective unconscious. We find theories of children's art that argue that the artworks children create are a function of the limited and limiting conception of art that modernism has imposed upon our schools and our society. We find theories that argue that the features of children's art are a function of a genetically unfolding program and biologically determined dispositions toward different styles of artwork. Perhaps the simplest though inadequate way to classify these theories is to divide them into those who argue that children develop primarily from the inside out, as contrasted with those who emphasize that they develop primarily from the outside in.

How shall we think about the changing features of children's art, and what, if anything, do their characteristics have to say about the relationship of the arts to the development of mind?

I spoke earlier of the "stages" through which works of art are realized. These stages include the ability to experience the qualitative world, to frame an idea or issue that the work is to address, to create an imaginative vehicle through which it is to be realized, and to use a technical repertoire that will make its realization possible within the constraints and affordances of a material. Each of these "stages" in the process of creation calls upon the use of mind; each requires the use of what might be called—a bit too narrowly—cognitive skills. The argument I intend to develop here is that the ways in which children express themselves in the visual arts depend upon the cognitive abilities they have acquired and that the cognitive abilities they have acquired are related to both their biologically conferred and their learned abilities as these human features interact with the situation in which they work. Human performance in the arts is the offspring of a dynamic medley of interacting features: development, situation, and the cognitive abilities the child has acquired as a result of this interaction. The process of education, whether in the arts or elsewhere, is promoted by teachers as they design the situations in and through which the growth of such abilities is advanced.

Consider once again the ability to read the qualitative environment. Readings are of many kinds, depending on the lens through which the world is viewed. Frame of reference matters;

frames influence both what will be seen and what will be made of what is seen. To look at the Golden Gate Bridge from the perspective of an engineer leads us to notice features relevant to the engineering marvel that it is. To see the bridge as a poet might is to confer or recover meaning from that bridge that is disclosed by the values the poet brings to the bridge as those values are expressed or embodied in a poem. To see the bridge as a painter might is to attend to relationships of form that can be made palpable or expressible in a painting. Meanings are made; interpretations are construed by the engineer, the poet, and the painter as each uses particular frames with which to attend. Seeing is a selective activity shaped by the frameworks that serve as screens in our consciousness.

Consciousness is the product of attention, and attention is guided by past experience and moderated by current need or purpose. Consciousness is also a form of awareness, and awareness is fed initially by sensibility. Thus, sensibility is the mother of consciousness and provides the content for reflection, analysis, and the making of connections. Because consciousness depends initially on sensibility, the refinement of the senses is of prime importance. We cannot write or paint about what we have not noticed, if "only" imaginatively. Arts education has a major role to play in creating situations through which the senses can be refined.

The refinement of sensibility profits from learning how to attend. It profits from an ability to compare and contrast. It profits from discussion with others about what is being displayed. It profits from knowledge of the context in which a particular form, process, or object resides. Knowing something about context enables us to search more efficiently for what is there. Think of a skilled mechanic diagnosing a malfunction in an automobile or a radiologist inspecting an x ray. It helps to know what to listen or look for.

In the context of appreciation such processes might be sufficient. In the context of creation they are not. In the context of creation an idea needs to be formed; something must be created that gives point to the work to be done. Put another way, the person needs to have something to express, something to achieve, something to say. For Monet it was the countenance of light, for Picasso

during his Cubist period the interaction of space and time, for the Senufo carvers the call and veneration of their ancestors, for Bridget Riley or Agnes Martin how optical illusions affect our visual field. Each of these artists worked toward something; their work was purposeful, but even work that is purposeful requires more than an aspiration or aim; it needs a vehicle. The artist, child or adult, must envision and invent a means through which purpose is made real in material form. It is here, in the context of one's work, that invention occurs.

Consider architecture. How does one design a building, say, a museum in which precision and proportion reach an ultimate level of refinement? I. M. Pei addressed this problem in the design for the National Gallery in Washington, D.C. How does one create a sense of movement in an object that is stationary? The Futurists did it, and so did the designer of the Ferrari. Each of these solutions depended upon someone's ability to imagine possibilities that could resolve the problem posed. Each imaginative solution is a solution to a problem, the realization of an aim. But not quite.

Solutions in the context of the imagination are one thing; solutions in the context of the world in which we live are something else, and for those kinds of solutions we need to have the knowledge and technical skills to convert what appears in the mind's eye into something having material existence. And to do this we need to be able to think within a medium. Thinking within a medium entails a subtle appreciation for the potentialities of a material and the kinds of moves we need to make for those potentialities to be made actual. For example, an individual doing an oil painting may want to create a certain translucency on the surface of the canvas. This might require the application of a particular opaque color directly on a primed canvas, followed by several layers of transparent color. The extent to which the artist's aspirations are realized will be significantly influenced by the individual's knowledge and technical repertoire.

The use of technical skills is not the mindless application of routine habits. At times techniques themselves must be invented to convey ideas, ideas that, at the time, cannot be served by existing techniques. The fourteenth-century achievement of perspec-

tive was a technical breakthrough intended to convey more powerfully ideas about religious beliefs. Perspective was no mere accident or decorative flourish; it served a critically important social and religious function.[15] It made religious stories more compelling.

It is relatively easy to regard technique as a kind of habitual motor skill. In some respect this vision of technique as habit is accurate. Many techniques are often so overlearned that they require for their successful application little or no conscious attention. Reflect for a moment on the use of a computer keyboard. If we need to think about the location of each of the keys in the course of writing, the probability of our being able to focus on the content to be expressed is diminished. We can walk easily for miles without conscious attention to our feet except on those roadways strewn with rocks, slopes, and debris that can cause injury. In other words, we attend to techniques only when the ones we have prove inadequate in enabling us to cope with a situation.

In the context of making art, the application of a repertoire of technical skills does not operate independently of other features of artistic competence. Children, like adults, eventually need to learn how to pay attention to qualitative relationships that unfold in the course of action. They must notice the weight of the tip of the brush charged with paint in order to estimate the consequences of a stroke when applied to paper. They must eventually learn that if a sheet of watercolor paper is sponged with water before the paint is applied, there is only a certain amount of time that can go by before it dries, thus undermining the effects they seek. When we consider the techniques needed to use video, film, and the computer effectively for artistic purposes, the significant role of techniques looms large indeed. In short, a technique is guided by aesthetic considerations.

I have spoken of techniques largely in terms of attention to qualities and to certain kinds of performances. However, the successful application of techniques is also monitored and managed by linguistic skills. One of the important functions of language is that we can play out our options mentally within language before taking actual action. We can, through a process called self-regulation, run through intended activities, rehearse certain choices, de-

scribe and analyze to ourselves the various pathways we can take toward the resolution of a qualitative problem. Although I have described the stages of artistic activity as independent processes, I want to emphasize again that these processes interact and that it is only because of the constraints of the language I must use to write this discussion that the distinctions among the stages are made.

## SUMMING UP SO FAR

The course of children's development in the creation of visual images is characterized by the gradual emergence and refinement of forms of thinking. What we see in the features of children's artwork over time are the fruits of learning. Such learning is promoted by teachers and others as they provide children with opportunities to experience the world qualitatively, as they provide children with materials with which they can work, as they offer guidance, examples, prompts, and assistance in ways that foster learning in the context of the visual arts. The forms of learning that are promoted pertain not only to the refinement of their sensibilities but also, when the arts are well taught, to the array of cognitive processes I identified earlier. These include the means they are able to imagine to carry their ideas forward and the acquisition and application of techniques that enable them to realize their artistic ambitions within a material. In the process the material becomes a medium, for it mediates their aims.

I have suggested that aims always come first and that means follow. But in fact aims, purposes, and ideas not only precede action; they often follow it. The material itself becomes a source of suggestive ideation. The qualitative exploration of a material can generate new ideas or aims. Thus, these processes are better thought of as a form of dialogue, a mode of conversation with the material rather than a monologue directed solely by the artist to a compliant material. This dialogic process not only may result in an artistically attractive image, but also has consequences for the child. These consequences pertain to the ways in which the exploration of material in the service of an idea becomes a way to sensitize and to discover the contours of one's interior landscape.

We learn how to feel what we have seen, for it is in the arts that a special level of focused attention is realized, a form of attention that is seldom called upon in most of the situations we experience. The arts invite—no, demand—that we attend sensitively to the qualitative arrays that we ourselves generate. They ask us to notice our own emotional response to these changing arrays of quality. The arts help us become aware of ourselves. Indeed, at their best we use the arts to remake ourselves.

## THE ARTWORK OF THE YOUNG

Students of children's art point out that there are competing theories attempting to explain its changing features.[16] One of these theories claims that children draw what they see, not what they know, while the other theory claims just the opposite: children draw what they know, not what they see. To draw what they know, children pay attention not to the visual features of the object to be drawn, but to their conception of that object: children know that a hand has five fingers and that a house has windows and make sure these things are present in their drawings. Those drawings are likely to be schematic or simplified and serve as economically defined representations of aspects of the visual world. For children interested in the didactic use of the image—a use that is intended to signify or convey an idea or story rather than to replicate something's visual features—drawing what one knows is the most efficient approach to graphic representation.

A competing view argues that children draw what they see, not what they know. The perception of young children is thought to be less detailed, more global, more generalized, and it is these generalized perceptions that emerge in the drawings children make. Children draw images that tend not to replicate the detailed proportional features of the visual world because, it is argued, they tend to see the world in less differentiated ways.

Reconciliation of these two seemingly competing theories is possible by moving in exactly the opposite direction. *Visual realism,* the tendency for children to draw what they see rather than what they know, presupposes that seeing makes no use of knowing. Yet

the objects and events of the world are known through many sensory modalities, and each contributes to children's awareness of the features of the object to be drawn. It is this awareness that manifests itself in children's graphic representations.

Intellectual realism and visual realism are not competing concepts or theories; they represent two sides of the same coin. Children cannot know what they cannot see, and they cannot see without knowing, for seeing itself is a way of knowing.

If this theoretical reconciliation of two seemingly competing conceptions exhausted our explanation of the features of children's work, the task of explanation would be relatively simple. However, children draw not only what they see and know but also what they imagine. Children draw what they imagine by generating images that never existed in the "real" world but that are possible in the world of the imagination; winged horses, centaurs, *Star Wars*–like images, purple cats, and the like. Imagination is not fettered by visual realism, and for many young children it is a rich source of imagery for drawing, for stories, for dance.

Children draw not only what they imagine, see, and know but also what they feel. How they feel about a particular object, person, or event is reflected in the way they treat it in a drawing. What is important is often exaggerated, what is important is often made more visible, what is important secures a prominence on the paper that confers on it the significance they want to express.

How children treat the material and the features of the images they create is related to, but not determined by, their intentions. Intention—when shaped by the imagination—is the mother of invention. If the child is interested in storytelling, simplified graphic descriptors of events, objects, and people may well be sufficient to get the message across. If the child is interested in expressing or communicating feelings about those events, then other features of the work need to be handled so that they express the desire to represent such feelings.

Put more simply, purpose helps define the way in which an image will be handled. Of course, how an image is handled is not only a function of purpose; it is also related to children's technical repertoire for making such representation possible. What is needed

in any of the arts is not only a conception of artistic possibility, but a performance repertoire that enables those possibilities to be actualized within a material.

The paper on which children work serves as the arena in which their graphic representations emerge. One of the important features of this workspace, as Jonathan Matthews points out, is that it provides for immediate feedback. Graphic visual images, unlike speech, *stick;* they remain visible and can be worked upon. One can inspect them; one can make alterations and then make comparisons among the alterations made. The workspace that children employ is a kind of laboratory for their efforts. This laboratory makes it possible for children to find out what happens when one thing, rather than another, is done.

In designing graphic forms on paper, children move from a simplified repertoire that manifests itself in arcs and circles, to forms that are very much related to the mechanics of the arm, wrist, and hand. Over time children acquire additional graphic skills that lead to the creation of circles and, later still, to lines attached to them. Children, in effect, move from the linear form to a closed form and from a closed form to a closed form with appendages. There is a kind of right-angledness to the connections made to a core visual form. This emerging repertoire gives a substance to the drawing that transforms lines into objects. The core and radial become a basic visual feature of the growing graphic repertoire.

As children mature, each of these repertorial acquisitions becomes an integrated part of subsequent repertoires. Thus, children's development in art can be seen as an expanding collection of increasingly refined and diversified repertoires that widen their visual options.

When a child wishes to represent, say, a table, the perspective or position from which it is drawn is one that is the most indicative of the table's visual features. For example, the child is not likely to draw a table from a top-down perspective; the table is most likely to be drawn from a side view in order to reveal the table's most telling visual features, the profile. The same is true with respect to the drawing of the human figure. It is most usually

PLATES

PLATE **1a.** Georgia O'Keeffe, *Red Poppy,* 1927, oil on canvas, 7 × 9 in. Private collection, Geneva, Switzerland

PLATE **1b**

PLATE **1c**

PLATE **1d**

PLATE **2**

PLATE **3**

PLATE **4**

PLATE 5

PLATE 6

PLATE **7**

PLATE **8**

portrayed frontally and symmetrically; no three-quarter or back view is typically present in children's drawings until quite late in their development, and only when they have the technical competence to render them. Thus, children are in a process of inventing repertoires through which their intentions can be executed on paper within the limits of paint, pencil, or any other graphic tool. As they get older this repertoire expands, and the choices that they can make expand with them. Thus growth in the visual arts, as in other fields, can be regarded as an increasing expansion of the means through which the contents of the human imagination can be given a public form.

Let's return to some of the features of children's artwork. What we notice in the drawings of children from, say, ages two to four is a rhythmic activity of crayon on paper or the pounding patterns of fist on clay. We notice that children attend both to the action and to the emerging images and depart from them. The process appears to be aimed at the sheer enjoyment of movement with the material and noticing the visual consequences of those movements. At this age children are developing a sense of personal agency. At about three and four years, children sometimes give names to the markings after they are made: this is Daddy, this is Mommy. Still later intentions are articulated before the action. This is a significant cognitive development; the child begins to discover that one thing can stand for another. The work begins to function as a symbol.

Another notable feature of the paintings and drawings of children under four and a half is the experimental attitude they display toward imagemaking. A large percentage of children from two to five years act and then see what happens as a result. At other times there is a clear intention to be realized. A child, for example, may want to draw a person doing something in a garden. The efforts made are intended to create an image of a person standing amidst flowers. In such circumstances, the function of the imagemaking is largely didactic: it is intended to tell a story, to convey a particular idea. To be sure, aesthetic considerations go into the selection of color and the ways in which the picture is organized; but its most important feature is the effort to communicate.

At other times, children's efforts are directed toward what might be called an Expressionist orientation: action precedes purpose, and the results of action provide the opportunities for choice. Action also provides an opportunity to escape from the literal and to engage in a process that makes it possible to "see what happens." In the didactic or narrative aspect of imagemaking, children aged four to four and a half may well employ a variety of schematic images that are already a part of their visual drawing repertoire. For example, they may produce schematized images of a face, a body, a sun, mountains, a house, flowers, clouds, birds, and so forth. These schematized images are then combined; they are composed in order to display the narrative the child wishes the picture to tell.

There is often an interior dialogue going on in relation to the imagemaking process. It is not uncommon for preschoolers to speak to themselves in the midst of painting, giving directions, making choices, telling stories. Often we find children gurgling or making other sounds in tandem with painting. The painting is a kind of accompaniment to the sounds, or vice versa. What such activities reveal is an immersion in the process. This immersion is both visual and kinesthetic. The rhythmic action of the hand and the arm, the sense of viscosity that flows from the brush, the visual surprises that such activities often yield create a dialogue or conversation between the child and the work. The child acts, the work speaks, the child answers, the image takes on a new configuration that leads to a change in the conversation. There is, as Mikhail Bakhtin might say, "a dialogic imagination" at work.[17]

Watching preschoolers even as young as two and a half and three reveals a capacity for intense focus during their work. They often lose themselves in their activity, a condition that Dewey regards as central to aesthetic experience. Rather than seeing a short attention span, we often observe just the opposite.

The materials that are made available to preschoolers—colored pencils, clay, paint, colored chalks—possess distinctive characteristics, and these characteristics affect the choices that children make and the images that emerge. Thus, selecting materials is an important way of influencing the kind of thinking children are

likely to do. A pointed pencil makes images possible that could not be easily rendered in paint. Conversely, the spontaneous expressiveness possible in the act of painting is more difficult to achieve with a pointed pencil. The pencil invites delineation; a wide brush and thick paint foster expressiveness. Thus, materials matter because they influence what children can think about and how they are likely to engage the work.

When children have substantial experience with paint and brush, even when they are under four, they develop a refined sense of control over it. They not only can control the brush in an impressive way; they often experiment with its limits. This experimentation leads to the appropriation of new schemata, that is, images they did not previously have but that they can use in the course of their painting. In a word, they learn. They create the conditions that promote their own learning by acting upon their work in novel ways.

Perhaps one of the most ubiquitous features of the imagemaking of preschool children is their ability to decide when they are finished. The children are in control. When children are learning to spell, the tacit expectation is that they have finished when they have spelled the word correctly. In spelling as in arithmetic, being finished is not simply a termination of one's work, but an arrival at something close to a correct answer. Similar conditions are not so prevalent in the visual arts. The latitude for choosing when one has finished is considerably wider. In fact that choice never leaves artists and their work; adult artists always ultimately decide when they are finished, and so, too, do children.

When young children, preschoolers for example, work, there is much peripheral learning, that is, learning through the observation of and socialization with others. Teachers also teach in peripheral ways. They demonstrate. Demonstrations promote tryouts by toddlers. All of this often takes place in a variety of "work stations" at which children can explore a wide variety of materials and projects. Their engagement in these projects is governed not by clock time, but by body time. Their interest defines how long they will work at a station. During their stay, teaching is largely

opportunistic, but in the professionally run nursery school, teaching is related to a developmental frame of reference. In other words, opportunism is guided by theory as well as by instinct.

We often see children engaged in making repetitive circles and lines, an activity that is often without direct eye contact in relation to the circles or lines being made. Motor repetition is sufficient. "Control" is kinesthetic rather than visual. Children as young as two and a half often develop remarkable levels of control over the media and tools they use. Even when they are unable to display compelling verisimilitude in their drawing, it is clear that their control of the materials is impressive. Graphic skills, for example, develop whether or not verisimilitude has been achieved.

The social setting in which preschoolers work is also an extremely significant resource for their educational development. Six children around a small square table provide many opportunities for peripheral learning; children function as models for one another. The models pertain not only to imagemaking, but to conversation and to the exercise of imaginative play.

We often see teachers demonstrating and children cutting, pasting, painting, drawing. Often they occupy a multimedia universe while working on a project. This multimedia universe encompasses verbal communication, graphic expression, acting, singing, and the other forms of activity that children not constrained by adult restrictions are able to explore in the context of a single project. In this context the selection of particular methods and tools evokes and refines different skills and encourages different modes of thought. The child with a pencil in his or her hand works within constraints and affordances far different from those he or she would have working on an upright easel with a wide bristle brush using thick paint. Thus, choices about which materials and tools children will use are also choices about the kind of thinking that will be promoted. The resource-rich nursery school is a kind of educational cornucopia; children interact socially at will, attend and stay at will; teachers talk and respond at will. Interest drives the work.

Studies of nursery schools show that children aged four and a half develop substantial control over the tools they are given an opportunity to use. Some can handle eye droppers to distribute

colored ink over a damp paper with extraordinary precision. The resulting images are often reminiscent of the stained canvases of Morris Louis or Helen Frankenthaler. Using such materials and speaking to the child using them, a teacher comments, "That's a beautiful thing you're making." Still at work, the child responds, "It's a butterfly." The relationship to abstract painting is obvious. The child has displayed the essential structural features of the butterfly through the bleeding and intensity of the colored inks being used on a damp paper.

The well-stocked nursery school is filled with resources for creative play such as drama, and tools such as drills, hammers, and saws, with which children develop skills and use to build. The tasks are far from bookish, although language in its written and spoken form is by no means unattended to. Given this dynamic context, the task of teaching might be described as knowing when not to intervene. It may be the withholding of intervention that sustains the child's interest in his or her activities. In such circumstances, there is nothing coercive about what a teacher expects a child to do. And of course this leads to the question of when and why education becomes somber when children enter grade school. In preschool, imagination and exploration are prevalent modes of being in this world. This being in the world includes tucking in and tucking out of reality as a part of the life of a four-year-old. Perhaps such a life cannot be led when one is seven. Although, I am not so sure.

From approximately four years of age children develop an interest in what might be regarded as the didactic use of images; that is, they use images drawn on a sheet of paper to tell a story. One of the primary functions of the drawing at this age is to convey a kind of visual narrative. Some writers such as Jessica Davis claim that aesthetic considerations dominate from ages four to seven, that expressiveness and spontaneity characterize children's drawings and paintings in ways that seem to be lost between age eight and adolescence. According to Davis, middle school–aged children's preoccupations with realism and narrative redirect their attention in ways that thwart the brilliance and spontaneity of preschool children's artwork. She believes that the images preschoolers cre-

ate suggest that they are making aesthetic decisions and are closer in spirit to adult artists than they are to children nine to twelve years of age. Davis writes:

> What emerges from these observations of artistic thinking in the symbol system of drawing is the view of a course of development quite different from the hierarchical progressions advanced by Piaget. In Piaget's structure, the young child is at the bottom of a steep linear ascent to the pinnacle of thought represented by mature exemplars. With young children producing drawings that seem similar to the work of professional artists, and children in that facility, the course of development in graphic symbolization looks more like a "U."[18]

For Davis the bottom of the "U" represents the low level of aesthetic interest in middle childhood, while preschoolers and adolescents have a keen interest in aesthetic matters.

Children may create work whose qualities they themselves may not appreciate or even recognize. A bold sunflower may have the attractiveness of a van Gogh to a sensitive adult, but to a preschool child it may simply be the result of another enjoyable activity with paint or clay. We seldom see preschoolers looking at their own work from a distance in order to do the visual editing that would enhance their work. The paper on which preschool children paint may represent more of an arena for making a gesture that leaves a visual residue than an occasion for creating an image that they intend to have aesthetic properties.

Some of the roles of art education are to enable youngsters to learn how to attend to the qualities they create, to promote through the design of an educative environment an appetite for creating visual images, and to enable them to secure in a developmentally appropriate way the skills that will enable them to work effectively with the material.

In a modest way, nursery school teachers already teach preschoolers technical skills, if only to enable them to learn how to wipe the black paint off their brushes before putting them into white tempera jars. A small bit of technology, but an important one.

Children between four and seven will often emphasize through size relationships in a drawing or painting that are important to

them; their emotional attachment to an individual or the significance that something has to them is reflected in the size of the images they make. The feeling and significance of something for children of this age swamp the aspiration to create visual verisimilitude.

Another feature of the artwork of children between four and seven is that they often focus on each entity drawn without paying much attention to the relationships among them. Instead of looking at relationships, they have local visual solutions. Local solutions do not take into account context; the young child wants the cookie now, even though dinner is five minutes away. Objects are drawn as if occupying their own space, largely independent of the visual field they share with other forms. One of the aims of art education is to help children learn to notice the expressive quality of relationships. Through good art teaching, students learn to compose relationships and to rely upon somatic knowledge, the bodily feel of a rightness of fit for making adjustments in what has been composed. The ability to experience such relationships is the result of developed thinking skills. These are skills that even many adults have not developed in the visual arts.

I have been describing the forms of learning that work in the arts promotes. Most of my comments have pertained to either the perception or the creation of visual form—the drawings, the paintings, the sculptures that children and adolescents create. But what matters with respect to learning in the arts is wider than matters of perception and creation, as significant as they are. As I indicated in Chapter 2 in relation to visions and versions of art education, there is more than one vision and more than one version of what matters. For me, the benefits of art education extend not only to a heightened sensitivity to expressive form, but also to the ability to discuss and to describe expressive form and the promotion of students' understanding of the social context—its values, its technology, its culture—that gave rise to the work itself.

Consider what must be learned in order to describe in a constructively critical way the qualities of a painting or sculpture. Any individual undertaking this feat has the difficult task of noticing what is subtle but significant, experiencing what is expressive about the work, and then finding the words that somehow trans-

form what has been visually experienced into a kind of linguistic equivalent. Of course, there never is an exact equivalent between one form of representation and another. Yet we are able through our capacity to perceive relationships, analogies if you will, to use language to describe and interpret qualities that have no literal equivalents.

For example, when a child calls a form "squishy," even though it is not literally squishy, a particular allusion is being conveyed. And when an adult describes the ways in which in a particular composition a curve is repeated, relationships are noticed that may not be obvious. To see art one needs to see beyond what is immediately apparent. As David Perkins might say, one needs to be intelligently reflective about the work; one needs to be able to see the unseeable.[19] Thus, programs in arts education can foster opportunities to students to learn how to use language figuratively, to somehow capture what cannot be said literally. Such linguistic skills get at what Aristotle thought was among the most profound of human capacities, the ability to create metaphor. The American art historian and art critic Leo Steinberg once commented that critics do not merely describe the work before them; they *render* its qualities through innuendo. The conceptual path to the work is indirect rather than direct.[20]

In our schools, literally oriented as they tend to be and often preoccupied with fealty to rule and procedure, such opportunities are especially valuable. They feed both feeling and the life of the imagination; they address what is sensuous and often subtle. Arts education, when well done, calls students' attention to the distinctive qualities of the particular.

Although I have emphasized discourse pertaining to the arts, visual qualities of all kinds can be addressed in the modes I have described. Reflections on a car's windshield are no less objects for apt linguistic description than Gilbert Stuart's portrait of George Washington or Mary Cassatt's picture of a mother bathing her child. The visual world that surrounds us provides an unlimited array of candidates for aesthetic attention. When arts education is done well, the frame of reference students learn to use and the subject matters to which they attend are not only subtle; they are

broad. We certainly do *not* want to promote the idea that the sensibilities cultivated and the language we use to describe what the sensibilities make available are restricted to objects incarcerated in museums, concert halls, and theaters. Our aspirations are substantially wider.

Those who have focused on the critical analysis of works of art have developed an array of categories through which artwork can be addressed. Critics not only attempt to capture in language the qualitative forms of life that works of art help make possible; they also attempt to interpret the meaning of those works. That is, they attempt to reveal what they signify. Interpretation is a process of sensemaking and often requires a deep understanding of the context in which the work was made, the position and background of the artist, the meanings of iconography that were used, and the technical means employed to create the image. Interpretation is an effort to penetrate the surface features of the work in order to construe meanings that would otherwise not be available.

In addition to interpretation, critics almost always make judgments about the quality of the work. Such judgments are statements about the merits of what has been seen, not statements about matters of preference. Judgments, such as "I think this is a good piece of work," can be debated. Preferences, such as "I like this painting," are not debatable; they are matters of choice.

Learning in the arts not only can enable students to use the metaphorical forms of expression I described earlier; it also can encourage students to seek the meaning or significance that works have. Such a search goes well beyond exclamations of preference into the deeper questions of justified judgment, even when differences in judgment cannot be resolved. Learning in the arts promotes these modes of thought as well—at least when the arts are well taught.

The focus I have just described is on the qualities of works of art and works of nature and culture more broadly speaking. I have been talking about what might be called critical discourse. Works of art reside within a culture, and cultures occupy locations in space; thus they are a part of our geography. They are not only a part of geography; they are a part of human history. Experience

with works of art is enhanced when students understand the context in which the work was created. The values that animated fourteenth-century monks creating icons for village churches participate in a worldview that is reflected in their work. Understanding this worldview can enrich one's experience with the work. The position of the church in Italy in the fifteenth and sixteenth centuries made possible the kinds of images that Michelangelo, Titian, and others painted. The availability of resources and the desire for works displaying status and position contributed significantly to the kind of images that were painted. Indeed, one could argue that the church made possible the work itself; we are its beneficiaries.

My point is that one of the important contributions of arts education is to enlarge the appreciation of the cultural and social context in which artists did their work. It matters not whether the work was done in China during the sixteenth century, in the third century in Nyarit, in the Congo of the early twentieth century, or in western Persia during the second millennium. All these locales and cultures influenced artists, and, just as assuredly, the art and artists during those periods influenced the cultures in which they lived. Thus, when we consider the affordances and constraints that arts education provides, it becomes clear that we ourselves define them, depending upon the values we wish to achieve.

I have proposed that arts education programs not only pay attention to the forms of thinking that make sensitive and imaginative imagemaking possible, that they not only cultivate the forms of perception that enable students to read the qualities of the visual world, but also promote students' abilities to describe those qualities intelligently. This discourse is often punctuated by the metaphorical and literary use of language.

I have argued here and elsewhere that students should come to understand art as a cultural artifact, one that both reflects and affects the culture in which it appears. Artists, through their work, can change our way of seeing. They can influence what we regard as art; they can challenge us in special ways to think about how those relationships influence our experience. Artists, like scientists, are often troublemakers, and the trouble that they make is

that their work confronts our customary modes of seeing and challenges us to think afresh about how aspects of the world might be experienced.

## LOOKING AT STUDENT ARTWORK

We return now to a reexamination of drawings and paintings made by children from primary grades through secondary school. What are the features of their images? Why do they draw the way they do? Consider the drawing in Plate 2. You will recall that it was made by a child twenty-three months old. What we see here is an image that records the swift, repetitive movement of the child's arm. I believe it is likely that the child is focused more on the stimulation received from seeing what happens when action of this sort is performed than on the desire to create an image that represents something in his visual experience. There is for children of this age a certain pleasure in action, and when action also leaves a visual residue, as this one does, the pleasure is intensified. Out of such action come visual discoveries such as the ability to create not only lines but shapes. In Plate 2 the visual closure needed to create shapes has begun to emerge.

Plate 3 displays not only closed forms but also a change in the scale of the images within the larger whole. These accidental variations provide the conditions through which the child acquires the graphic repertoire needed later to make images that are recognizable.

Plate 4 even more than Plate 3 presents us with a closed form. It is likely that this closed form was an accidental image rather than the result of intention. The child who made the images in Plates 3 and 4 is the same child who made the image in Plate 2, but six months older. We can see a greater degree of control in Plates 3 and 4 than in Plate 2.

What we have in Plates 5 and 6 are drawings of Mom and Dad by a four-and-a-half-year-old girl. Here the plot thickens! The graphic discoveries of the two- and three-year-old are now used by the child to represent two people important to her. The images are simple in form. They are differentiated sufficiently to indicate who

is mom and who is dad. The sun is up, and the ground is down. Mom has long hair; dad does not. The visual differentiation in the images is sufficient for them to function as a kind of visual narrative.

What is truly impressive is the child's ability to get to the visual essence of a visual field. The child has created the structural equivalent by using a colored marker on paper to reveal what is in her visual field, and she has done it with utmost economy. I believe economy of image is emphasized because the drawing need not be elaborated to serve its primary function: representation. In a sense, "less is more." As images take on more of a didactic function, as they become closer to narrative, the "story" may supersede interest in the aesthetic properties of the image. The point for the child is to tell the story through the image.

We turn now to Figure 1, a drawing of a cat made by a six-year-old. What is striking about this image is the utter simplicity with which the child has captured the essential "cat-ness" of a cat.

FIGURE 1

There is an extraordinary economy of line used to render the image. In some ways, the drawing is reminiscent of something that Henri Matisse might have created. What we have here is an image that distills the student's experience with cats, and that distillation emerges in a portrait of the cat's most telling features: the eyes, nose, mouth, and, of course, the two peaked ears along with a tail.

The child has made no effort to draw the hind legs of the animal; what is necessary for the child is the production of an image that captures the essential, not the photographic, features of the cat. What has been created is what is sometimes called a schematic image, a flat, simple depiction of structural relationships. Why such an image? The child is interested in representation. The representation is schematic in the way in which a sign on the men's and women's restrooms is schematic. There is enough detail in the image to do the job, that is, to represent cat. More is not needed.

Figure 2, drawn by a six-year-old, also distills the essential features of the scene and objects the child wants to draw, but this drawing contains several conventional signs. For example, the sun

FIGURE 2

is handled as a formulaic indicator of meaning. It is a conventional use of a drawn sun that many children share. It is up, and it is tucked away in the corner of the paper. The house, too, reflects the use of learned conventions. Few if any houses in the area in which this student lives have windows of the kind he has drawn or a peaked roof. The door, replete with handle, is lower in height than the windows. Again, attention to particulars rather than relationships dominates, although in this drawing relationships are attended to. The trees overlap; the animal and the drawing of the child are situated on the ground. Clouds occupy their own space above; another use of convention.

Still another use of convention is the placement of flowers on a horizon line. What we have in this picture are essentially a baseline and a horizon line. The baseline accommodates the two trees, and the horizon line provides a grounding for the flowers. In each case the renderings of the objects are schematic and simplified. The picture is a narrative, a kind of didactic expression that conveys a

FIGURE **3**

scene. This drawing is a narrative in which visuals rather than words have been used to tell a story.

Figure 3, made by a kindergartener, presents another simplified schema, this time of a bird. What is notable here, in addition to the child's effort to render the essential features of the bird, is the attempt to ground the bird with the horizontal strokes, thus providing a platform for its feet. The texture of the bird is conveyed by both the vertical lines on the bird's body and the horizontal lines protruding from the right side of its body. Additional lines are placed around the bird's neck and head as if to indicate the presence of feathers. The child clearly knows the visual features the bird possesses.

Simplification is visible as well in Figure 4, made by a third-grade student. Here we have an elephant drawn from the side view. The side view of an elephant, like the side view of a chair or table, is its least ambiguous angle. To render an elephant convincingly from a realistic perspective looking straight on from the front would be a formidable technical achievement. The image that is

FIGURE **4**

most telling and easiest to portray is one from the side, an image that shows the animal's most revealing feature, the trunk. Children grasp the perspective of an object or animal or person that is most revealing of its essential structural properties and then create its structural equivalent within the limits of the material with which they work and their technical repertoire.

Figures 5 and 6 are drawings made by two third-graders of the activity of jumping rope. Particularly interesting in this pair are the two ways in which movement has been achieved. In Figure 5 there is a visual illusion, almost like that in Duchamp's *Nude Descending a Staircase*, that projects the movement of the rope as it encircles the jumper. But in this drawing the figure's feet and legs are stationary. In Figure 6 the ropes the jumpers use are all overhead, but the feet and legs of the jumpers are moving and, in two cases at least, off the ground. What we see here is greater attention to detail and to realistic proportion.

Note that in both rope-jumping drawings the figures are flat.

FIGURE **5**

FIGURE **6**

There is no attention to matters of volume as there will be later on. The creation of roundness and the illusion of light and shadow have not yet become a part of either the intention or the graphic repertoire.

Figures 7 through 11 reflect the expansion of both perception and graphic technique. Figure 7 shows the ability to attend to detail, to describe proportion, and yet to employ convention (note the way the nose is handled) to draw a portrait. The use of convention shortcuts the careful perception of the forms to be drawn. With convention, the empirical world need not be consulted; one simply moves to the convention one knows how to draw. The creator of this drawing draws not what she sees, but what she knows how to depict, namely the conventions that stand for house, tree, and, in this case, nose. Since the aim of the drawing is not to render realistically, the use of such conventions for many children is not a problem until the desire to draw realistically emerges.

The ability to create a realistically convincing drawing is a man-

FIGURE **7**

ifestation in our culture of mastery. The ability to render realistically is an object of admiration that many students wish to accomplish. It is not necessarily a universal ambition. Cultural values and the forms of art children are exposed to influence the images they consider desirable. Culture, therefore, influences what counts as an artistic performance.

Figures 7 through 11 display growing sophistication in the technical repertoire. Figure 8 was made by a sixth-grade student and shows some of the features of Figure 7. Look at the way the nose is handled in Figure 8. The nostrils are still present, but in a more realistic form, and the bridge of the nose moves into the eyes in a way that the child who drew the woman's portrait in Figure 7 was not yet able to accomplish. In addition, the child who drew Figure 8 was able to address the turn of the collar as it circles the neck. Strands of hair now look more realistic.

Yet Figure 8 is still a flat, frontal portrait whose visual qualities are similar to those of the drawings by the younger children. Fig-

FIGURE **8**

ure 9, in contrast, incorporates the creation of volume and the use of light and dark. This technical achievement is associated with a high level of graphic competency, a competency fueled by careful attention to the person portrayed.

Figure 9, a portrait made by a twelfth-grader, displays not only sophisticated graphic technical ability but also playfulness in the treatment of light and dark and in the stylized patterns through which light and dark emerge. There is an intentional abstractness employed for aesthetic purposes; this student is thinking about the image as an artistic achievement, not only as a representation intended to serve didactic purposes. This image is considerably more than a two-dimensional schema.

So, too, are Figures 10 and 11. In both cases the qualities of the medium, ink drawing, are exploited to generate qualities that are intended to yield aesthetic satisfactions. Note the free treatment of line in Figure 10 and how the transparency of the pants over the two legs

FIGURE **9**

of the man is left as is. This student appears to recognize that in art there is license, and that with license there is liberty, and that the liberties that one can take in drawing can serve aesthetic values.

Figure 11, made by a sixteen-year-old, teaches the viewer that there are many ways and many vantage points by which to view a tree. Here we have an intentional selection of that part of a tree that displays a composition of form captured through texture and light. The contrast between the rough solid bark and the lacelike branches and small budding leaves provides a visual interplay of what is strong and what is delicate and in so doing affords the viewer a visual delight.

Figures 12 and 13 provide additional examples of how eight-year-olds and twelve-year-olds handle visual representation. The drawings in Figure 12 are similar in character to those in Figures 1, 2, and 3. Each is a schematic representation displaying the most revealing features of the objects drawn; the simplest form is used

FIGURE **10**

FIGURE **11**

FIGURE **12**

to display the most telling characteristics of the subject. Each of these drawings depends upon the child's ability to grasp the overall configuration of trees, birds, cats, and bicycles. But then the child must represent those telling characteristics on a flat surface. Again, the aim of the drawing is didactic. It is to represent in a straightforward way the "bicycleness" of a bicycle.

In Figure 13 it is clear that the attention to detail and the technical skills of the twelve-year-old artist have enabled him not only to reveal the telling features of a bicycle, but to treat convincingly the front wheel in its least most revealing perspective. In a sense, the drawing says: "Look what I can do with illusion! No low board diving for me!"

Figures 14, 15, and 16 are all concerned with the creation of illusion. Figure 14 creates a sense of illusion through the overlap of forms and through the effort to create shadow by darkening sections of the figures. It also represents an interest in groups. We cannot tell whether the group represents family or friends, but clearly the image displays an interest in the social aspect of life and seems to capture the trendiness of outfit and the sunglasses the images display. Line, shadow, and overlap are used to project the visual meaning of the image.

FIGURE **13**

FIGURE **14**

Figure 15 is also concerned with illusion, but here technical controls are not as well developed. The image is flat, yet at the same time conveys a charming awkwardness in the child's effort to seat a figure on a chair. It is not unusual to find an active, expressionistic character in children's drawings. This is an instance of such work. In some sense, the child has reduced the image to its essential features and in the process created a drawing that has movement and a sense of liveliness. However, it seems to me highly unlikely that these features were the result of conscious intent. An adult artist who attempts to create such a feeling is likely to know what he or she is trying to accomplish and how to achieve it. Many children create extremely expressive work intuitively rather than through a conscious sense of control and the sort of appraisal that adult artists exercise. To some degree these works are the result of happy accidents that can be used by teachers to advance students' understanding of what might be called the architecture of form.

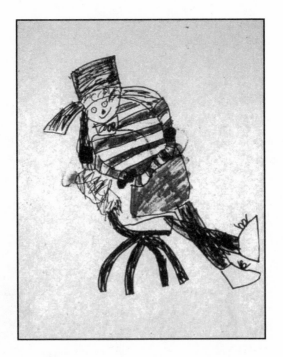

FIGURE **15**

Figure 16 displays a sophisticated rendering in the simplest terms of a portrait of a girl. The image is almost Lautrec-like in its flat, almost posterlike features. Here, too, illusion is sought, but within the stylistic constraints the student is using.

In the series of drawings shown in Figures 17, 18, and 19, all made by high school students, we encounter the results of a different kind of task. Here, the problem set by the teacher is to start with a familiar subject and to make successive modifications on that subject so that it comes to represent an entirely different subject through gradual transformations. Thus, in Figure 17 we start with a clothespin, which then is transformed to suggest a couple embracing, followed by another drawing of a couple embracing, but this one perhaps slightly more ambiguous. This is followed by the emergence of a frog, whose features one can readily identify in the preceding drawing. This fourth drawing is followed by a detailed representation of a frog, a representation that displays considerable technical acumen.

FIGURE **16**

FIGURE **17**

FIGURE **18**

FIGURE 19

One of the contributions that all teachers, but perhaps especially art teachers, can make to the cognitive development of their students is to frame tasks that challenge them to think in new ways. The drawings in Figures 17, 18, and 19 are solutions to a problem that was framed by the teacher and that adolescents often find intriguing. It requires the ability to break a perceptual set so that the forms that constitute a familiar object can be gradually transformed; the object itself becomes something other than what it was at the beginning. Imagination must be exercised in order to conceive the potential of the forms for transformation. In the series in Figures 17, 18, and 19, students display convincingly that they are able to make those transformations, and with a high degree of technical competence. The drawings are not only clever; they have an aesthetic appeal stemming directly from their creators' skills.

Figure 20 displays a playful attitude toward the use of line. The student is able to treat line abstractly and to use it playfully to cre-

FIGURE **20**

ate a flat design that itself makes it possible to take a visual trip through the mazelike features of what appears to be a maplike display of a city, a building, or a castle.

Plate 7, made by a nine-year-old, displays a rather remarkable overlap between the two female images. Almost Picasso-like in character, the overlap of the images gives a second eye to the figure beneath it, even though only one eye can be seen from this angle. Whether this result is conscious or accidental cannot be determined at this time. Nevertheless, the image is a powerful rendition of composition and color. Note the oblique axis on which the two images appear, conferring upon the drawing a sense of motion that would otherwise be absent.

Plate 8, made by a seven-year-old, is a simplified, almost de Kooningesque characterization of a female. The image is simplified and visually strong, filling the entire picture plane; and it treats color not simply as something to fill a space, but as something to modulate in order to create variation and nuances of color. There is a tactile quality to the surface as a function of the way color sits upon it. The result is a powerful, frontal, strong, richly colored image.

Figures 21, 22, and 23 display drawings of crowds. One way to create a sense of depth on a flat surface is to use overlapping objects. Another is to reduce the size of objects of similar size; a third is to decrease the color intensity of objects in the background. Students often have difficulty handling distance, particularly with respect to the overlapping of form. What we see in these images is the result of another teacher-initiated activity, the drawing of a crowd. By suggesting this subject and by discussing with students how crowds might be portrayed, the teacher opened the door for students to secure another array of technical skills, ones that open up new possibilities and confer a freedom derived from growing technical competence.

These drawings look almost like tapestries. They are similar in their overall configuration, but display individuality in their details; each reflects the artistic signature of its creator. The acquisition of a newfound method for displaying depth through overlap can now function as a part of the technical repertoire that these children can employ in addressing other visual problems. The

FIGURE **21**

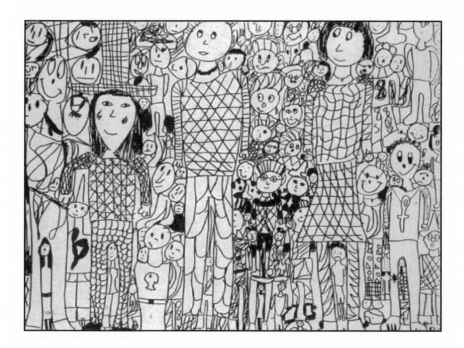

FIGURE **22**

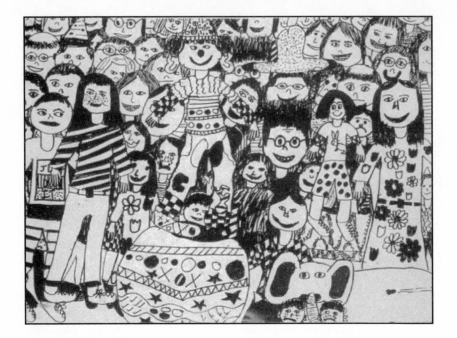

FIGURE **23**

teacher's role was critical in promoting and supporting the development of these skills, which in turn reflect distinctive ways of thinking about the creation of visual art.

Because I have focused my comments, in large measure, on the acquisition of technical skills, there may be a tendency to regard the images described above as the result of a manual, technical undertaking. Techniques represent ways of doing something, but techniques also reflect ways of thinking about the thing to be done. Thus the acquisition of a technique is not merely a technical achievement; it is a mode of thought; and as such the changing features in children's artwork are the result of changes in the way in which they think about what they are doing. The shift from a didactic to an aesthetic or expressive mode is a reflection of the mental models children employ in defining the purposes of their work. The adjustments and "corrections" that they make on their work are a reflection of what they have learned to see and the distance that exists between what they have made and what they want to make. That kind of analysis is important not only in the

arts but in virtually every walk of life. The ability to appraise, to project revisions, to act on those projections, and to evaluate their consequences is fundamental to good work in any field. Such accomplishments require the ability to think. What we see in children's artwork, particularly when it is laid out over time, is the progression of the development of such thinking.

# 6 THE CENTRALITY OF CURRICULUM AND THE FUNCTION OF STANDARDS

*THE CURRICULUM IS A MIND-ALTERING DEVICE*

In previous chapters we examined some examples of what teaching looks like in the visual arts and encountered descriptions of the forms of learning that are reflected in the features of children's artwork. But what about the school's program; what about the curriculum?

The curriculum is central to any educational enterprise. The curriculum constitutes that array of activities that give direction to and develop the cognitive capacities of individuals. You will remember that I include under the term *cognitive capacities* the capacity to feel and to act as well as the capacity to deal with the abstractions found in what are typically regarded as "intellectual" subjects. I am advancing here a wide conception of cognition that includes what we normally regard as perception. It is a conception that embraces the variety of ways in which humans represent what they have cognized. The curriculum is, looked at from a distance, a program designed to promote the development of that broad conception of cognition. Thus, when policymakers and educational theorists define a curriculum for a school or a classroom, they are also defining the forms of thinking that are likely to be promoted in the school. They are, in effect, laying out an agenda for the development of mind.

School programs and programs in classrooms employ curricula that always need some form of mediation. Teachers and teaching are, of course, the primary sources of mediation, although increasingly it is becoming possible for computers to provide forms of mediation that once belonged to the teacher.[1] Whether through a computer or through a human teacher, mediation there must be.

Curricula can be conceptualized in a number of ways.[2] Curricula can be the plans that humans make that are designed to influence what they should learn. Curriculum work in this sense results in plans and materials. These plans and materials might be sketchy notes created by a teacher in preparation for a lesson or elaborate productions designed by illustrators and designers working for large publishers who sell their materials to very large populations of schools, teachers, and school administrators. This design of plans and of materials associated with them is intended to be used to influence what students learn. This conception of curriculum has been referred to as the intended curriculum or the curriculum *in vitro*. In the field of art education there are a number of such curricula on the market. Each is designed or at least intended to enable teachers to increase the quality of their programs by following the leads and guidance that such materials provide.

But there is always a distance between the intentions of curriculum designers and actual teaching practices. The curriculum *in vivo*, as contrasted with *in vitro*, consists in the actual activities employed in classrooms. No professional curriculum designer can know the details or specifics of individual classrooms or the needs of particular children. The person closest to the situation—the teacher—does know and hence is in a position to make the sorts of adjustments that are needed to suit local circumstances. One of the marks of professionalism in teaching is precisely being able to make the adjustments or to create the improvisations that will render the materials effective. Although at one time in the history of American education, in the 1960s, there was talk of developing "teacher-proof curricula," that is, designing curriculum materials that were so prescriptive and detailed that they could not fail to be effective, that illusory aspiration has long passed, and most people today recognize that professional discretion is needed in teaching

just as it is in virtually every other professional field. If recipes for teaching were adequate, teacher education programs would be unnecessary.

Although I have drawn a distinction between teaching and curriculum, if one probes deeply enough, the separation between them tends to evaporate. *How* one teaches something is constituent with *what* is taught. Method or approach infuses and modifies the content that is being provided. Thus, teaching becomes a part of curricular processes, and curricular processes, including their content, become a part of teaching; you can't teach nothing to somebody.

The interpenetration of teaching and curriculum does not exhaust the factors operating in the classroom that affect what is taught and therefore what students experience and learn. Another extraordinarily important factor is the process of evaluation. Like teaching, evaluation is often treated as a separate or independent process, something one does after one teaches a curriculum. The fact of the matter is that evaluative activity goes on concurrently with both curriculum planning and teaching. The curriculum designer takes into account questions pertaining to the significance of the content selected and its appropriateness for some age level or for the teacher, it makes judgments about the sequence of events that are planned to determine whether they are sufficiently connected, and appraises the materials with respect to ease of use and the like. Evaluation occurs as teachers make judgments about the quality of the responses or the degree of activity and engagement students are displaying in the classroom. Teaching without evaluation would be a blind enterprise, almost as if someone were trying to teach a group that he or she could not see or hear. Under such circumstances, making modifications on the basis of feedback would be impossible.[3] Thus, both teaching and evaluation interpenetrate curriculum. They are a part of an inseparable whole.

The core phenomena in curriculum are the curriculum activities that teachers and students design.[4] The curriculum activity shapes the sorts of thinking that children are to engage in. For example, a teacher who asks youngsters to compare the expressive character of a teapot with the expressive character of a Honda mo-

torcycle is inviting students not only to compare these two visual forms, but to pay special attention to the relationship of those forms to their expressive content. The student needs to attend in ways that are quite different than if the teacher asked the student to describe their practical utilities. The curricular activity, in this case, promotes the use of a particular perspective or frame of reference. It requires a certain level of effective engagement if the student is to have something to say about the differences in the teapot's and motorcycle's expressive qualities.

Every time a teacher designs a curriculum activity, events are planned that have an impact on students' thought processes. Thus, how curriculum activities are designed, the modes of cognition that are evoked, the forms of representation that are presented or which students are given permission to use all affect what students are likely to think about.

Of course, no one can be certain that every student will always employ the same processes given a particular curriculum activity, but in general, if students are asked to draw comparisons and contrasts, they need to attend to the work in ways that will help them notice their similarities and differences. Thus, it is said (and I concur) that at the heart of curriculum is an activity or event planned by a curriculum designer or a teacher through which the forms of experience that educate are promoted.

There are substantially different views among educators, particularly when they think about the education of young children, regarding the time at which formal curriculum planning should occur.[5] For some, it is important to lay out systematically a program of activities and their objectives well in advance of their use. Thus, a teacher would have a kind of timeline that described the sort of activities that would be engaged in during a given week of a given month. The aim is to make sure that the material is covered at a pace that is consistent with what has been planned. In this view, curriculum planning provides not only a direction but a framework in which to manage the class's pedagogical pace. The teacher knows, or is supposed to know in September, where his or her students are likely to be at the beginning of December.

Another view treats time much more flexibly. How much time

will be needed for a class or even a single student to engage in a particular activity in a productive way cannot be foretold weeks or months in advance of the activity itself. The teacher's task is to be sensitive to the flow of events and to the student's engagement in those events in order to make appropriate adjustments and, indeed, to invent activities that are appropriate for the students. This model suggests that curriculum activities "grow out of," or emerge from, events that immediately precede them. The teacher is less concerned with arriving at a predetermined destination on time than with getting students engaged in activities that are emotionally satisfying and intellectually productive. Sequence grows out of the links that the teacher helps forge between his or her more mature knowledge of a field of activity and the work that students engage in.

To be able to make educational gold out of emerging activities in the classroom requires a high degree of artistry in teaching.[6] Artistry in teaching is more likely to occur when the classroom provides a context for improvisation and where unpredictability, rather than predictability of activities and consequences, is acknowledged. When plans are tightly organized, when objectives are highly specified, where a timeline is prescriptive in its detail, routine is given a place of privilege. Efficiency and effectiveness are seen as more likely when the tracks are smooth and where all students are expected to move down those tracks toward a common goal.

When the teacher's perspective is one that might be called emergent rather than prescriptive, the stakes for pedagogical innovation are higher and the demands greater. And when students themselves are invited to have a hand in defining their own purposes and in framing their own curricular activities, uniformity among students with respect to what they do and what they learn is much less likely. The more teachers open the door to the suggestions of students, the more opportunities they provide for genuine individualization. What such a curriculum promotes are individualized outcomes and individualized activities.

Many students find it difficult to cope with the opportunity to define their own goals; it takes practice to do so well and a willing-

ness to accept such an opportunity as an appropriate part of one's own education. When birds have led their life in a cage, it is not difficult to understand that when the door is opened, they might not have a desire to leave.

Even when students have a hand in framing their own purposes and in forming their own curriculum activities, the teacher has a considerable role to play. Such an approach to curriculum makes greater demands on the teacher than one that is packaged by a curriculum production company. More is required if the teacher is to work more or less individually with students to enable them to think through and to plan what they are going to address in their art program. In addition, the teacher has a key role to play in calling the students' attention to qualities in the work they produce that need attention of one kind or another. The students might learn how to address certain formal relationships, technical matters, or imaginative features of their work that they had not noticed. Calling the students' attention to such matters addresses other minicurricular activities that invite students to think about the content of their work in new ways and to experiment with ways to strengthen what needs attention. Thus, curriculum and teaching merge within a dynamic context.

Thus far I have been talking about the importance of curriculum activities and the interpenetration of teaching, curriculum, and evaluation. But I have also been talking about curriculum as it pertains largely to a single content, the visual arts. Curricula need not be organized around single domains or fields of study. They can also be integrated across fields. It is to this option that we now turn.

## INTEGRATED ARTS CURRICULA

The integration of the arts with other subjects can take more than one form. Perhaps the most common is to bring the arts in touch with the social studies or with history, so that when students are studying, say, the American Civil War or the Jazz Age, they also are being exposed to the painting, sculpture, music, and dance of the period.[7] The point of such contiguity is to provide students

with a wider picture than the one they are able to secure through written materials alone. After all, it is extremely difficult to know what the music of a period sounds like without being able to listen to it, or to understand the form painting took during a particular period without being able to see it, or to experience the forms of dance or theater that were created at a particular period without images to consult. The availability of such images can enrich students' experience and their historical understanding.

At times, particularly at the elementary school level, teachers will make it possible for students to produce artwork that emulates the features of the work produced in the culture they are studying. Thus, fish measuring, say, a foot long, are sometimes used in classrooms as "plates" to be painted with ink so that paper once laid upon them and pressed will yield a fish form, scales and all. Such an activity produces "Japanese-like" images and is designed to give students the flavor of Japanese culture.

Of course, it is very easy to convert art programs into handmaidens for learning the social studies or history without providing youngsters with occasions for developing artistic judgment or securing aesthetic forms of experience that mark effective art education. It is possible to dilute art programs and to delude oneself that art is being taught when in fact there is little in the way of artistic activity going on.

To say this is not to suggest that integrated curricula cannot pay attention to both aesthetic and imaginative features and at the same time enrich historical understanding. After all, life is a multimedia event, and the meanings that we secure from life are not simply contained in text; they yield their content through a wide variety of forms. Hence, the utilization of an experientially rich array of resources for understanding some aspect of the human condition is not a bad thing to pay attention to. What must also be paid attention to is the art in the project. Simply exploring materials without encouraging attention to aesthetic matters renders them void of their artistic potential. Such practice results in integration without art.

The practical implications are significant for teachers. They suggest that as much time and attention and effort need to be de-

voted to enabling students to attend to their work aesthetically as is paid to the social studies or history material they are studying. This means helping students learn to scrutinize their work aesthetically, to make judgments about it, to acquire techniques that will make it more powerful, and to acknowledge achievement by other students in such matters. An integrated curriculum makes more, not fewer, demands upon the teacher.

A second form of integration involves identifying a central, key idea that a variety of fields would examine. Consider the idea "It is always darkest just before dawn." Assume that you're a high school art teacher collaborating with teachers of English, history, and one of the sciences. What might be done with a group of high school sophomores or juniors in discussing the meaning of this statement? How might its meaning be expressed in different subject matter forms, and how might these forms of subject matter— English, history, one of the sciences, and the arts—be related to one another to produce a work that utilizes the various fields productively? In other words, how can various fields be instrumental to the illumination of a large idea?[8]

Consider others: "survival of the fittest," "the process of metamorphosis," "the constancy of change"—the list could go on and on. Selecting an idea that is open-ended and stimulating to a group of high school students is a basis for thinking about the ways in which various fields address such notions and how those fields might be related to one another to create something that is more powerful than any single field could achieve. What needs to be kept salient in such a conception is the key idea to which works in the various fields serve as instrumentalities.

There has been a longstanding tension in the field of education between the desire to be rigorous in a disciplinary way, that is, to provide programs that initiate the young into the concepts and procedures of the disciplines taught within the school curriculum, and programs that relate field to field and are relevant to the student.[9] Thus, a student studying biology would be expected to understand the basic concepts of biology and the procedures used for biological inquiry. The same aspirations are applied to history or to the processes of writing literature. Students are to understand

what needs attention in the construction of narrative and are to have practice in producing it.

Yet even individuals seeking to develop disciplinary rigor acknowledge that most school curricula are highly fragmented, that their parts do not fit well together, that subjects have an independent existence, and that the models that we use to plan programs are designed to produce junior disciplinarians rather than to help students understand the ways in which knowledge is integrated and how it might be used in the practical world that they will occupy. In short, we have broken Humpty Dumpty and cannot put the parts back so that they all fit together as they once did. Integration is, on the one hand, an aspiration and on the other hand a problem when one tries to maintain the "integrity" of a discipline. How one can achieve both—which, if possible, is desirable—remains to be worked out. The farther students proceed in school, the greater the separation among the various disciplines.

The practical need for time to learn is perhaps made most vivid in the acquisition of skills. It is one thing to survey the pottery of the Han dynasty, and it is quite another to have the time needed to learn how to throw a pot on a wheel. Unless there is sufficient time devoted to learning how to center a ball of clay on a potter's wheel and to pull up a gracefully formed, thin-walled vessel, students are unlikely to reach a threshold that makes it possible for them to understand what throwing a pot entails. In other words, there is an irreconcilable tension between the demands that need to be met in understanding what a discipline requires and, on the other hand, understanding its connection to other disciplines. I have no good resolution to this dilemma.

Each of the visions and versions of art education that I described in Chapter 2 has its own particular features and its own emphasis. Discipline-based art education requires attention to four domains; using the visual arts to promote cultural literacy requires a different emphasis. Developing students' capacity for creative problemsolving suggests an emphasis on certain kinds of curriculum activities rather than others. An emphasis on creative expression would lead to still other aims and activities. Each vision of art education has implications for curriculum development. We see

such differences, often in subtle form, in classrooms throughout the country. And as I indicated in Chapter 2, I do not believe that there is one sacrosanct version of art education. Different programs are suitable or appropriate for different populations and the values that the community embraces. There is no "one size fits all" curriculum for a nation as diverse and as large as ours. Intelligent curriculum planning takes into account such differences and uses them to inform its own policymaking and construction processes.

In this chapter I have been discussing curricula either as emergent processes decided largely by the teacher's assessment of what seems appropriate under developing circumstances or as planned programs that lay out an agenda over time, enabling both teachers and students to know what's ahead and what is expected. I also indicated that the latter approach to curriculum development is closer in spirit to the technocratic expectations salient in American schools today. Some people feel comfort in knowing not only the direction in which they are headed, but the precise destination. These destinations are often operationalized through standards and rubrics, two notions that I will be discussing shortly. However, it would be a mistake to conclude that what is learned in the classroom is a function only of the curriculum, whether emergent or not, and the teacher's ability to teach. Although curriculum and teaching are surely at the core of classroom life, children never learn one thing at a time. Nor do adolescents.

The conditions of teaching and learning in a classroom or in a school are a function not only of the curriculum and of teaching practices, but of the entire cognitive ambiance of the classroom and the school. The social conditions, the prevailing norms, the comments and attitudes of peers, the organizational structure of schools, the hidden messages that are conveyed to students in evaluation and testing practices—these also teach. Indeed some scholars have concluded that these teach more powerfully than the curriculum and the forms of teaching students are afforded. Students live in an educational world. Indeed, by law they are required to be in school during the better part of their childhood. The culture that is developed in schools and classrooms constitutes a way of life. I also indicated that "culture" can be conceived of as

a medium for growing things. In the biological sense, cultures are used to grow organisms. In schools, the culture is used to "grow children," and the pace and direction of growth are influenced by the features of the environment in and through which they live. Thus, a comprehensive understanding of what students learn in school requires considerably more than attention to curriculum and teaching practices. It also requires attention to the hidden messages, values, and ideas that are conveyed tacitly if not explicitly by fellow students and teachers in the classrooms in which students spend so much time.[10]

These hidden messages are referred to by some writers as the implicit, in contrast to the explicit, curriculum. Other writers refer to them as the hidden curriculum of classrooms and schools. One wonders about the extent to which such curricula are in fact hidden. Students seem to understand quite well what these covert messages are and to adapt accordingly.

What is the place of the arts in the school curriculum or in the classroom's curriculum? How does it compare in importance with other fields of study? How much time is allocated to the arts in schools? When are they taught? Are they electives, or are they part of the core curriculum? Are grades in the arts taken into account by selective universities in calculating grade-point averages? Does the school publicly acknowledge, as it does in athletics and some of the sciences, students who are excellent in the arts? These questions and more need to be addressed to get a comprehensive picture of the culture of schooling as it bears upon the arts.

One last concept is crucial to thinking about curriculum matters in relation to what children learn. The formal program of the school, the program that is planned, taught, and graded, constitutes the school's *explicit curriculum*. This curriculum consists of the subjects that virtually everyone acknowledges are being taught in one way or another. This is the curriculum for which teachers are hired, grades are given, records are kept, and the like.

Classroom ambiance, school norms, modes of assessment, and the like teach not explicitly, but implicitly. Thus, we not only have an explicit curriculum in schools, but also an *implicit curriculum*, and it is the implicit curriculum that endures while sections of the

explicit curriculum change over time; a unit on printmaking in the visual arts or the westward movement in social studies is here today and gone tomorrow. The features of the implicit curriculum continue.

But there is also another curriculum, one that is paradoxical: the *null curriculum*.[11] What is not taught can be as important in someone's life as what is taught, whether explicitly or implicitly. The null curriculum constitutes what is absent from the school program, what students in schools never have the opportunity to learn. When the arts are absent or taught so poorly that they might as well be, students pay a price. Acts of omission can be as significant as acts of commission. Thus, in thinking about curriculum development or curriculum reform we should think about the explicit curriculum, the implicit curriculum, and also the null curriculum.

Of course not everything can be taught, and hard choices have to be made. What those choices are with respect to the arts is, perhaps, the most telling indicator of their significance to those who make educational policy.

## CURRICULUM OBJECTIVES

The formulation of curriculum objectives is an effort to describe what a student is to know and/or be able to do with respect to some body of content at the end of some designated instructional period. Objectives describe *intended* outcomes. The effort to specify objectives in curriculum planning was initially a reflection of a desire to make planning rational by indicating what its goals would be. In the early 1920s in the United States, an educational administrator by the name of Franklin Bobbitt was particularly instrumental in developing the idea.[12] As he saw it, and as others did after him, each unit of instruction was to have one or more objectives, and the journey through the curriculum was a journey intended to make it possible for students to achieve those objectives. At the end of schooling, a student would have mastered hundreds of objectives. Bobbitt had over seven hundred in his book.

The dominant idea is that it is important to know what students

are expected to learn. The specification of objectives is the way to describe those outcomes.

In the 1950s and 1960s there was a movement to operationalize objectives by specifying conditions that would make it possible to measure their achievement. Robert Mager was the leading proponent of this trend.[13] The current push toward standards is, in part, an effort to specify in operational terms the desired outcomes of curriculum and instruction.

Educators in the arts have been encouraged to think about curriculum planning in terms of intended outcomes, and, clearly, there is reasonableness in this request. At the same time, one of the features of the arts is the encouragement of improvisation and the cultivation of a personal rendering of one's ideas. As a result, activities in the arts do not always lend themselves to the kind of predictability that is inherent in an objectives-oriented approach to curriculum. When objectives become operationalized, there is a strong tendency for them to become particularized; increasingly finer and finer distinctions are made, and objectives can become so numerous that they swamp a teacher's ability to cope with them. In addition, most students do not proceed at the same rate in their learning. Children learn what the teacher intends to teach, but the way they interpret what the teacher is teaching and the way in which they express what they have felt, believed, or imagined often differ, especially in the arts. Thus, heterogeneity in outcome is clearly more characteristic of the outcomes of art teaching than the kind of outcome one might expect and indeed desire in a factory. There is a tension between specification and desired predictability and the sort of emergent quality of curricula that was described earlier in this chapter.

There are several ways to think about outcomes with respect to objectives, ways that ameliorate the prescriptive features of most curricula.

Problemsolving objectives are objectives in which the criteria to be met are specified, but the form the solution is to take is not. An architect, for example, may be asked to design a house with particular features or to design a kitchen that performs in particular ways. The form such a house or kitchen possesses, however,

can be extraordinarily diverse. Indeed, competent architects are likely to provide several versions for a client to select from. The problem presented has open-ended solutions that nevertheless meet certain criteria. Problemsolving objectives are in some ways much more congenial to work in the arts than objectives that aim for an isomorphic relationship between the objective and the features of the student's work.

Another perspective is to think about expressive outcomes rather than curriculum objectives. Expressive outcomes are the outcomes that students realize in the course of a curriculum activity, whether or not they are the particular outcomes sought. In fact, activities can be intentionally planned that are likely to yield an unpredictable and heterogeneous array of outcomes. The teacher then builds upon those outcomes in developing additional lessons. This requires what Robert Stake calls *responsive evaluation*, in contrast to preordinate evaluation.[14] That is, the evaluation process connected to expressive outcomes is applied after the fact instead of attempting to match outcomes with intentions. Responsive evaluation in some ways resembles a husband and wife's analysis of events the morning after a party, a matching of specific expectations to performance. Whether the evaluation is preordinate or responsive, evaluation does take place.

## STANDARDS

Over the years the concept of objectives has generally been replaced by the concept of standards. Standards are considered the lynchpin of the reform movement.[15] The logic for establishing standards is rather straightforward: educators should know in clear and unambiguous terms not only the direction in which they are headed but also the precise destination. Standards, it is believed, will provide such clarity. Thus, the first task in school reform is to create standards that will tell the public what students should know and be able to do at the end of an instructional period, say, by the end of a school year. Furthermore, if standards are useful for defining expectations for students, by the same logic they are useful for defining expectations for teachers. In other

words, teachers can be held to standards that in form, if not in content, are like those applicable to students.

If one wants to extend the principle, one can reason that if standards are good for students and teachers, why not for school administrators? And not far behind administrators is the curriculum. Why not content standards for curriculum and process standards for the kinds of classroom activities through which that content is taught? Standards, to a public concerned about schools, seem like a powerful way to achieve clarity and to shore up a system that has been sagging for too many years.

There is an undeniable appeal in the idea of clear, unambiguous expectations. Yet one can only wonder if our schools are in as desperate a condition as we are led to believe, and, even if they are, whether the creation and application of standards are the powerful remedies they are believed to be.[16]

Interest in standards is associated with other efforts at reform. One of these is the production of national curriculum frameworks. These frameworks are the result of efforts by national committees of subject-matter experts to define, by professional consensus, the aims and content of each of the subject-matter fields that are normally part of schools' curricula. Thus, there is a framework for math, for English, for the social studies, for science, for each of the arts, and so forth.[17] These national frameworks define the character of each subject and its aims. In addition, each of the frameworks is to have a set of content standards and student performance standards defined for each grade or level of schooling. In a sense, the reform movement aims to create a common curricular focus if not a common curriculum with respect to aims and content for a state's or the nation's schools.

There are many who applaud the effort. Indeed, one national educational laboratory has mounted an approach called "standards-based reform."[18] The belief is that establishing clear standards is the first and most important step in school improvement. In addition, it is assumed that the presence of one national set of standards for each subject will contribute to educational equity, since all students will be given about the same curricular fare and will be working toward the same aims. Furthermore, with the same

aims, the same content, and the same standards, it will be possible to identify failing schools and unproductive teachers and, where necessary, make a change. The process is called accountability.

Standards are claimed to have other virtues. Using a uniform array of standards will enable teachers to talk to one another more productively; they will be able to learn from one another what works and to implement what works in their classroom. But most important, the public will know what to expect, and when standards are operationalized supplemented by standardized tests, it will, at last, be possible for teachers to be held truly accountable for their students' performance.

In any case, how could anyone be against standards? To be without standards is, it seems, to be in favor of sloth, mediocrity, or worse. Standards will not only give us better schools; they will make it possible for our schools to become "world class."[19]

I have some reservations. Why does a nation as diverse as ours need a common curriculum? Is there only one defensible conception of a good curriculum, a good school, or a good teacher? In a nation that boasts that one of its strengths is its diversity, are differences in the way the subjects are conceptualized exempted from that diversity?

In Chapter 2 I spoke of visions and versions of arts education. There are many legitimate conceptions of a subject field, and the existence of options with respect to the aims of a field has made choice possible. Choice is needed to be free. I am not persuaded that a nation as diverse as ours needs to have a "one size fits all" curriculum. I am not convinced that all our students need to march to the beat of the same drummer, down the same road, to the same destination.

Now some will claim that programs need not be the same, that under a national curriculum teachers still have the freedom to choose how they will attain curricular aims. In other words, the teacher has the freedom to determine means, but not ends. This restriction applies to teachers, and it applies to communities, as well. Matters pertaining to the formation of aims, in this view, are a settled issue. From my perspective this position deprofessionalizes teachers and disfranchises communities.

But there are other problems beside the problematic view that a single program for all the nation's schools will improve them. One of these problems is the belief that it is possible to predict what a class will study and at what pace over the course of the school year. What we do know is that political, economic, and social events do affect schools, and that student interests develop that provide teachers with especially teachable opportunities, opportunities during which sticking to the lesson plan is the surest road to a pedagogical Waterloo. What is needed in such circumstances is pedagogical improvisation in the service of meaningful teaching and learning. It is here, especially, that teachers' professional judgment must come into play so that they can exploit those moments in the classroom. The ethos of much of what flies under the flag of standards-based reform flies in the face of such improvisation.

In the arts, as in many other fields, surprise is a friend, not a foe. During the course of their work, students and teachers alike encounter the unexpected, students in images and qualities that they could not have foreseen but that beckon in one direction rather than another, and teachers in surprises that unscripted students create. The joys of teaching are often found in these unpredictable events. Just what do such events have to do with standards? Only this: to the extent that standards dampen the desire to treat the content and aims of teaching flexibly, they impede artistry in teaching and therefore impede moments in learning that can be among the most meaningful for students. Planning and teaching profit from flexibility, from attention to the changing colors of the context. Assumptions and concepts that seek predictability of routine and the security of conformity militate against it.

But there are other considerations as well. One of these pertains to a paradox that one encounters in the process of formulating standards: to be useful for determining if they have been attained, standards need to have a high level of specificity; general statements about desired outcomes may point in a direction, but they are not very helpful in the context of evaluation, one of the important contexts that standards are intended to serve. To be useful, they need to be specific. The more specific, the more numerous

standards will be. But, like objectives, the more numerous they are, the more cumbersome they are.

Those advocating the use of standards have tried to address this problem by specifying benchmarks or rubrics for each standard. Benchmarks and rubrics are exemplars or descriptions derived from standards of what students should know and be able to do at a particular level or grade. But this practice does not ameliorate the problem; it merely shifts it and, in many cases, exacerbates the problem, since benchmarks are often specified not only for each standard, but for three or four levels of attainment within each standard.

Another issue that needs to be identified is the assumption that linguistic descriptions of artistic performance will be adequate for describing the nuances and features of such performance. That assumption is questionable. Language is often a very limited vehicle for the description of qualities. How, for example, would water be described? Or the color blue? The assumption that language will always serve as an adequate means for describing what students are to be able to do and know is itself problematic. Some things can be known only through exemplification and through a direct encounter with them. If someone is really good at crafting language, a closer approximation to the qualities it seeks to describe may be possible, but even here it will be limited. The language of the critic, someone whose work it is to address qualities descriptively as well as evaluatively, always requires something of a leap from the language to the work. Few of the descriptions of intended outcomes through the application of standards have the linguistic virtues of the best of our critics.

The McRel Laboratory, an educational laboratory committed to standards-based reform, lists thousands of benchmarks for grades one through twelve. It is not likely that teachers, even at one grade level, will find such a load helpful. For example, in their report *Designing Standards-Based Districts, Schools, and Classrooms*, Robert J. Marzano and John S. Kendall state: "The issue of how many standards and benchmarks should be articulated was also addressed. We recommend about 75 standards and 2250 benchmarks in

grades 1 to 12 as a reasonable number to handle the inherent complexity of subject matter material without placing undue demands on reporting, assessment, or instruction."[20] Each benchmark has four proficiency levels: advanced, proficient, basic, and novice. When one does the arithmetic, the 75 standards not only turn into 2,250 benchmarks, but since each benchmark has four proficiency levels one ends up with 9,000 descriptors. In addition, the standards that Marzano and Kendall describe are only student performance standards; they do not include content standards. One can easily see without being a mathematician how the numbers grow, and one can speculate on what such numbers mean for a teacher.

Another problem pertains to learning rates among students. Students learn at different rates. The idea that students will take the same paths and learn the same things at the same rates flies in the face of what is known about human development. Under optimal pedagogical circumstance, as I indicated earlier, variance among students will increase as they are exposed to learning opportunities that are appropriate for their aptitudes. The image of applying uniform standards to assess their learning at the same point in time conjures up an assembly-line model of schooling. In this model predictability is a premium virtue. Each component of the product to be assembled proceeds at a controlled, predictable pace. The components come together in a predictable order and react to the impact of each assembly process virtually identically because, as far as we know, inert material such as steel, for example, has few interests and no particular motivations; one expects nothing but uniformity in response to whatever acts upon it.

Although the factory model developed during the efficiency movement in education was the darling of school improvement efforts in the 1920s, it is a model that radically oversimplifies the processes of teaching and learning.[21] Its applicability to arts education is problematic. In the arts, individuality rather than uniformity is prized. Surprise is not only permitted; it is pursued. Individual signature matters.

The considerations I have described might seem pale in light of the anticipated benefits of the organizational rigor that standards

suggest. And when a nation is concerned about the quality of its schools, the promise of relief through standards is appealing. But standards do not come without baggage. The concept itself participates in a more generalized orientation to education. The same uniformity that standards suggest has its echo in the mandate in some school districts to require students to wear uniforms in the belief it will remedy behavior problems. Such policies can only be cosmetic at best. Collectively they adumbrate a conception of schooling—I resist saying a conception of education, for seldom is there a conception of education described in policies on educational reform—that gives its garlands to what is uniform and rigorous. Rigor, in Latin, means "stiff." Stiffness connotes inflexibility. The prescription of standards, and uniforms, and national testing, and uniform curricula masks the deeper problems of schools. The nostrums that are prescribed are recipes for yet another return to school reform in a matter of a few years. It is this return engagement that breeds cynicism among experienced teachers, who have been there before.

Given the incongruity, in spirit at least, between the arts and the tradition in which standards are embedded, why have arts educators embraced the concept? There are several reasons. The first, and perhaps the most important, is that arts educators, like others working in the field of education, do not want to be left off the political bandwagon that not only confers legitimation on fields that join in, but also provides financial support. It is difficult to be left behind, and because the concept of standards is so salient and the arts so marginal from the core of educational priorities, the temptation to join in is especially strong.

When, in 1995, the arts were omitted from the initial list of subjects defined as basic in the reform movement, there was a clamor among arts educators and others to include them—as they should have been in the first place. It is this feeling of not wanting to be left out, of not wanting to be further marginalized, that motivated arts educators to get on board.

But there are more basic reasons, these of a conceptual nature, that account, at least in part, for the attractiveness of standards in arts education—and for their attractiveness in other fields as well.

These reasons relate to the fact that the meaning of *standards* has not been adequately examined. And because the term has such obvious attractive connotations, it has been seen as a powerful lever in school improvement. Key concepts, especially those that function as the lynchpin of a movement, should be examined. So it is well worth asking: What does the term *standard* mean?

## CONCEPTIONS OF STANDARDS

One conception of *standard* is related to a banner, a flag—as in *standard-bearer.* Standards in this sense are symbols to which people pay allegiance, even die for. To have a standard is to have a symbol that represents what you cherish. "Rubrics" are intended to describe what a student is to know or be able to do to achieve the standard.

A second meaning of *standard* is quite different: "average," as in a standard hotel room or a standard meal. Far from connoting a cherished value, *standard* in this sense conveys mediocrity or something typical, as in a "standard operating procedure."

A third meaning of *standard* is a unit of measure. Units of measure are the result of arbitrary choices that create a commonly used metric that can be applied to describe matters of amount.

A fourth meaning is a level of attainment needed to receive some type of license or acknowledgment, such as a degree or permission to drive an automobile. Standards in the context of school reform pertain, in large measure, to this fourth meaning, but units of measure often enter into the process of determining if standards have been met. For example, a multiple-choice test contains, say, 100 test items, each of which has one response that must be selected to be scored as correct. That one response is the standard to be met for that item. It constitutes one unit. To pass the test, a student must get 75 of the test items correct. Thus, standards are used in education both as values and as units of measure.

Standards as units of measure are regarded as the most objective form of description because measurement procedures do not permit much in the way of judgment to enter into the scoring of student performance. The objectively scored test is objective be-

cause determining correct and incorrect responses does not require the exercise of judgment; scoring can be automated.

Yet assessing student performance almost always must take into account that which cannot be measured. Measurement is one way to describe the world; measurement is a description of quantity. Some descriptions require prose—even poetry!

## STANDARDS AND CRITERIA

What does one do when the standard is not clear or when there can be no standard formed in advance that is appropriate for the particular work under consideration? The answer, according to John Dewey, is to appeal not to standards, but to the use of *criteria*. The distinction is subtle, but important.

While discussing the role of the critic in art Dewey describes the difference between standards and criteria:

> There are three characteristics of a standard. It is a particular physical thing existing under specified physical conditions; it is *not* a value. The yard is a yardstick, and the meter is a bar deposited in Paris. In the second place, standards are measures of definite things, of lengths, weights, capacities. The things measured are not values, although it is of great social value to be able to measure them, since the properties of things in the way of size, volume, weight, are important for commercial exchange. Finally, as standards of measure, standards define things with respect to *quantity*. To be able to measure quantities is a great aid to further judgments, but it is not itself a mode of judgment. The standard, being an external and public thing, is applied *physically*. The yardstick is physically laid down upon the things measured to determine their length . . . yet it does not follow, because of absence of a uniform and publicly determined external object, that objective criticism of art is impossible. What follows is that criticism is judgment; that like every judgment it involves a venture, a hypothetical element; it is directed to qualities which are nevertheless qualities of an *object;* and that it is concerned with an individual object, not with making comparisons by means of an external preestablished rule between different things. The critic, because of the element of venture, reveals himself in his criticisms. He wanders into another field and confuses values when he departs from the object he is judging. Nowhere are comparisons so odious as in fine art.[22]

For Dewey, the function of criteria is to promote inquiry. Their function is to deepen experience with the individual work: What is this work as a work of art? What are its qualities, what are its features? How does it "feel"? *The aim of the process is not to confer awards or to assign grades or to make comparisons, but to promote a fuller reading of the work that will be useful to students and teachers alike for knowing what to do next.* For the student the aim is to recognize what needs attention; for the teacher it is to be in a position to choose a course of pedagogical action. Given where the student is, a teacher might ask, "What do I do to promote further growth?"

Dewey's observations on criteria versus standards offer a far more sophisticated conception of the way aims can be formulated and performance evaluated. Uniformity and standards are soul mates. Standards are very close to standardization.

I said earlier that standards come with conceptual baggage: They also come with historical baggage. This is not the first time in the history of education that efforts have been made to "scientize" educational practice. The efficiency movement in education, which took place in the United States between 1913 and 1930, was motivated by public concern about the quality of schools. Too many children were failing, and the cost of failure was substantial to the society. At the same time, scientific management was being used to increase efficiency. The brainchild of Frederick Taylor, an engineer who developed the "science" of time-and-motion study, the plan was to employ efficiency experts to study the motions of workers on the assembly line in order to identify excess or wasted movement and to prescribe ways to eliminate wasted motion so as to increase their productivity while expending less effort. In the process the industrial plant in which they worked would become more productive and, as a result, they would become more prosperous. The stopwatch was the key tool.

School superintendents saw in time-and-motion study and in scientific management a way to increase school productivity. It was the latest in the scientific management of organizations, science had status, and if it worked in industrial plants, why not in schools? The task before administrators was to define aims for each teacher, to monitor teaching, to provide scientific supervision to

make it more efficient, and then to measure the results. They even believed it was possible to calculate how much it would cost to get the results achieved. One example of the kind of thinking that characterized the efficiency movement is found in a statement by Frank Spalding, superintendent of schools in Newton, Massachusetts. In 1913, assigning monetary values to pupil recitations in different subject matters, he told an audience: "I know nothing about the absolute value of a recitation in Greek as compared with a recitation in French or in English. I am convinced, however, by very concrete and quite local considerations that when the obligations of the present year expire, we ought to purchase no more Greek instruction at the rate of 5.9 recitations for a dollar. The price must go down, or we shall invest in something else." Spalding went on: "Why is a pupil recitation in English costing 7.2 cents in the vocational school while it costs only 5 cents in the technical school? Is the 'vocational' English 44% superior to the 'technical' English and 44% more difficult to secure? Why are we paying 80% more in the vocational than in the technical school for the same unit of instruction in mathematics? Why does a pupil-recitation in science cost from 55% to 67% more in the Newton High than in either of the other schools?"[23]

This practice is not far from a "payment by results" approach to teaching. Some school districts are now considering paying teachers in relation to their students' test scores. School superintendents often receive bonuses for high test performance by students in their school district.

Despite good intentions, in the process of specifying aims, hundreds of objectives for teaching were formed, so many that they were nearly impossible to administer. The movement eventually collapsed of its own weight, but not until after Franklin Bobbitt had come on the scene.[24]

Bobbitt was a professor of school administration at the University of Chicago and widely regarded as one of the founders of the curriculum field. Bobbitt, too, was enamored with objectives. He believed they were required for rational planning, and likened the construction of a curriculum to the process of planning a journey. Objectives were stations along the way. "But the many short steps

make up the long journey," he said. Objectives were steps along that journey. His book, *How to Make a Curriculum*, published in 1924, was an encomium to objectives; it contained over 700 of them.[25]

Thirty years later the movement was to emerge again, not in the form of scientific management, but in the form of mandates for behavioral objectives, which all teachers were expected to formulate for each of their teaching activities.[26] This, too, resulted in the formulation of hundreds of objectives for the subjects that were to be taught. Indeed, the task was so formidable that a behavioral objectives "bank" was created at the University of California at Los Angeles so that teachers who could not or did not want to formulate their own objectives could buy them from the bank. Today we have a similar movement, framed in terms of standards. The terminology is different, but the spirit is much the same.

What is particularly disconcerting with respect to standards-based reform is the way it distracts us from looking really deeply at our educational system. If we begin to ask what is needed to infuse the arts in a meaningful way into our schools, surely the following considerations would be important. We would need adequate time allocated in the curriculum for the arts to be taught; no time or radically inadequate time, and little can be taught. We would need a curriculum worth teaching. At present there is a need for good curriculum materials that teachers can use. We need teachers who know enough about the arts to make good judgments about the work their students create in their classrooms. We need assessment practices that address learning that matters in the arts. We need a climate in schools that does not assign to the arts an inferior status vis-à-vis other subjects. To create such a climate we need graduation and college-entrance criteria that acknowledge the arts as legitimate areas of study for college-bound students. Finally, we need within schools a form of organizational life that nurtures the professional lives of teachers.

These are only *some* of the conditions that need to be addressed to increase the probability that the arts will be well taught. These conditions are not unique to the arts; they need to be addressed to teach any subject well. Obviously, these conditions interact, they

collectively form a milieu; put another way, they constitute a culture. Significant change in schools requires a change in the culture of schooling.

## DO STANDARDS HAVE A CONSTRUCTIVE ROLE TO PLAY IN ARTS EDUCATION?

Where does this leave us with respect to standards in arts education? Does the analysis I have provided mean that having well-stated aims or objectives is useless? Am I saying that reflection on what one wants to accomplish as a teacher or curriculum developer is irrelevant to better practice? Am I advocating a policy for arts education that has no rudder? I hope I am not interpreted that way.

I believe standards can make a contribution to arts education if they do the following: if they represent in a meaningful and non-rigid way the values we embrace and the general goals we seek to attain, if they provide those who plan curricula with an opportunity to discuss and debate what is considered important to teach and learn, and if they suggest criteria that can be used to make judgments about our effectiveness. Standards should be viewed as aids, as heuristics for debate and for planning. They should not be regarded as contracts or prescriptions that override local judgments. My argument is an argument not for mindlessness but for a recognition of the virtues of diversity and of the need for curriculum planners and teachers to be sensitive to local circumstances and individual efforts.

The idea of using the process of formulating standards as a heuristic is, to me, especially appealing. It provides a focus for discussion, deliberation, debate, analysis, and ultimately clarification regarding the aims one wants to achieve in a classroom, a school, or even a school district. It provides a practical hub around which conversations can take place among teachers and others working in a school or school district. We need such opportunities in education; we need opportunities to assume responsibility for defining ends that matter in a particular locality. The opportunity to define standards also presents an opportunity to describe and examine

the conception of art education that is embraced by the discussants and more generally to deepen the dialogue. Put another way, it affords teachers an opportunity to function as professionals.

There are no permanent solutions to educational problems, because every solution once tried gives rise to other problems; relief is always temporary. Nevertheless, to try to do one's best in whatever circumstances one finds oneself will require attention to much more than standards, or national curricula, or national testing. It will require, at minimum, attention to the factors I have identified. Highly touted single-variable solutions are distractions from approaches that have promise for significant improvement. That improvement will require attention to the culture of schooling and the factors that shape it. There can be no widespread improvement of the arts in our schools as long as school districts and universities assign them marginal status. Thus, part of the effort at school improvement requires vision-building in the community and political as well as educational efforts to make those visions an educational reality.

In saying this I do not imply that gifted teachers cannot somehow overcome the impediments of local constraints. They can and they do. The visual arts teachers I have seen traveling from school to school, wheeling out their art carts to work with children in one classroom after another, in one school after another, some of which have no water, deserve, in my opinion, the Medal of Honor—or its educational equivalent. But exceptionality is not a good basis for framing policy. I'm talking about the conditions of effective educational reform.

I am also suggesting that a policy built upon a mechanistic model of control and payoff, that requires measured results, that demands high-level specification of intended outcomes may not be, in our day and age, the most promising paradigm for school improvement. Such a model is particularly incompatible with the spirit of the arts. Reforms in education harbor an implicit conception of human nature; so do governments. What needs to be scrutinized is the conception of human nature residing deep within the reform. Reforms in education that are born out of suspicion and distrust of professionals typically lead to policies and practices that

monitor, mandate, measure, and manage, policies that seek to pre-scribe and control, policies that do not distinguish between train-ing and education.

One of the most important services teachers and school ad-ministrators can perform is public education, by which I mean not only the education of the public in school—children and adoles-cents—but the education of the public outside of schools, parents and members of the community. This form of public education is crucial, for in the end the school will be permitted to do only as much as the community believes is appropriate. If the public mis-conceives the educational functions of the arts, if it believes they are a diversion from what is really important, arts educators will have a hard time securing the resources they need to provide re-ally substantive arts programs to students.

## WHAT THE PUBLIC NEEDS TO UNDERSTAND

How can such a form of public education go forward? One way is to help the community understand the forms of thinking reflected in students' work in the arts. For most, a clay sculpture made by a child is nothing more than a clay sculpture, but for an art teacher a clay sculpture must be much more than an opportunity for the child to play with clay. Designing a clay sculpture is an invitation for the child to use his or her mind in particular ways; it is an op-portunity to imagine and to act upon the images that imagination provides. It is an opportunity to become sensitive to the potential-ities of clay, to the ways in which it can be handled, and it is an op-portunity to learn how to see three-dimensional form and to make judgments about three-dimensional relationships.

The opportunity to work with clay for expressive purposes is also an opportunity for the teacher to display and interpret to par-ents and others the kind of growth that the changing qualities of the sculptural forms the child has created display. The evidence of such growth is displayed in what the child makes and is able to see and say about the work. In other words, the teacher can use the child's work not only to display something made by the child that is charming, but to reveal significant forms of cognitive development.

What contributes to such understanding is the design of what I have called the *educationally interpretive exhibition.*[27] Most exhibitions of children's art are modeled after a gallery display; the best works are usually displayed with nothing more than the child's name, grade, and school provided. What I have suggested is the creation of *educationally* interpretive exhibitions that explain to viewers the features of the work on display and describe the forms of thinking that the child had to engage in to create such work. This work can be limited to art forms, or it could also include the child's interpretation and appraisal of his or her own work. What does the child believe he or she learned from doing this work? The point is not to assume that the educational import of the work speaks for itself. The standards attained by the child are embedded in the work, but to recognize those achievements that work needs to be unpacked. The professional preparation of arts teachers should include opportunities to learn how to make such interpretations. It is in this process that laypeople and educators alike can learn most meaningfully about the educational functions of the arts.

What are the major perspectives that this chapter provides? First, standards, taken alone as a source of educational reform, are destined to be not only inadequate, but a distraction from the deeper problems of education that need to be addressed. These are problems in the arts as well as in other fields. Second, the term *standards* itself is not without ambiguities. Ambiguities can be a virtue if they open up new possibilities. They can also be confusing when there is no strong consensus regarding their meaning. Third, standards in a field that puts a premium on individuality have significant limitations. What the field needs are criteria rather than standards. If standards are conceived of as fixed models of outcomes, then their appropriateness in a domain in which ingenuity and imagination are important is questionable. Criteria, however, are ideas that prompt a teacher or evaluator to inquire into the work at hand in order to discern its educational and aesthetic value. Criteria invite inquiry; they do not close it off. Fourth, standards can be a major asset to teachers if the school provides them with the time and support needed to discuss with their colleagues the meaning of standards and the possibility of different

standards for different populations, different schools, indeed, different students. Teachers need to have time to deliberate and to share their achievements and their problems and to discuss the directions they wish to take in their teaching. If standards can provide a motivation for such processes, all to the good.

Fifth, there is an ineluctable tension between the level of specificity necessary to be able to apply standards to student work in an illuminating way and the number of standards one needs to achieve such levels of specificity. As standards become general, they provide direction but not destinations. As they become specific, they provide clarity of destination but become so numerous that they can impede the quality of teaching if teachers take them seriously. This problem has been historically important. It is no less important today. Its resolution is not an easy one.

I would urge teachers to use standards as an opportunity for discussion, as considerations for curriculum development, but not as prescriptions for processes or even for goals. What goals or aims are appropriate for students is not best defined by policymakers who are not in contact with the students schools are intended to serve. Localism in this context is far preferable. That is the route I would urge teachers to take. With it arts education, like the rest of education, can be a kind of Rainbow Coalition of teachers designing programs and indeed adopting programs when they suit the educational needs of the students they teach.

# 7 THE EDUCATIONAL USES OF ASSESSMENT AND EVALUATION IN THE ARTS

*NOT EVERYTHING THAT MATTERS CAN BE MEASURED,*
*AND NOT EVERYTHING THAT IS MEASURED MATTERS*

Although the terms are often used interchangeably, *assessment* generally refers to the appraisal of individual student performance, often but not necessarily on tests. *Evaluation* generally refers to the appraisal of the program—its content, the activities it uses to engage students, and the ways it develops thinking skills.

Both assessment and evaluation have been unwelcome concepts in arts education, for several reasons. First, the conduct of assessment is predicated on judgments about the quality of student work, and such judgments are often regarded as impediments to the liberation of creative potential. Second, both assessment and evaluation connote to some the measurement of performance. Measurement is regarded by many arts educators as incompatible with the arts: the arts put a premium on forms of experience that cannot be quantified. Third, assessment and evaluation are related to the outcomes or products of the student's efforts, and more than a few arts educators regard the process that students engage in to be what is important, not the product. Fourth, assessment is closely associated with testing, standardized testing at that, and standardized testing, many arts educators believe, has little or no place in a field whose desired outcomes are anything but standardized. Fi-

nally, assessment and evaluation are closely associated with grading, and grading in arts education, especially for young children, is frowned upon as worse than irrelevant; it is considered harmful. Arts educators have until quite recently escaped the narrowing influences of formal assessment and evaluation, and many would like to keep it that way, for all the reasons described above.

But when carefully examined, the views I have described cannot be sustained, in part because they misrepresent assessment and evaluation, and in part because to abandon assessment and evaluation in education, regardless of the field, is to relinquish professional responsibility for one's work. Without some form of assessment and evaluation, the teacher cannot know what the consequences of teaching have been. Not to know, or at least not to try to know, is professionally irresponsible. And to claim that such consequences cannot, in principle, be known is to ask people to support educational programs on faith.

Now it must be admitted that all assessment and evaluation is always partial; we will never have all the data needed to know all of what a student has learned. But that does not mean we should not try to find out what we can about how our students—and we—are doing. Assessment and evaluation are about that attempt. They are about getting information that can help us get better at what we do.

## THE USES OF ASSESSMENT AND EVALUATION

This chapter explores the uses to which assessment and evaluation can be put in arts education. But before we embark on that journey, it is well to try to clear up some misconceptions about assessment and evaluation. Many of these are embedded in the fears described above. Consider the concern about making judgments about student work. Is it humanly possible to teach anything and not to make judgments about what students have learned?

Judgments are made each time a teacher determines if a student understands an idea. Judgments are made when a teacher decides if a student is engaged in her or his work. Judgments are

made when a teacher chooses what to emphasize in his or her comments to a student. Judgments are made when a teacher determines the progress a student has made over time. In short, assessment and evaluation are not only a critical part of teaching; they are a basic part of human behavior. We would be lost without them.

Judgments *can* impede student performance and *can* thwart student learning if they are conveyed to students in insensitive ways; their effects depend very much on the way they are communicated as well as on their content. There is a difference between the way a judgment is conveyed and the making of a judgment. Obviously, one can make a judgment about a student's work and not convey that judgment. But since the point of teaching is to advance learning, the absence of guidance, which depends upon evaluative forms of judgment, is no asset. Presumably the teacher is in a position by virtue of greater expertise to assist the student. Assessment and evaluation can help that agenda along.

Assessment and evaluation are often confounded with measurement, but there is no necessary connection between evaluating and measuring or between assessing and measuring. Measuring has to do with determining magnitude. Measures of magnitude are descriptions of quantity. They are not appraisals of the value of what has been measured. Assessment and evaluation are preeminently valuative; they ask about the merits of something. In fact we evaluate all the time without measuring. You, the reader, are evaluating the ideas you read without measuring a thing. We evaluate without measuring, and we measure without evaluating. If I say a painting is three feet by four feet, I have provided a measurement. If I say the painting is a fine example of someone's work, I am evaluating but not measuring. Thus, to assume that assessment and evaluation require measurement is to make the wrong assumption.

The assumption that assessment and evaluation must focus on the results of a process and not on the process itself is also mistaken. Of course evaluation and assessment can focus on outcomes, but they need not. I can evaluate the ways in which the student is engaged in his or her work. I can evaluate the student's

willingness to take risks. I can evaluate the manner in which a student goes about his or her work, the ways in which problems are solved, his or her willingness to ask questions or to speculate about possibilities. There is a host of qualities displayed in the processes the student employs that can say much to teachers about how the student works. All of these can be assessed. Both process and products can be assessed and evaluated. Assessment need not focus on products alone.

Now it should be said that the distinction between process and product is in some ways artificial. If we view the student's work from a long-term perspective, it becomes clear that what we now regard as the products of that work are really a part of a larger process. They are markers along a journey; the end is also the beginning. The point here is that what counts as process and what counts as product depends on how we look at it.

Another faulty assumption is that assessment and evaluation require the use of tests. They don't. Tests are devices that are used to evoke responses that can be evaluated. Tests often create artificial situations that look like no other situations in life and are used to determine if a student can perform in a particular way. Neither assessment nor evaluation requires the use of tests as a means for securing information for evaluative purposes. For example, an art teacher can evaluate student work by looking at a student's portfolio or observing the student at work; a test is not necessary. Evaluating people through the use of tests is rare. The vast majority of our evaluations are done daily in everyday situations.

The final misconception I want to address is the belief that assessment and evaluation result in grading. Again, they might, but they need not. Grading is a data-reduction process used to symbolize the merits of student work. Grades are supposed to represent the pooled judgments we make about that work. Aside from the impossibility of disaggregating the data that were pooled to assign the grade, judgments made about someone's work need not eventuate in a grade. They can eventuate in a report or in a conversation with the student about his or her work. The giving of a grade is not a necessary consequence of assessment and evaluation.

## THE FUNCTIONS OF BROAD-BASED TESTING
## AND CLINICAL ASSESSMENT

What functions do assessment and evaluation perform in the arts? Two general functions are central. One pertains to the evaluation of populations, the other to the assessment of individuals. Perhaps the clearest example of broad-based evaluation in the arts can be found in the National Assessment of Educational Progress.[1] Initiated in 1969, NAEP was designed to provide an index of the educational health of the nation by testing students at three age levels—eight, twelve, and seventeen—from five sections of the country—Northeast, Southeast, North Central, Northwest, and Southwest—in a number of academic fields, including visual art, music, and theater. What is distinctive about NAEP is that no student answers all the items on any section of the test. By means of what is called multiple matrix sampling, the responses to the items by large groups of students at each age and in each geographic section of the country are pooled. NAEP does not provide scores for individuals, only the scores of the groups representing age and location.

The aim of broad-based evaluation is to describe the performance of populations, not of individuals. Populations are described in broad strokes as a kind of educational "temperature taking." Although such information is not particularly useful to teachers for making decisions about individual students or about their particular classroom, the public uses such information to make judgments about the quality of its schools. When it comes to standardized testing, individual scores are provided for each student and are also often aggregated for grade, school, school district, and state. Why does the public display a keen interest in test scores? One answer is that there is precious little else provided with which the public can assess the quality of its schools. In addition, it realizes that those standardized-test scores will be used by colleges and universities to make life-defining decisions about children's futures. Unlike reading, writing, and mathematics, until recently the arts have been relatively free from the impact of such tests.

Clinical assessment has to do with the performance of individual students. Unlike broad-based evaluation, the aim of assessment

is not primarily to classify or to promote or to fail students, but to secure information that can be used to enhance their educational development.[2] One might assess to determine if students have attained course objectives or standards for that subject. One might assess to determine where a student is in his or her development in the arts. One might assess to secure diagnostic information: What are the student's strengths and weaknesses? Put another way, given where a student is, what course of action seems most appropriate as a next step?

The entry points for the teacher with respect to evaluating where the student is are numerous. The art teacher has many options in assessing the student's work, but among these options are aspects of the student's development that may have little directly to do with the arts. The student might need to build her or his confidence, or have more opportunities to assume responsibility, or be willing to try new things. In making an assessment the teacher may very well give these options priority, for in the long haul, in terms of the overall aims of education, these aims might take precedence.

## FEATURES TO LOOK FOR IN STUDENT WORK

What can we look for when assessing student artwork? Three features commend themselves: *the technical quality of the work produced, the extent to which it displays an inventive use of an idea or process, and the expressive power or aesthetic quality it displays.* By technical quality I mean the extent to which the material with which the students work has been handled with control and understanding. It also includes the extent to which the forms that are used display an intelligent use of technique. Put another way, do the techniques employed support what the work is intended to express; is there a consonance between the two?

By inventiveness I refer to the productive novelty the work displays: Does the work say something new or say something quite familiar in a new way? Put another way, does the work reflect a creative use of idea or process that relates constructively to its expressive intent? Is the work imaginative?

Finally, we are concerned with a work's expressive power, its

aesthetic impact. The ability to create work that is satisfying aesthetically is and has been a prime artistic value. The achievement of such qualities is largely related to the ways in which forms have been composed and technique handled. In assessing the quality of student work these three features can serve as criteria for assessment. Criteria are features that one can look for in a work; they are not fixed descriptions that obey some formulaic recipe. Technique, inventiveness, and expressive power can be realized in an infinite number of ways. Their identification here can serve as criteria to guide our search, not as prespecified features that obey a fixed set of rules.

## WHAT CAN BE ASSESSED AND EVALUATED?

What is it that can be assessed and evaluated? There are three dimensions that are fundamental: the content and form of the curriculum, the quality of the teaching, and what students learn.

The curriculum that is provided in a school or classroom can be regarded as having two dimensions. One of these pertains to the content used to create the curriculum. Is it substantive? How important is it in the domain in which students are to work? Is it relevant to their development and interests? Questions such as these traverse the path between substance defined within the domain from which the content was selected and the relationship between such considerations and the anticipated relevance or meaningfulness of the material to the students who will encounter it. On the one hand, there is no virtue in creating a curriculum that is relevant to the interests of the students but has little substantive value. On the other hand, there is no virtue in designing a curriculum that is strong on substance but of little relevance or meaning to students. What one wants is both substance and relevance.

But considerations of content are only one aspect of what ought to be considered in curriculum design. Another pertains to the design of the activities in which students are to engage in order to learn what is being taught. The design of these activities has everything to do with the form of thinking that will be promoted by the activity. For example, say a teacher of art wants to help stu-

dents notice differences in the early and late work of a contemporary artist. A teacher can show examples of these works and then describe the differences between them. I do not recommend this process or practice; I use it only as an example of what would *not* be good to do. The teacher might, instead, ask the students to comment on the differences they see and to point them out to the class. The latter approach, though simple to arrange, requires students to take a much more active role. It is the students who must find the right words, and in this search something important is likely to be learned.

I use this very simple example to make a point. The point is that curriculum design entails far more than selecting content, even substantive content; it entails creating an organization of activities that will influence what students learn. Furthermore, these activities should be ones that promote the development of complex and subtle cognitive processes. What kind of thinking do students need to use in order to engage in the activities? Thus, when we talk about evaluation, the curriculum becomes a prime subject matter, because if the curriculum is saturated with trivial content or if the activities designed make little demand on students' thinking, there may be little reason to worry about how well it is being taught.

Curriculum materials in most circumstances require mediation.[3] The primary *initial* mediator is the teacher, and the primary means the process of teaching. In most school situations the curriculum is outlined or embodied in an array of materials. Curriculum frameworks constitute some of those materials, textbooks others, curriculum guides others. The function of these materials is to influence teaching and learning. At times the materials consist of text materials, at other times of educational games, at still other times of visual resources the students can use. But regardless of how elaborate these materials may be, the teacher serves as a prime mediator regarding the way they will be used and under what circumstances. Teaching can enhance the materials or it can undermine their use; hence assessing the quality of the teaching is a way to find out about the conditions that operate in the classroom. If weak outcomes are a function of a weak curriculum, remedies might be found in one direction. If they are a function of

poor teaching, they are to be found in another. Evaluation and assessment need to look at both.

Another major subject matter of assessment is what students have learned. A focus on what students have learned is wider than determining the extent to which students learned what the teacher intended them to learn or determining if they learned what course objectives or standards described. I have posed the assessment and evaluation task as one that seeks to appraise the *outcomes* of teaching and curriculum. Many of those outcomes are likely to be related to objectives and standards, but not all will be, and perhaps not the most important ones. Attention to outcomes asks what the students got out of their work in a classroom. To secure such information the assessment procedures need to be sufficiently open-ended and flexible to allow students to reveal what they have learned. Thus, interviews with students about their experience in an art class and opportunities for them to talk about their own work in relation to what they learned from doing it are altogether appropriate. In fact such opportunities are likely to reveal outcomes of which the teacher is unaware.

What is also relevant for appraising what students have learned is, of course, an awareness of the qualities of the students' work. What a student creates in a class and the ways in which her or his work has changed over time are data sources for determining what a student has learned because what a student creates, whether verbal or visual, is the result of the kind of thinking the student is able to do. The work, in whatever form the student elects to use, is a proxy for the student's thinking *in that context*.

What do such considerations imply for assessment in art education? They suggest that the modes of thinking that students display in the course of their schooling—and outside it, if those can be accessed—are perhaps the best indicators of what students have learned, for assessment samples their thinking in a number of contexts, not simply on a high-stakes test. A test, if it is taken seriously by students, can tell a teacher what students can do, but not necessarily what they will do. Many students who know how to read never read either a newspaper or a novel. Knowing what a student will do or what he or she customarily does is a much more reliable

indicator of how that student is likely to behave. The context that really matters educationally is the life context outside school, for the educational aim of schooling is not merely to help students do well in school, but to help them lead personally satisfying and socially constructive lives outside it. The "same" behavior in different contexts may have entirely different meanings. Taking contexts into account and being able to notice and to judge significant subtleties is not a liability in assessment, but a strength. One must, of course, provide support for one's judgment, but judgment there must be. The exercise of judgment is found in the work of connoisseurs and critics. We turn now to their work to determine its implications for ours.

## EDUCATIONAL CONNOISSEURSHIP AND EDUCATIONAL CRITICISM

Connoisseurship is the art of appreciation. Connoisseurs notice in the field of their expertise what others may miss seeing. They have cultivated their ability to know what they are looking at. *Educational connoisseurship* addresses itself to classroom phenomena; just as individuals need to learn how to "read" a football game, so too do people need to learn how to read a classroom or student work.[4]

Connoisseurship, the art of appreciation, is a process that can be carried on in solitude. One need not utter a word about what one has experienced, and yet have deep and complex experience with some thing or process. The task of making public what someone as a connoisseur has experienced requires an act of criticism. In education I call this process *educational criticism.*[5] The aim of criticism, as Dewey put it, "is the re-education of perception of the work of art."[6] In our schools educational criticism is aimed at the reeducation of perception of the work of education. This work includes any aspect of education, both its processes and its outcomes. Put another way, an educational critic talks or writes about a student's or a teacher's work, the features of a curriculum, or the life of a classroom in ways that help others see what they otherwise might not have noticed and, if not noticed, not understood.

Educational criticism has four related dimensions or features. First, the critic usually describes what he or she has seen—a stu-

dent's work, or how the student works, or the kind of questions the student asks. These distinctive qualities would be described vividly so that someone listening to or reading what the critic had written would be able to see or imagine those qualities for her- or himself.

A second feature of educational criticism is that it is interpretive. By "interpretive" I mean that the critic tries to account for what he or she has given an account of. One does this by showing the connection between what one has described and the conditions that appear related to it. Recall my interpretation of Mr. Harsh's teaching and why the red ink in the small cup of water seems to be so effective in evoking imaginative student responses. I related the responsiveness of the students to the ambiguity of the free-floating red ink, likening it to a Rorschach inkblot, a stimulus sufficiently amorphous that it is used by psychologists to evoke projective responses from individuals. The aim in this phase of educational criticism is to explain. When pertinent, theory in the social sciences can be used to provide an interpretive framework to account for what has been described.

The third feature of educational criticism is evaluative. Although description and interpretation will reveal what something is like and why, they are not used directly to assess educational value. The evaluative aspect of educational criticism requires judgments about merit. In this situation the criteria for merit are educational. Evaluation addresses questions such as the following: Of what quality is the student's work, and does it display aspects of growth when compared with its earlier phases? What do the student's comments reveal about what she or he has learned, and what do they signify about the student's development? How imaginative are the activities that constitute the curriculum? Are students meaningfully engaged in these activities? These questions are but a few that can focus the evaluative aspect of educational criticism. Because the process of education is normative—that is, the educational process seeks to achieve certain values—determining the extent to which those values are being realized is a primary feature of any educational evaluation.

A fourth feature of educational criticism is located in the general observations and conclusions derived from what has been ob-

served, described, interpreted, and evaluated. This feature is known as thematics. Thematics extracts from the detail of particulars the large ideas that might guide the perception of other situations like it. For example, the concept of treaties between students and the teacher was created by Arthur Powell and his colleagues after seeing how high school teachers and their students mutually agreed not to cause each other too much trouble.[7] In this context a treaty represents a kind of collusion that enables students and teachers to lead their lives together with a minimum of friction. The concept of a treaty can be used to search for similar conditions in other classrooms. The point here is that the evaluation of particulars can yield information of a general kind that can alert teachers and others to important but unnoticed aspects of classroom life that might be found in other settings.

I have been describing the features of educational criticism as if each of them were independent. The fact of the matter is that they interact. Even more, there are aspects of evaluation in description, in interpretation, and in thematics.

We use educational connoisseurship to see the rich and multi-layered events unfolding in the classroom. We are interested in rendering what we see in a way that does not reduce those phenomena so radically that they no longer represent the situation we are trying to describe, interpret, evaluate, and thematize. Educational criticism is intended to avoid the radical reductionism that characterizes much quantitative description. It is designed to provide a fine-grained picture of what has occurred or has been accomplished so that practice or policy can be improved and high-quality achievement acknowledged.

## A SUMMARY OF MAJOR POINTS

Let me summarize three major points addressed so far. First, assessment and evaluation should not be confused with measurement, testing, or grading. One can measure without evaluating, evaluate without testing, and assess without grading. Further, evaluation need not focus only on the product of a student's work; it can focus on the process as well.

Second, although it is not a hard-and-fast rule, in general assessment focuses on individual performance, and evaluation addresses the performance of populations and/or the features of the program.

Third, the major dimensions of assessment and evaluation are the content and activities selected and designed for the curriculum, the quality of teaching, and student outcomes. One way to think about the assessment of students as they interact with teaching and curriculum is through the processes of educational connoisseurship and educational criticism. These processes emphasize the description of the situation observed, an interpretation of the events described, an appraisal of their educational merit, and the distillation of the major ideas or themes from the material described, interpreted, and evaluated.

An important aim of educational criticism is to provide a fine-grained picture of what is transpiring in the classroom and in the student's experience as a result. It is an understanding of the student's experience that provides the most promising information for improving teaching and learning.

Thus far I have sketched some of the major considerations in developing an informed approach to evaluation and assessment in the arts. What I hope has become clear is that assessment and evaluation address a variety of phenomena—curriculum, teaching, and learning—and that these phenomena interact, making assessment and evaluation in the arts, as it is in other fields, a complex enterprise. What I hope is also clear is that not only are the subject matters of evaluation and assessment multiple, but so are its purposes. For some purposes a broad, general picture of a population is what is wanted. For other purposes what is wanted is specific information about the experience and performance of individual students. Given different purposes, one will use different approaches.

## PRIORITIES IN EVALUATION

All things being equal, my own priorities lean toward the clinical uses of assessment, because my priorities are to enhance the educational process rather than to rank-order populations. I believe

that educational processes are more likely to be advanced if information is secured with particular reference to the individual and the context in which he or she functions. One of the problems associated with broad-based evaluation is that the results are typically provided to the public with little or no contextual information it can use to interpret the scores. Without such information, prospects for misinterpretation are significant. In addition, the public often uses test scores as proxies for the educational quality of a school. If you want to know something about the quality of a school, you need to know something about the quality of educational life in that school. Here is where educational criticism comes in. Achievement tests, in this area, provide very limited information, even in the domain tested. Tests shed no light on what went wrong or right in classrooms. As one teacher in Nebraska once told me after I had given a lecture on evaluation, "I'm from Nebraska, and one thing that we've learned here: You can't fatten cattle by putting 'em on a scale." The woman was right—you have to pay attention to their diet. At the core of the student's diet is the quality of the curriculum and teaching.

There is a tension between complex and "simple" forms of assessment, or between clinical assessment and broad-based evaluation. That tension pertains to the covert function of evaluation. That covert function has something to do with competition and the rewards associated with performance. Broad-based evaluation, particularly standardized testing, is used not merely to find how well a school or population is doing, but to pick winners from losers.

This function is made explicit in the league tables that are published in local newspapers that display the rank-order positions of schools, grades, and sometimes classrooms in relation to student test scores. To make such comparisons meaningful, the content and tasks that students respond to need to be the same. If content and tasks differ, meaningful comparisons are extremely difficult, even impossible. As a result, the use of assessment procedures that provide a complex, detailed picture of the performance of individual students, while more revealing of those students, is more difficult to use for comparative purposes than simple achievement testing.

In a nation that appears to need losers as well as winners, the use of standardized testing is understandable. Clinical assessment is labor intensive and, for purposes of comparison, even counter-productive. One of the reasons arts education has not been subject to the use of standardized testing is that student performance in the arts has not been considered important enough to warrant the expenditure of time and money needed to secure such data, given the kind of performance the American public believes important for schools to promote. Thus the tension. If the American public begins to take the arts seriously as a part of the core of general education, the arts might be subject to standardized testing and, associated with it, a standardized curriculum. Debate on the ramifications of educational policy on this issue is of vital importance. We need to assess and evaluate, but we do not need standardized tests to do so. Until educators interested in assessment practices can design viable and compelling alternatives to the forms of assessment represented by standardized tests, the likelihood of replacing such tests is dim indeed. The American public needs what it does not have: a credible alternative to standardized testing. It needs also a fresh and more robust conception of what matters in education.

I have been discussing evaluation and assessment of student performance largely in terms of the manifest behavior of the student, but it is well to remember that it is possible for a student to work on a project that he or she decides to discard and that, from the perspective of the product alone, looks like a failure. Yet that project may be an educational success story. What needs attention in assessment and evaluation is not only manifest behavior, but also the kind of thinking that went into the project.

I once taught art to fifth-graders. One of my students wanted to make a crayon that would produce a veritable rainbow of colors. I asked him how he might go about making such a crayon. He said he thought he could make a plaster mold and then melt crayons of different colors into the mold. I asked him how he planned to make the mold, and he said he could use a cap from a jar, mix some plaster, put a crayon in the plaster, and when the plaster dried, he would have a mold. He could then melt crayons

into the mold and then break the mold, leaving him with the multicolored crayon he wanted.

I encouraged him to give it a try. In the end the experiment failed; he couldn't remove the crayon from the plaster. But the experience of thinking a project through and trying it out was an educational success. What the teacher needs to focus on is how students needed to think in order to get the results they did and what they learned as a result. In assessment and evaluation we need to penetrate the surface features of activity to get at what lies beneath it. As long as the visual arts are regarded as occasions for students to make things for the refrigerator door, they will be marginal in our schools, and if they are taught as if they were simply occasions for making things for the refrigerator door, they should be marginal.

## STUDENT-CONDUCTED ASSESSMENT AND EVALUATION

Thus far I have been talking about assessment and evaluation as if the process were entirely in the hands of the teacher. It need not be, and some would say it should not be. Two other sources of evaluative judgment are the student's peers and the student herself. The use of peers to serve as constructive critics of a student's work is common in art schools and in college and university studio-art departments. The practice of students discussing another student's work in the context of a class is called a "crit." It is a practice well described by Lissa Soep in her study of the language that students use when engaged in a crit.[8] According to Soep, crits differ in significant ways from standard art criticism and from the comments that art teachers typically make to their students. One difference is that because peers are engaged in the practice a reciprocity exists that simply is not there when teachers and critics appraise works of visual art. The reciprocal relations that students recognize creates a sensitivity to the process that is reflected in the kind of language they use when speaking to one another about their work. Students know it will soon be their turn to be on the receiving end.

Another difference between a crit and art criticism is that a crit is intended to help the student improve his or her work. This is not

the case in typical acts of art criticism. Art criticism as it is provided in newspapers or in magazines is more of a summative evaluation than a formative one.

The opportunity to participate in a crit and to learn how to be helpful to those engaged in the making of art is good not only for the student whose work is critiqued, but also for the student who critiques the work. Having to help someone requires one to look carefully, to assess carefully, and to use words carefully. The greater the need to comment, the greater the need to search the work in order to have something to say. Sight breeds language, and language breeds sight. There is no reason why the crit could not be a regular part of the instructional practice in the art room, not only for students in college and university but, when well prepared for it, for students in grade school as well.

The student is also a prime resource in the evaluative process. Teachers can learn a great deal about what students have learned by listening them talk about their work. What do they pay attention to? What do they believe was successful? Do they support their judgments? If so, how?

The opportunity to stop and assess, to comment and to justify, to appraise and to plan for further work can be a powerful source of learning in the art room. In the other arts similar opportunities can be made available. In music, performances can be tape recorded, replayed, and assessed by the student. Group crits in music can also be provided. The source of evaluative content need not be owned by the teacher. When students are in on the process, the opportunity to evaluate becomes a medium for advancing their own education.

Being able to act on the practices I have described means exchanging one mental model of what evaluation entails for another one, one that makes it a shared enterprise. Will teachers be willing to share one of their most powerful sources of authority? I hope so, but for some it may be next to impossible. A shift in one's mental model of evaluation is also a shift in what it means to teach. The change in view from a teacher-controlled approach to evaluation to a role that is shared but not relinquished by the teacher is a fundamental change in one's view of the teacher's role. It also requires

a shift in the student's mental model of his or her role. Because the school, by virtue of its mode of organization and way of life, promotes a conception of the roles students and teachers are to take, the idea that students have a role to play in evaluation might come as a surprise to many students—and they might not be comfortable with it. My view is that the assumption of a part of the responsibility for evaluation is precisely what students need to learn, because when they are out of school there will be no teacher around to do it for them. Becoming mature means becoming self-reliant.

# 8 WHAT EDUCATION CAN LEARN FROM THE ARTS

*PROMOTING A LOVE AFFAIR BETWEEN THE STUDENT AND HIS OR HER WORK IS ONE OF OUR SCHOOLS' MOST IMPORTANT AIMS*

To suggest that education has something to be learned from the arts is to turn topsy-turvy the more typical view that the arts are basically sources of relief, ornamental activities intended to play second fiddle to the core educational subjects. Yet those interested in enhancing the processes of education, both in and out of schools, have much to learn from the arts. Put simply, the arts can serve as a model for teaching the subjects we usually think of as academic.

This chapter describes what art's lessons might be for education in general and indicates why they are important lessons for those who teach and shape educational policy.

One lesson the arts teach is that there can be more than one answer to a question and more than one solution to a problem; variability of outcome is okay. So much of current schooling is predicated on the assumption that success in teaching means getting a class to converge on the single correct answer that exists in the curriculum guide, or in the textbook, or in the teacher's head. The aim of teaching is to get everyone to the same destination and, in our culture, at about the same point in time.

For some of what we teach, but certainly not everything, single correct answers to an array of questions may be a legitimate way to think about some aspects of student performance in a field.

For example, most teachers are not particularly interested in what might be referred to as "creative spelling." We want students, and we should want students, to put letters in the right order in the words that they spell, and if a class is given the same set of words to spell, success in teaching spelling means that all children will spell words in exactly the same way. Children need to learn cultural conventions. Spelling is one of them.

Spelling is not alone in this desideratum. Arithmetic is also taught in this manner, though it need not be. Typically, students are taught how to prove the correctness of their arithmetic solutions: if they add, they can subtract to prove their answer; if they subtract, they can add. If they divide, they can multiply; and if they multiply, they can divide. Children in the process are learning the lessons of certainty.

In contrast, the arts teach children that their personal signature is important and that answers to questions and solutions to problems need not be identical. There is, in the arts, more than one interpretation to a musical score, more than one way to describe a painting or a sculpture, more than one appropriate form for a dance performance, more than one meaning for a poetic rendering of a person or a situation. In the arts diversity and variability are made central. This is one lesson that education can learn from the arts.

Another lesson that education can learn from the arts is that the way something is formed matters. We tend in our culture to *processes* differentiate between content and form. *What* is said, for example, is believed to constitute content. *How* it is said is believed to constitute form. It's all very tidy.

However, what is said cannot be neatly separated from how something is said. Form and content interpenetrate. The way in which something is spoken shapes its meaning; form becomes content. Actors have learned this lesson well. So, too, have poets, painters, and musicians. How a historical episode is described creates a spin that influences readers' views of the episode being rendered. The interpenetration of content and form is a fundamental insight that the arts reveal. That revelation is not limited to the arts; it can be manifest in any activity humans undertake.

What would attention to the relationship of form and content mean in the teaching of mathematics? How would it play out in the social studies? What would it mean in any of the sciences? Addressing such issues, when one digs deep enough, brings us into epistemological considerations. Attention to such matters would help students understand the sources of our experience, how the ways in which a form is crafted affects our experience and, therefore, how we relate to what we pay attention to.

In the arts and humanities, the implications of the content-form relationship are rather transparent. The "shape" of a poem matters. So, too, does the form-content relationship matter in all the other arts. But what does the form-content relationship mean in fields not usually regarded as belonging to the arts or the humanities? This question is not an easy one to answer, but it is one that ought to be on the intellectual agenda of those who design curricula and teach students. In fact, it may very well be that the impact of form-content relationships on the student's experience influences his or her inclination to pursue the ideas represented in a particular field of study.

Another lesson that the arts can teach education is the importance of imagination and, as intimated earlier, of refining and using the sensibilities. In the arts, imagination is given license to fly. In many—perhaps most—academic fields, reality, so to speak, imposes its factual face. Little time and attention are given to matters of imagination. Yet inventive scholarship depends upon imagination, not to mention the delights that imaginative processes make possible. In schools we tend to emphasize facticity, correctness, linearity, concreteness. We tend to underestimate and underplay those imaginative processes that are so characteristic of the cognitive life of preschool and even primary-school children. We often fail to nurture a human capacity that is absolutely central to our cultural development.

One example of the function of imagination in science is revealed in the work of Nobel laureate Barbara McClintock. To get a sense for the organism, as she called it, McClintock employed her imaginative processes to participate empathically in the interior of a living cell. Her biographer, Evelyn Fox Keller, writes:

A hundred years ago, Ralph Waldo Emerson wrote: "I have become a transparent eyeball; I am nothing, I see all." McClintock says it more simply: "I am not there!" The self conscious "I" simply disappears. Throughout history, artists and poets, lovers and mystics, have known and written about the "knowing" that comes from the loss of self—from the state of subjective fusion with the object of knowledge. Scientists have known it, too. Einstein once wrote: "The state of feeling which makes one capable of such achievements is akin to that of the religious worshipper or of one who is in love. Scientists often pride themselves on their capacities to distance subject from object, but much of their richest lore comes from a joining of one to the other, from a turning of object into subject."[1]

Evelyn Fox Keller helps us understand that empathy, a process that depends upon the imagination, also helps us to understand the world through science.

Recognizing that the development of the imagination and the refinement of the sensibilities can be thought about aesthetically is no small matter. John Dewey once commented that the stamp of the aesthetic needed to be on any intellectual idea in order for that idea to be complete. It is this feel, both imaginative and sensible, that the so-called academic studies would foster if they were modeled after the arts. John Dewey had something to say about the relationship of the intellectual to the aesthetic. It is this: "What is even more important is that not only is this quality a significant motive in undertaking intellectual inquiry and keeping it honest, but that no intellectual activity is an integral event (is *an* experience), unless it is rounded out with this quality. Without it thinking is inconclusive. In short, esthetic cannot be sharply marked off from the intellectual experience since the latter must bear an aesthetic stamp to be itself complete."[2]

Inviting students to use their imagination means inviting them to see things other than the way they are. And, of course, this is what scientists and artists do; they perceive what is, but imagine what might be, and then use their knowledge, their technical skills, and their sensibilities to pursue what they have imagined.

Regarding the refinement of sensibility, the use of approaches employed in the visual arts, in music, and in literature might be an effective way to refine the sensibilities in the context of so-called

nonarts academic subjects. One approach is comparative analysis. How do ideas differ in their feel, even when they address the same subject matter? What differences exist in essays written by two historians describing the same situation, but whose use of language is dramatically different? And what does each convey? Consider the following description of the start of World War I.

> So gorgeous was the spectacle on the May morning of 1910 when nine kings rode in the funeral of Edward the VII of England that the crowd, waiting in hushed and blackclad awe, could not keep back gasps of admiration. In scarlet and blue and green and purple, three by three the sovereigns rode through the palace gates, with plumed helmets, gold braid, crimson sashes, jeweled orders flashing in the sun. After them came five heirs apparent, forty more imperial or royal highnesses, seven queens— four dowager and three regnant—and a scattering of special ambassadors from uncrowned countries. Together they represented seventy nations in the greatest assemblage of royalty and rank ever gathered in one place and, of its kind, the last. The muffled tongue of Big Ben tolled nine by the clock as the cortege left the palace, but on history's clock it was sunset, and the sun of the old world was setting in a dying blaze of splendor never to be seen again.[3]

Now consider the following account:

> War erupted in Europe in August 1914, to the surprise and horror of most Americans. There were many causes, including decades of imperialistic rivalries over trade and colonies. By the first decade of the twentieth century, the great powers of Europe had joined two rival coalitions, each armed to the teeth. The Triple Alliance joined together Germany, Austria-Hungary, and Italy. The Triple Entente combined Britain, France, and Russia. All members had economic and territorial ambitions that involved them in the affairs of unstable countries and provinces on the Balkan Peninsula. A series of crises in the Balkans caught powers of Europe in a chain of events that propelled them to war. Within the Balkans, Slavic nationalists sought to build a major power by prying territories from the Austro-Hungarian Empire and adding them to Serbia. One of these territories was Bosnia, which contained a large Serbian population. On June 28, 1914, at Sarajevo, in Bosnia, the heir to the Austrian throne, Archduke Franz Ferdinand, was assassinated by a Serbian terrorist, Gavrilo Princips.[4]

What images do these two excerpts generate? How do they do this? What kind of feeling and understanding do they promote? What role do the forms of the language they use perform?

What would happen if the criteria through which curriculum materials to be selected for state adoption required that weight be given to the development of the imagination in the domain those materials addressed? What if the literary quality of the writing was considered important? What about the visuals? The point here is that the arts can open up new considerations for the aims and the form of what we teach. They can give direction to the practice of teaching so that the qualities that the arts celebrate can be realized.

Another lesson that education might learn from the arts is that God lives in relationships. The capacity of an art form to touch us depends on the relationships that are composed by artists. How forms relate to one another is critical, so much so that artists will spend years refining the relationships in their work. Is this section of a painting too bold, are the colors too bright, is this section too subtle, does this edge need to be sharpened or softened, is there sufficient movement in the image or is it too static? Questions of these kinds require an individual to learn how to attend to relationships, to escape the narrowing influence of focal perception in order to see how an array of forms congregate as a whole.

One of the interesting and important features of such judgment is that it cannot be reduced to rule or recipe or formula or algorithm. There is no chart that one can consult, no prescription that one can follow. Judgment depends on feel, and feel depends on a kind of somatic knowledge that enables one to determine if the form at hand has what Nelson Goodman once called "rightness of fit."[5] The body is engaged, the source of information is visceral, the sensibilities are employed to secure experience that makes it possible to render a judgment and to act upon it. What would such considerations mean in writing up a scientific experiment, in organizing a project for a civics class, in creating a short story or writing an essay? I believe that such a consideration is fundamental to good work on any of these tasks. And for good work to be achieved, attention to relationships among the "parts" of the material produced must be addressed experientially, for it is from such

experience that one can make judgments about what needs modification. The arts invite attention to such relationships. Those working in academic subjects would be advised to attend to those relationships as well.

I have been speaking of relationships largely in terms of the work that students produce and the forms of attention that might be encouraged. But relationships need to be addressed not only in the work that students create, but in the planning and forms of teaching that teachers practice. How one designs a lesson or a curriculum unit matters, and the design of such plans and activities depends every bit as much on attention to relationships among their components. In the course of teaching matters of pacing, timing, tone, direction, the need for exemplification are components whose relationships need to be taken into account. The ability to do so constitutes a part of the artistry inherent in excellent teaching.

Making judgments about matters of pace and timing is not simply a consequence of calculation prescribed by formulaic equations. Judgments, too, require a sensitivity to "rightness of fit," a feeling that the time is right for something to be addressed. Teachers who engage in the artistry of teaching recognize this sense of rightness and, when guided by it, secure some of teaching's most satisfying intrinsic rewards.

Another lesson the arts can teach education is that intrinsic satisfactions matter. Increasingly in American schools, there is a tendency to instrumentalize educational activities and to emphasize the importance of extrinsic rewards. Often students are habituated to reinforcement practices that take the intellectual heart out of learning. As grades become important and as test scores define achievement, as artificial incentives are employed to motivate students, the need for activities and situations that generate intrinsic motivations for achievement looms larger and larger.[6] Engagement in the arts when you see it happen seems to place the individual in another world. Aesthetic satisfactions, when they develop, enable a person to lose a sense of distance and time; one seems to occupy a spaceless and timeless universe that in retrospect yields high degrees of satisfaction. People who, on their own, pursue painting, singing, dance, or the writing of poetry do it for

the quality of life that such activities make possible more than for the financial rewards they secure from the products that they create.

The importance of intrinsic satisfaction was recognized by Alfred North Whitehead when he observed that while most people believe that scientists inquire in order to know, the truth is that scientists know in order to inquire. Whitehead's point is that the joy, for scientists, is in the journey rather than in a focus solely on the destination. It is the process, the immersion in the activity itself and the quality of life that it makes possible, that should command more of our attention. The arts remind us of what life can be at its most vital.

One way to think about matters of satisfaction is to recognize that there are basically three reasons for doing something. The first I have already alluded to: one does something because of the quality of experience that it makes possible; sex and play are two basic examples. A second reason for doing something is not because one necessarily enjoys or values the process, but because one values the outcome. One might not enjoy cleaning one's kitchen, but one might enjoy a clean kitchen. A third reason for doing something is not because one enjoys the process nor does one necessarily enjoy the outcome; what one values are the rewards that the process and outcome make possible. Someone may work at a job in which neither the process nor the outcome is particularly satisfying; what is valued is the paycheck. The analogue in school is the grade. Hannah Arendt regarded such activity as being a form of labor as contrasted with a form of work.[7] From her perspective—and from mine—we have much too much labor in our schools and not enough work.

There is another very important reason for paying attention to the development of intrinsic satisfactions. Intrinsic satisfaction in the process of some activity is the only reasonable predictor that the activity will be pursued by the individual voluntarily, that is, when the individual is able to make a choice about an activity. It's no great victory to learn to do something that one will choose not to do when given the choice. There is a substantial difference between what a student can do and what a student will do. It is what

a student will do, it is in the dispositional or motivational aspects of behavior, that the significant consequences of schooling emerge. The cultivation of conditions that promote intrinsic satisfactions is a way to increase the probability that such dispositions will be developed.

How can intrinsic satisfactions be promoted in the study of history? What might educators do in mathematics to make engagement in it a source of vital satisfaction? What role does meaning play in increasing satisfaction with academic studies? To what extent would engagement by students in the formulation of purposes in the various fields increase the degree of satisfaction they secure from those fields? How could the use of various forms of representation by the teacher help students understand important ideas? Would the use of various forms of representation increase students' intrinsic satisfaction with respect to academic studies? Questions such as these provide a lead for developing ways to move from an extrinsically directed system into one built on a foundation of intrinsic rewards.

Another lesson that the arts can teach education is that literal language and quantification are not the only means through which human understanding is secured or represented. So much of schooling privileges discursive language and the use of number that types of intelligence and forms of understanding not represented in these forms are given marginal status. It must be acknowledged, of course, that the abilities to read, to write, and to compute are of crucial importance. Students who cannot read, write, or compute are in deep trouble. But important though these skills are, they do not encompass all of what people know or the ways in which what they know is given public status.[8] We appeal to poetry to say what cannot be expressed in literal language. We secure from images ideas and other forms of experience that elude discursive description. We experience through music qualities of lived experience that cannot be rendered in quantitative form. In short, our sensibilities and the forms of representation associated with them make distinctive contributions to what we notice, grasp, and understand. As Pascal said, "The heart has its reasons that the head knows not."[9]

Ideas rendered in nondiscursive form or in number need to be "read" to be experienced. The ability to read these forms constitutes a form of literacy that schools must develop if their content is to be accessed by students. The best way to ensure that students will leave school semiliterate is to deny them access to opportunities to acquire these literacies. The long-term result of such deprivation is a diminution of the varieties of life that students are able to lead.

In some ways we already recognize the importance, say, of visual forms for conveying information that does not take as well the impress of literal language. Maps, globes, charts, histograms, scattergrams, pie charts, photographs, and drawings convey information that is not easily translatable into either the language of words or the language of number. We appeal to literary forms and to poetry at the most poignant periods in our life, to bury and to marry. Paradoxically, we use poetry to say what words can never say.

It is important for students to recognize that neither meaning nor human intelligence is the sole province of literal language or of number. It is important for teachers to recognize that nonlinguistic and nonquantitative forms of representation should be a part of the programs that they design and, when it is warranted, to provide students with the option of displaying what they have learned in a field through video, film, and literary forms and through other means that suit the interests and aptitudes of the students they teach. The provision of such materials and opportunities makes a substantial contribution to educational equity. Educational equity is not demonstrated simply by providing students with an opportunity to cross the school's threshold; rather, it is realized by what students have an opportunity to do once that threshold is crossed.

Yet another lesson the arts can teach education is the importance of being flexibly purposive in the course of one's work. In standard views of rational planning, objectives are held constant while means are varied when the means planned do not succeed in enabling one to achieve the goals one has described. When that is the case, new means are conceptualized and implemented, and the evaluation process examines the relationship between out-

comes and intentions. The arts are examples of activities in which ends are held flexibly. The particular aims to which a work is eventually directed need not be and often cannot be specified with any degree of certainty in advance. In a sense, artistic activity is opportunistic. When new openings emerge, they are exploited.

This ability is one that can be profitably employed in a wide range of fields. It certainly characterizes the most intelligent aspects of organizational behavior. Organizations may define goals but keep their eye on the context in order to shift goals when needed. In a similar vein, those working in the arts keep their eye on the context defined by the work itself and take advantage of unanticipated developments in order to realize goals that were not a part of their original agenda. This, too, is an important lesson that those who teach in other subjects can employ and, if not employ, at least encourage.

Of course, to be in a position to shift goals implies that there is in fact an inquiry process under way. By an inquiry process I mean a process in which an effort is made to resolve a problem. Without such a process in place, the shifting of goals is a largely empty enterprise, since it performs no important function. Thus, the arts provide vivid examples of individuals immersed in tasks in which they are trying to bring something to resolution but who are not rigidly pinned to aims that initiated the inquiry. As I indicated earlier, this is a process of being flexibly purposive, a concept that Dewey articulated in *Experience and Education*.[10]

A vivid example of flexible purposing is evident in jazz improvisation. Indeed, it seems as though the entire enterprise of musical performance in, say, a quintet is to exploit the surprising musical opportunities that emerge when there is no prescriptive script to follow. Musicians, of course, are aware of the theme that is going to be addressed, but the particular forms that it takes will be a function of unanticipated emerging qualities. Flexible purposing is built into the enterprise of musical improvisation. The capacity to improvise, to exploit unanticipated possibilities, is a substantial cognitive achievement fundamentally different from the lockstep movement of prescribed steps toward a predefined goal. Subject areas other than the arts that can embrace such an ap-

proach to teaching and learning would enhance the cognitive development of students.

Another lesson that the arts can teach education is the importance of taking one's time to relish the experience that one seeks. Experience is not so much something that you take; it is more like something you make. Experience, the medium of education, is a made process, and it is made by the ways in which people attend to aspects of the world they care about. If there is any lesson that the arts teach, it is the importance of paying close attention to what is at hand, of slowing down perception so that efficiency is put on a back burner and the quest for experience is made dominant. There is so much in life that pushes us toward the short term, toward the cursory, toward what is efficient and what can be handled in the briefest amount of time. The arts are about savoring.

Savoring is not limited to the arts. It can be applied to the examination of ideas, to the ways in which they are manipulated and used, to the forms that they take, and to their implications. Ideas, whether in the abstract forms we call mathematics or in the qualitative forms we call the visual arts, can be beautiful entities, but for them to be experienced as beautiful requires an attentive and constructive mind. The arts can serve as a model to other fields that illustrate what such attention looks like.

The mere presence of the arts is insufficient for them to be attended to in the way in which I am suggesting. We have a tendency in our culture to treat things rapidly. The average museum visitor spends only a few seconds looking at a painting. Most of the time paintings are seen on the run—or at least on the walk. In fact our culture puts a premium on movement and on quickness. Simply think of the image shifts on television, particularly on commercials: every three seconds the focus of the camera is changed. Reflect on the ways in which lunches are eaten at stand-up restaurants serving workers who must get back to their desks as soon as possible. Yes, we put a premium on efficiency and in the process lose the experience that savoring makes possible.

The places that we call concert halls, art museums, and theaters are places that are dedicated to experience; they are venues for creating the conditions in which we experience a certain qual-

ity of life, a quality generated both by the features of the object or event we pay attention to and by what we bring to it, not least of these being the kind of attitude we possess as we search its countenance. These activities of learning how to attend and taking the time to do so are potent means for enriching our experience, and it is the enrichment of experience that much of art is about. Since aesthetic qualities are not limited to what we normally call the fine arts, since they emerge in doing science, doing mathematics, in history, and in other fields, enabling individuals to learn how to attend to such fields with an eye toward the aesthetic and with time to undergo its flavors is a nontrivial outcome of education that is perhaps most acutely emphasized in effective art education.

The fact that aesthetic features are not the sole possession of what we normally refer to as the fine arts or even the popular arts leads me to another observation about the consequences of learning the lessons from the arts described above. That lesson is this: When other fields, indeed, when other activities are pursued for their aesthetic properties and when they are acted upon with an eye toward the generation of such experience, the activity or the field increasingly begins to approximate an artistic one. In other words, science, both its products and its practice, under the circumstances I have described, increasingly becomes a means for generating artistic forms of life. The same holds true for the other fields. Thus, education can learn from the arts what it means to treat fields as potential art forms, and in so doing the arts become a model for education.

# 9 AN AGENDA FOR RESEARCH IN ARTS EDUCATION

*SCIENCE IS A SPECIES OF RESEARCH; RESEARCH IS NOT A SPECIES OF SCIENCE*

Before discussing the kind of research that might strengthen arts education, I would like to make two points regarding the development of a research agenda for arts education. The first is that what the field needs is an *agenda*. By an agenda I mean not simply more unrelated studies, but, rather, research programs of related studies that ultimately will advance our understanding of some of the important issues and problems in the field. It is unlikely that single-shot studies will have the power needed to add significantly to what we come to understand about, say, the factors that advance various kinds of learning in the arts. An array of related studies that build upon each other over a five- to ten-year period might. Too many studies in the field of arts education are stand-alones. Although no individual researcher will be able to deal with everything that might be of theoretical or practical interest, even in a narrowly defined domain, the likelihood that research will yield significant outcomes is increased if the work undertaken is a part of a larger, incrementally developing picture. Thus, the first point I wish to make is that individual research studies should be seen as an ongoing part of a research *program*.

The second point pertains to assumptions about the "nature" of research. Since the late 1960s there has been a virtual revolu-

tion in thinking about the meaning of research. Assumptions that at one time went unexamined have been made problematic as traditional conceptions of knowledge have been challenged and methods for doing research have diversified.[1] Some of these changes have been influenced by the demise of foundationalism, the increasingly problematic character of positivism, the emergence of postmodern thought, the rise of feminist theory, the growth of multiculturalism, and dissatisfaction with the modest usefulness in education of conventional research methods in the social sciences, research methods whose assumptions and procedures have been influenced by the natural sciences. To be sure, the new developments I speak of have not always been accepted by scholars heavily invested in traditional research methods, but it is fair to say that even among the most conservative, conceptions of how research may be pursued have become more liberal in character.

## CHANGING BELIEFS ABOUT RESEARCH

What are some of the ways in which ideas about research have changed? I identify a few of the beliefs and assumptions that have been brought into question.

One of the most significant beliefs that has been challenged is that "real" research requires quantification. For many, doing research in education required one to measure the phenomena investigated and then to apply statistical techniques to treat the quantified data. Research and measurement were like ham and eggs—an inseparable pair. What has happened is that young researchers, in particular, have felt limited by the requirement that phenomena be reduced to what is measurable. They have recognized that form influences meaning and that much of what needs to be understood and conveyed needs a narrative more than it needs a number. As a result of the uneasiness with the limits of numbers and statistics, qualitative research methods have emerged as a legitimate way to study and understand the educational problems researchers care about. Narratives, films, video, theater, even poems and collages can be used to deepen one's understanding of aspects of educational practice and its consequences. As I have indicated

earlier, form and meaning interact because the form in which ideas appear affects the kinds of experience people will have. Hence, the use of forms of representation that previously had little or no place in research have been recognized as providing new meanings, something needed if understanding is to be enlarged.

A second shift has redefined the status of the experiment as a way to understand the effects of educational practice. Experiments have a number of attractive features, not the least of which is the experimenter's ability in the laboratory to control variables that in natural settings can contaminate experimental treatments and therefore confound effects. The ability to explain the results of an experimental treatment is compromised when unaccounted-for sources of variation inadvertently become a part of the treatment or interact with it. Yet effects that might be secured under controlled conditions in the laboratory are precisely the conditions that often cannot be controlled in typical classrooms. As a result, findings derived from experiments might not generalize to classrooms that look little like the situation from which the findings were secured. As a result of these conditions, researchers in education have begun to look to schools and classrooms for what might be called "natural experiments"; researchers are increasingly interested in what actually goes on in ordinary circumstances rather than in the results secured in laboratories.

A third belief rooted in traditional research practice that has been problematized is the belief that the aim of research is to discover true and objective knowledge. What has been problematized is the notion that knowledge is discovered—like unearthing the facts, or collecting the data, or digging for the truth—implying that truth is independent of the perspective, frame of reference, values, or criteria used to define the truth. Put another way, what a society regards as knowledge depends upon the consensus of a critical community and the efforts of a researcher to use a form of inquiry that will meet the criteria that have been socially defined. Knowledge is less a discovery than it is a construction.

Related to the issue of knowledge creation is a fourth shift in view. It pertains to the question of objectivity.[2] One meaning of the term *objective* pertains to the use of a research procedure that is so

prescriptive that it does not permit human judgment to be exercised. But another, more commonsense meaning of *objective* pertains to the belief that objective knowledge describes something as it *really* is. It is this conception that has become problematized, since there are infinite ways in which something may be described. The idea that there is *a* way to capture the "real" way something is is presupposes that one can come to the world with a mind empty of all the prior experiences that might color or bias one's view; all perception has its bias, that is, its angle of refraction. Yet a mind empty of what culture and experience have provided, that is, empty of bias, would see nothing.

A fifth traditional belief that has been challenged is that generalizations must be statistical in character. In conventional approaches to statistically oriented educational research, the ability to generalize rests on certain assumptions. One of these is that generalizations depend upon the random selection of a sample drawn from a population. A random selection requires that every subject in the population have an equal chance of being selected for the sample. Once the sample has been randomly selected the appropriate statistical tests can be employed to determine, for example, differences, if any, between two randomly selected groups. The probability that differences in the scores of each group are not random can be calculated to determine whether the differences, if any, are statistically significant. If they are, the results of this analysis allow one to infer that what is true of the sample also generalizes to the population from which the sample was drawn. This form of inference is perfectly reasonable for data that lend themselves to inferential statistics; but it is not the only way to generalize.

Statistical generalizations depend upon assumptions of randomness, but it is clear that humans generalize all the time without randomly selecting a sample from a larger population. We use our experience of individual events to form expectations and to draw conclusions. The data that feed those generalizations are often far more complex and subtle than what statistical data usually provide. We use a wider, more complex, and more subtle array of information to anticipate the future or to draw conclusions about the past. We do not draw these conclusions by selecting random samples.

But there is still another basis for generalization, and it has to do with the use of *canonical images*. These images are derived from the arts, from the sciences, and from daily life. The arts provide images that are so powerful that they enable us to see or anticipate what we might not have noticed without them. For example, the images of Don Juan and Don Quixote define for us two different ways in which people live their lives.[3] They enable us to recognize these qualities in others—and even in ourselves. The images created by painters like Edward Hopper and pop-culture icons such as James Dean provide what Ulric Neisser calls anticipatory schemata, schemata that help us notice by suggesting to us what we can look for.[4] Indeed, the function of a case study is to learn about more than that particular case, for a case is always a case of something. In short, the generalizations I am describing yield, not so much conclusions, but heuristics for inquiry, which in any case is the function that all generalizations serve. Robert Donmoyer calls such nonrandom generalizations "naturalistic generalizations," as contrasted with statistical generalizations.[5]

A sixth changed belief is that research is, and can only be, the result of scientific inquiry. In this view research is considered a species of science. In the more current view, science is one, and only one, species of research. Research need not be scientific to count as research. Research can be arts-based as well as science-based.[6] Arts-based research begins with the recognition that the arts as well as the sciences can help us understand the world in which we live. For example, fiction can reveal qualities about social class, individual character, home life, marriage, and war that would elude scientific description. It is the view of arts-based researchers that bias enters into descriptions and analyses of, for example, a school that has been studied, by virtue of omission as well as commission; when perspectives on a complex matter have no chance of emerging, they cannot be taken into account. Arts-based research is a way to ensure that science-based research alone does not monopolize how educational practice can be studied or what needs to be done to describe it.

A seventh shift in view is the challenge to the belief that through research we will find out what works and that once we know, it

will tell us what to do and how. This view is now regarded as a gross oversimplification of the function of research. The idea that research conclusions can be applied, like prescriptions for action independent of context or circumstance, underestimates the inevitable gap between theoretical knowledge and practical action. The distinction between the theoretical and the practical is not a new one; it is Aristotle's.[7] Theories describe regularities, while particulars always deviate from what is regular or ideal. A theory of cows, Joseph Schwab reminds us, never applies perfectly to "Old Betsy."[8] If distinctiveness is present among bovines, how much more so must it be the case with humans.

This shift from the supremacy of the theoretical to a growing appreciation of the practical is a fundamental one because it also suggests that practical knowledge cannot be subsumed by the theoretic; some things can be known only through the process of action. In addition, contexts inevitably differ, and these differences are neglected at great peril. Teachers, curriculum designers, and evaluators need to know the context to know if the decisions they are considering make sense. Knowledge of the context is an eclectic mix of what multiple frames of reference provide and "a feeling for the organism," to refer again to Barbara McClintock.

The changes in view I have been describing all have something in common. They represent efforts to dethrone theoretical science as the only legitimate way to come to know. They all emphasize the importance of the practical, what Michael Connolly and D. Jean Clandinin call "personal-practical knowledge."[9] They all call attention to the hopelessness of the quest for certainty in research. We will continue to deal with the changing nature of circumstance, a condition characterized by ambiguity and uncertainty. Finally, they give saliency to the practitioner, the individual who, in the context, might act on what research suggests, but which it can never mandate.

The ultimate implication of these shifts in view is not to discard scientific research, but to recognize that it has no monopoly on the ways in which humans inquire; it is one of many ways of coming to know.

This move toward a more liberal conception of method is not merely a methodological expansion; it is an epistemological one. It represents a change in the way knowledge is conceptualized. It is a much more fluid concept of method. What counts as knowledge depends on perspective, time, interest, method, and form of representation. What has been recognized—a lesson the arts teach—is that the choice of an approach to the study of the world is a choice of not only what one is able to say about that world, but also what one looks for and is able to see. Methods define the frames through which we construe the world.

This, then, is the context in which we find ourselves at the beginning of the new millennium. From my perspective it is a wonderful position in which to be, for it confers options for inquiry that did not exist, say, in the 1950s.

## RESEARCH NEEDED IN ARTS EDUCATION

Let's turn now to the kind of research that might be helpful in arts education.

Among of the most important kinds of research needed in the field are studies of teaching and learning. By studies of teaching and learning I mean studies that try carefully to answer the question "What do teachers of the arts do when they teach and what are its consequences?" By what teachers do, I mean questions like the following: What kind of curriculum activities do teachers ask students to engage in? To what content are those activities related? What forms of thinking do they evoke? How do they introduce what they want their students to learn? What kinds of comments do they make to their students as they view their work? What kind of scaffolding do they provide? What kind of emotional support do they provide so that their students can take risks? How do they go about developing their students' technical skills? Do they promote the use of imagination through their teaching? If so, how?

What proportion of the teacher's discourse focuses on aesthetic matters, what proportion on technical matters, and what proportion on matters of classroom management? When they talk to stu-

dents about artwork, theirs or others', what do they talk about? What connections does the teacher help the student make between his or her own work and the work of others?

Does the teacher encourage group critique of individual work and what role does the teacher play in this process if it occurs? How does the teacher provide for sequential learning, that is, teaching in a way that enables students to build upon what went before and prepare for what is to come?

Research on teaching implies to most readers research on what teachers do when they teach. But if teaching is conceptualized in terms of the conditions that influence learning in classrooms, it can include not only what teachers do to influence what students learn, but with what students do to influence one another. How the classroom can be organized as a community of practice with its own norms and procedures so that those norms and procedures positively influence those who inhabit that community, namely students, is an important and often neglected consideration in the study of teaching. The situation teaches, as Dewey pointed out, and professional teachers can and do have a hand in shaping the design of that situation. Thus, the consequences of forms of social organization in arts classrooms are no trivial subject matter for research on teaching.

How much access do students have to one another? What is the nature of their discourse? To what extent does it focus on aesthetic matters as contrasted with other topics and concerns? What kind of sharing takes place? What norms pervade the classroom? To what extent are students helpful in providing guidance to one another? Do they function as mutual mentors?

Almost all aspects of the classroom community can be resources for promoting learning. A broad and generous conception of research on teaching would include not only what it is that professional teachers do, but what in the design of the environment, particularly the social dimensions of that environment, promotes student learning.

Questions such as these are important, for if we know little about the processes teachers employ in classrooms, we will be in a poor position to improve teaching. The development of an agenda

for teacher education can be substantially informed by what we know teachers actually do when they teach. There is no way to know without looking.

Two caveats. First, looking is not enough. The "looker" must see. Seeing is a matter of connoisseurship.[10] Seeing means interpreting the significance of what is seen. Second, my remarks should not be taken to mean that there is one correct way to teach: I am not in search of a universal system. There are many ways of teaching well, and the differences among those ways need to be respected. But even given the diversity, there will always be room for improvement. Discovering the strengths *and* the shortfalls of arts teachers is one way to improve practice.

It seems likely that qualitative studies of practice are an appropriate methodological orientation to the study of teaching. There are some examples of such work in the literature. One of these is a study, by Pamela Orman Sharp, of the discourse of primary-school teachers in the process of teaching the visual arts. Sharp wanted to find out what these teachers said to their students in the conduct of their art lessons.[11] She observed and tape-recorded their discourse. What she found was that the preponderance of the teachers' talk to students focused on matters of management rather than on the aesthetic qualities of visual form that they presumably wished to teach. As a result, Sharp developed an experimental program designed to teach teachers how to use what she called "aesthetic extensions" to increase their attention to aesthetic issues rather than devoting so much attention to matters of management. This study is a good example of how research on what teachers actually do can inform in-service education programs.

I have already described an array of thinking processes that the arts promote, but what are needed are careful studies of the specific cases of such thinking. What we need are empirically grounded examples of artistic thinking related to the nature of the tasks students engage in, the materials with which they work, the context's norms, and the cues the teacher provides to advance their students' thinking. Such studies of process would help us frame tasks and provide forms of teaching that optimize the student's cognitive development. I believe many effective arts teachers do this with-

out conscious attention to cognition, but we need an explicit rendering of those relationships, particularly those of us interested in the relationship of cognition to the arts, as well as those of us who work in teacher education.

In the 1960s Kenneth Beittel and Robert Burkhart studied the painting strategies of college art students.[12] Using time-lapse photography they tracked the way in which students went about their work. They found that their painting strategies could be divided into three types: divergent, spontaneous, and deliberate. They then tried to relate these strategies to their personality characteristics. Although, in my opinion, the demonstration of those relationships needs further support, the approach they took to studying work in process was impressive. We need studies that pick up where Beittel and Burkhart left off in tracking decisionmaking in the creation of an art form.

In my own review of the literature pertaining to claims made about the effects of art experience on Scholastic Aptitude Test scores, namely that the more courses a student takes in the arts the higher his or her SAT score, I found that, indeed, the more arts courses a student takes, the higher the score. The problem with causal explanations of the effects of art courses on SATs is that the more science a student takes, the higher the SAT score, the more foreign languages a student takes, the higher the SAT score, the more history and social studies a student takes, the higher the SAT score. Taking more of anything is associated with higher SAT scores. However, such competing data are seldom shared in making claims about the effects of the arts on academic performance, since, in the main, the aim of such information is public relations rather than an even-handed exposure of the facts of the case.

Another area of focus for research pertains to the relationship between experience in the arts and performance in the academic subjects of the school curriculum. The study of this relationship resides within the area called in the psychological literature *transfer*. Put most simply: Does what is learned in the arts transfer to non-arts tasks? Put another way, does experience in the arts confer an advantage on students on tasks outside those in which arts experience was secured?

There is considerable interest in the transfer of learning. If it can be demonstrated that transfer occurs, there would be a double benefit—even triple or quadruple benefits. If experience in the arts affected in a positive way the performance of students in the so-called basics, the arts would, some believe, become important at last, because they would contribute to what people really care about. There are claims made by arts advocates to that effect, but a careful review of the literature will demonstrate that really good studies of such transfer are scarce, and that where they exist, in general they do not provide convincing evidence (as yet?) that transfer occurs.

One of the major problems with existing research on the so-called transfer effects of experience in the arts is that the groups that are studied are nonrandomly selected.[13] Students constituting the experimental group are either in intact classes of students, or students who have elected to work in out-of-school arts settings, or those who elect to work in the arts because of an interest in them. When one is working with nonrandomized populations, it's not possible to determine whether effects, if they in fact occur, are a function of the features of the population or a function of the treatment. Similarly, when one uses as a population students who have elected a subject area to work in, one is not in a position to know whether the effects are due to higher levels of general motivation among those volunteering, or whether they are due to experience in the arts. The two major ways of creating comparable groups for purposes of comparison are either to match students to each other on theoretically relevant variables and then to assign matched pairs to the control and experimental groups or to assign students randomly to experimental and control groups. Very few studies using such methods have been undertaken thus far.

In discussing transfer, some important distinctions should be taken into account. We can distinguish between *in-domain,* or specific, transfer and *out-of-domain,* or nonspecific, transfer. In-domain transfer is the application of ideas and skills acquired on one array of tasks to tasks within the same domain, say, the relationship of drawing to painting. Both are examples of visual art, and one might expect that what a student learns in drawing would provide him or her with an advantage in thinking about painting.

Out-of-domain transfer pertains to the application of ideas and skills from drawing to, for example, history. Say that in a drawing class a student learns that he or she should pay attention to figure-ground relationships and that coherence should be pursued in the way the drawing is composed on the paper. Out-of-domain transfer would ask whether the student is able to apply the criteria acquired in her or his art class to a writing assignment in his or her U.S. history class. It is this type of transfer that is difficult to demonstrate, and at present I know of no good evidence to suggest that on their own students transfer what they have learned.

It is important not to confuse efforts that intentionally use the arts to teach, say, history or that explicitly point out to the student the connections between coherence in a drawing and coherence in a history text. Such learning, promoted by the explicit teaching of such relationships, is not an example of transfer, but of parallel learning promoted by the teacher. Out-of-domain or nonspecific transfer is a kind of learning in one field that has benefits in another field without being explicitly taught.

The design of a study that convincingly demonstrated transfer from the arts to other subjects when the arts were not intentionally used to teach them would be quite complex, but it can be done. As of this writing, in my opinion, such convincing evidence does not exist, even though there are some research efforts that demonstrate some effects of music on the spatial reasoning in preschoolers.[14]

## A DESIGN FOR A RESEARCH STUDY ON TRANSFER

What would it take to get the kind of evidence that would provide credible support for claims about transfer? Join me in reflecting on the design features that a study might have if we were trying to assess the extent to which experience in the arts boosted academic achievement. I will suggest a research design; you can reflect on modifications and additions. The research design I will describe is a conventional one. I am attempting to break no new methodological ground here. Given conventional or traditional assumptions about research design, how might we proceed?

For starters, we would need to determine the kinds of academic outcomes that we cared about; we would then need to decide what would count as evidence and we would need to determine how that evidence might be secured, measured, and evaluated. Since this is a thought experiment let's simply assume that we have a reliable and valid test that measures important educational outcomes in the social studies. Let's assume further that these outcomes are those that the faculty of the school in which the study is going to be done believe to be not only important, but consistent with what they are teaching and trying to accomplish. Let us assume further that the faculty have examined the social studies tests we propose to use and regard them as fair and appropriate.

Which populations should we study? Again, for simplicity's sake, let's arbitrarily select four classes of ten- and twelve-year-olds, two at each age level. If we get the effects we seek they would increase our study's credibility of being able to demonstrate these effects on more than one population.

Now, to get students for this experiment we cannot rely on volunteers, for such a sample might bias the results. If we used volunteers we could not know if we would get the same results with nonvolunteers. We would therefore need to select randomly from a larger population a sample of classes and then randomly assign students from those classes to the experimental and control conditions. This practice, you will recall, is called random selection and random assignment. It is used to randomize any differences between groups. If we could, we would also try to eliminate group differences by matching students on relevant variables in the experimental and control groups, but unless we had a very large population pool this approach to equating groups probably would be very difficult.

In the experimental design one ten-year-old group would receive the art curriculum, the other would not. The same design conditions would apply to the twelve-year-old groups.

Having made the selection and assignments, we would want to make sure that the competencies of the teachers were about the same for each of the four classes, for if some teachers were far better than others the results could be biased in favor of the better

teachers. Assuming about equally able teachers, we might then want to design or acquire an art curriculum that from a theoretical perspective was most likely to develop the cognitive skills that gave students in that art program an advantage in learning social studies. To do this we would need a theory of cognition that enabled us to identify the kind of cognitive demands activities in the art curriculum imposed and the relationship of those demands to the cognitive demands made in the social studies. If we could design curriculum activities that fostered such skills, the probability of finding positive relationships between performance in the arts and the social studies would be increased.

Having designed or acquired such a curriculum, equalized to the extent possible the teachers' teaching abilities, and randomly selected and assigned the students to experimental and control groups, we could proceed. Of course we would need to determine the length of the experimental treatment and to monitor that treatment to make sure that the program as intended was actually provided; many experiments fail because the treatment investigators thought was being provided was in fact not provided. To avoid this problem we would need to make sure that the art curriculum was a curriculum teachers could teach; if not, then we would have an in-service problem to deal with as well.

In addition, to avoid the Hawthorne effect it would be good to give some kind of placebo to the control group, some kind of novel activity in order to equalize novelty as a motivating factor in the experimental group's performance.

How long should this experiment last? Many experimenters expect too much in too short a period or use a short treatment time in order to maximize control over potentially confounding variables. Until rather recently too many experiments in education were like commando raids. Let's say that we will conduct this experiment for at least five months, preferably ten. We want to provide enough time for the art program to have effect. So we now have a five- to ten-month experiment in which an art program designed, in part, to develop artistically relevant cognitive skills is used to determine if the skills developed in the art program increase academic performance in an out-of-domain field like social studies.

But is that all? Don't we want to know something about what the students have learned in art? What if the students do very well in social studies, but pay for it by poor performance in art? We need to assess the students' performance in art as well as in social studies. We are working with the tacit theoretical assumption that the kind of thinking students do in art is related positively to high-level performance in social studies. How shall we know about the performance level of students in art? One thing we can do is to look for it in student work and listen for it in student discourse. We can read it in what students write. What counts in art education can include not only what art students can create, but also what they are able to say and write about art. We need assessments in these areas too.

I won't go into how these art assessments might be undertaken. I only want to point out that they ought to be done. Another area I won't go into has to do with the statistical analysis of the data we collect. What we have been talking about so far pertains to the research design of our study, not to its statistics.

A 1993 study by Richard Luftig approached some of the features I have described.[15] It provided mixed results. The study purported to demonstrate that the arts influenced performance in a number of areas, including self-esteem, locus of control, creative thinking, appreciation of the arts, and academic achievement on total reading score, reading vocabulary, reading comprehension, total math score, math application, and math comprehension. Results reported in this study, which had both a control group and a placebo group, showed no differences on any of the academic achievement measures except that in one of the two schools studied total math score differed by gender. Significant differences were also found on creativity measures and on measures of art appreciation.

You must get some sense from the abbreviated journey we have just taken that doing research of this kind is no pushover; it's complicated, and questions of generalization abound. Ironically, when the internal validity of an experiment is high, its external validity is often compromised; it is difficult and often impossible to replicate the experimental conditions in your typical school.

But let us assume, for a moment, that we got the results we

were seeking: the experimental group did indeed do significantly better on our social studies test than the control group. What would that mean for art education? Would we now have a rock-solid basis for justifying and supporting the arts in our schools? Would this provide a safe haven for the arts? I think not. What if other ways of boosting social studies scores—or math scores, or reading scores—were found to be more effective and more efficient? How would we justify the arts then?

Although I do not endorse the practice of justifying the arts on the basis of their putative effects on academic achievement, I support the pursuit of research in this domain because such effects might exist and because studying the relationships between learning and thinking in one area on performance in another might advance our general understanding of cognition. What I do not subscribe to is the argument, often implicit in the advocacy of those claiming such effects, that justification of the arts in education depends upon their positive effects on extra-artistic outcomes. If arts educators use that justification and if another array of educational practices demonstrated that the same effects could be achieved in less time at less cost, the case for arts education could be irreparably undermined.

## DEMOGRAPHIC RESEARCH

Another area of study that deserves attention is what might be called demographic or status studies of arts education. Demographic or status studies tend to lack the glamour of studies of transfer, but they are necessary to know the status of the field.[16] By demographic or status studies I mean studies that would answer questions such as the following: How many arts teachers teach at each level of schooling in the United States? Which states require elementary classroom teachers to have some college or university course work in one of the arts or in arts education as a condition for certification? On a state-by-state basis, which states require course work for students in one of the arts as a condition for high school graduation? Are arts courses included when schools calculate a student's grade-point average? Do colleges and universities

include arts courses when they calculate grade-point averages for those seeking admission?

Which states have statewide standards for arts education, and how is their attainment determined? Who decides what will be taught in the arts in a state's schools? What procedures are used to evaluate student performance? To what extent does the curriculum used in the schools include attention to art criticism and art history, as well as to matters of production? To what extent do colleges and universities include course content in arts education that addresses the critical and historical aspects of the curriculum?

What do parents, administrators, and teachers regard as the primary benefits of arts education? What level of priority do the arts enjoy compared with other subjects in the curriculum? What would teachers like most to learn to enable them to teach the arts more effectively?

Questions such as the foregoing, when organized in the light of a larger set of general concerns, could be very useful for determining the condition of arts education in the United States or in other countries with arts programs in the schools. Knowledge of the condition of the field would be useful for shaping educational policy and for identifying potential problems. At present, finding answers to such questions is difficult, although some efforts have been made to secure some answers. What is needed is a comprehensive survey to serve as a baseline that would make it possible to track changes in the field over time.

## HISTORICAL RESEARCH

Another domain that deserves attention looks backward in order to better understand the present. The domain to which I refer is the history of arts education. In visual arts education there is a bevy of scholars pursuing the history of the field.[17] Their work has made a number of important contributions. Through their work we have a perspective with which to understand the nineteenth-century beginnings of art education, especially in the eastern part of the United States. Work on the political intrigues surrounding Walter Smith, an Englishman invited to serve as director of the

first art school in Massachusetts and the first supervisor of art education in Boston, makes plain the fact that commercial interests and the ways in which art education was believed to serve those interests have not wavered. Such interests are still being expressed, with respect not so much to specific artistic skills, but to attitudes toward the world of work and to the development of cognitive abilities that some believe will be applicable to the workplace. There is a common thread running between the context in which an English art teacher named Walter Smith worked in Boston in the 1870s and justifications for art education today.[18]

Other scholars interested in feminist studies have focused on the fact that art, largely in the form of drawing, was regarded as a girls' activity and in many ways still is; aesthetic matters in contemporary life, except for few designated domains, are largely regarded as feminine. According to cultural stereotypes it is the male, after all, who kicks the tires on the new car, while it is the woman who pats and admires the interior upholstery. History can reveal the sources of such stereotypical attitudes and the forces that sustain and change them.

A good example of the ways in which conceptions of masculinity and femininity at a particular period (in this case, the late nineteenth century) affect the arts can be found in Janice Ross's study of the evolution of dance on university campuses in America.[19] She traces the transformation of dance as a part of the physical education program to its place as an artistic practice that is a part of arts and humanities education. Her work illustrates quite clearly some of the consequences of gender stereotyping on participation in dance and does so in a way that has implications for other arts as well.

Scholarship in the history of arts education is a way of getting a perspective on the field and retaining a memory. There is not much virtue in acting like new Columbuses when the land has already been trodden. Studies in the history of arts education can provide a kind of map useful for getting one's bearings.

Historical scholarship can also help us understand how the arts were taught, who taught them, how teachers were prepared, what the curriculum consisted of, what assumptions about learning in

the arts prevailed at different periods, and what brought about change. An understanding of such factors does not seem to me to be an unreasonable expectation for those going professionally into arts education.

## RESEARCH ON CURRICULUM AND TEACHING

Another arena for research deals with the effects of different approaches to curriculum and teaching. Identifying these effects will require either experiments on the effects of different kinds of curricula or the comparison of differences found in the classrooms in which arts teachers work. Let me provide two examples. One of the aims of an increasing number of curriculum scholars is the integration of the various subjects. What are the consequences of relating the visual arts to the sciences, what do they have in common, where do they differ, and what connections can be made by students when the curriculum is designed to help them see differences and similarities?

Questions such as these could be used to design curricula aimed at the integration of fields. The general rationale for such an approach to curriculum design is that the separate disciplines are modeled after the disciplinary studies of university academics, yet the ordinary citizen does not need to deal with subjects that way. Approaches that emphasize relationships, as well as differences, may be more useful and therefore more meaningful. The question is, are they? Just what is it that students learn when subjects are integrated? What relationships are they able to identify? Do they see these relationships in the world outside school?

But equally important is what costs, if any, do students pay when subjects are integrated? What ideas and skills are they less likely to learn? In evaluating the effects of experimental programs, particularly when policy decisions rest upon the results of experimental efforts, it is important that the assessment criteria be appropriate for appraising the distinctive contributions the experiment was intended to achieve. It is also important that assessment attend to the effects of the program on outcomes that the conventional program produced. The reason for doing this is to be in a po-

sition to assess costs as well as benefits. It might be not only that the experimental program produced the experimental results hoped for, but that it also produced results normally achieved in the conventional program.

Another example of an experiment pertains to the notion of distributed expertise and the effects of small groups on the performance of its members.[20] Let's say that a teacher is interested in distributed expertise and in small-group effects and decides to organize his or her class in groups of five; in this art class there will be six groups of five each. The responsibility of each of the groups is for students to share with other members of their group their plans for their work, to receive feedback from their peers, to show their work in progress, and to get similar feedback on it. What are the effects of such practices on the quality of student work, and how do they compare to conventional arrangements? Here we have an approach to teaching that is predicated on the expertise of students and on their willingness to assume responsibility for their peers. What are the effects of such arrangements? What do students miss in such interactions, and in what ways must the teacher supplement the small-group input?

Such studies would require assessment expertise not only in appraising student work but also in describing, interpreting, and assessing process. In this kind of study qualitative methods are most appropriate.

The two experimental studies I have outlined would need far more specification than it is appropriate for me to provide here. Nevertheless I hope the examples I have provided, examples that could be tested in most schools, will illustrate the kinds of studies the field could profit from. These studies are not exotic experiments that require special equipment and unusual circumstances; they require a will to investigate curricular and pedagogical possibilities and their consequences when implemented.

## INVENTING APPROACHES TO EVALUATION

One of the great needs in education is finding ways to evaluate the effects of arts education that provide information the public will

find convincing. To secure convincing information that does not trivialize the educational effects of solid curriculum and excellent teaching, a campaign needs to be mounted to invent the procedures needed. These procedures cannot be found; they must be created. Creating them requires confronting two problems. First, the relevant procedures for arts education will need to reflect the distinctive aims of arts education that are related to the visions of the field that were described in Chapter 2. Each vision and version has its own priorities, and these priorities need to be reflected in the way evaluation occurs.

In addition, allowances must be made for students to proceed at their own pace and to move in directions not solely defined by common objectives. As a result, meaningful comparisons among students will be difficult. When everyone is on the same track, comparisons of speed of travel are quite easy, but when there are differences in route and in destination, meaningful comparisons are hard to make. Each student's individual journey becomes the object of attention. Such a focus is fine on theoretical grounds, but whether the public will accept programs and forms of evaluation that put a premium on the promotion of such differences remains to be seen. When education is seen as a horse race, who comes in first matters. Thus, the form evaluation takes is not only a theoretical matter reflecting a conception of education. Like all educational matters, it is a political one as well.

Despite these complexities, the design of evaluation procedures that present a convincing body of evidence regarding the benefits of arts education is one of the primary research needs in the field. The trick is to resist the reductionism that has characterized much of conventional assessment and at the same time to secure approaches that are not so labor intensive as to render them impractical. It is a challenge, but one worth taking.

# 10 SUMMARY AND SIGNIFICANCE

*THERE IS MORE BEAUTY IN A ROCK THAN YOU CAN EXPERIENCE IN A LIFETIME*

This chapter brings to a close the journey that we have taken. The road has had many turns, as it must in a field that addresses so many complex issues and that requires that so many be considered. It is now time to distill some of the ideas that we have encountered. This chapter revisits thirteen important ideas that have been elaborated in the preceding pages.

1. *Meaning is not <u>limited to what words can express</u>*. Among the most important ideas that *The Arts and the Creation of Mind* addresses is the idea that humans are meaning-making creatures. All of us wish to create meaningful experience. Some meanings are "readable" and expressible through literal language; other meanings require literary forms of language; still others demand other forms through which meanings can be represented and shared. The <u>arts provide a spectrum</u> of such forms—we call them visual arts, music, dance, theater—through which meanings are made, revised, shared, and discovered. These forms enable us to construct meanings that are nonredundant; each form of representation we employ confers its own features upon the meanings we make or interpret. Educational programs aimed at expanding the meanings individuals are able to secure during their lives ought to help students learn to "read" the arts meaningfully as well as

*[margin note: limitations of language]*

the literal and numerical forms of meaning-making, forms that now dominate the aims, content, and time allocated to school programs.

2. *Judgments about qualitative relationships depend upon somatic knowledge or "rightness of fit."* The creation of a poem, a painting, a dance, or a melody depends upon the ability to attend to, to invent, and to adjust qualitative relationships in a medium. In music, the medium is sound; in drama it is speech, movement, gesture, and set; in the visual arts it is visual form; and in dance it is the countenance of a human body moving in space over time. The creation of forms that satisfy in any medium demands attention to highly nuanced relationships among the qualities with which one is working. The process of composing relationships in qualitative material does not yield to algorithms or other formulas, at least not when the process is inventive. One must make judgments about relationships by "consulting" one's somatic experience: How does the image feel? Is there coherence among its constituent parts? Does it hang together? Is it satisfying?

These questions direct one's attention to one's own bodily experience. We cannot consult a menu or retreat to a recipe. Cultivating the sensibilities is necessary to be able to experience these relationships so that our somatic processes can be touched by them. In the process we undergo an aesthetic form of life. It is a form of life pervaded by feeling. The anesthetic dulls feeling. The aesthetic promotes it. An education in the arts refines judgments about qualitative relationships and sensitizes the individual to the highly nuanced relationships that any work in the arts must, of necessity, display.

3. *Aesthetic qualities are not restricted to the arts; their presence depends upon how we choose to experience the world.* Although the arts function as paradigms through which aesthetic experience can be secured, aesthetic experience is in no way restricted to what we refer to as the fine arts. Virtually every form that can be experienced, from sound, to sight, to taste and touch, can yield aesthetic forms of experience if we learn how to attend to them through an aesthetic frame of reference. A tree, for example, can be viewed as an investment in the value of one's property, as a species of flora,

as a source of shade, or as an expressive form that provides a certain quality of experience when one looks through its leaves just before sunset. The tree's aesthetic features become salient when we choose to perceive the expressive features of the tree. Aesthetic experience, therefore, is potential in any encounter an individual has with the world. One very important aim of arts education is to help students recognize that fact and to acquire an ability to frame virtually any aspect of the world aesthetically.

4. *Artistic activity is a form of inquiry that depends on qualitative forms of intelligence.* The arts, especially the visual arts, have often been regarded as a kind of discharge of personal expression, where *expression* refers to an emotional release through visual materials. Painting is, for example, a process that is often regarded as emotionally therapeutic because it affords one opportunities to release what is pent up inside. Although the processes of painting, to use that example, can be used to discharge feeling, discharge alone, without reflection, imagination, and control, seldom results in either aesthetic growth for the individual or the creation of an aesthetically satisfying image. Learning to paint, to draw, to compose music, or to dance requires learning to think. Thinking in the arts is a form of qualitative inquiry in which sensibility is engaged, imagination is promoted, technique is applied, appraisal is undertaken. It is a complex and delicate process that depends upon the ability to experience the nuanced qualities with which one works and to undergo forms of somatic experience that enable one to make judgments in the course of one's work. Painting well requires thinking well within the constraints and affordances of the materials one uses. Indeed, *ex*pression, as Dewey indicated, requires *com*pression.[1] In this process there is a distillation of experience; it is compressed through the material so that it takes on a life of its own. Such activity can be thought of as a form of *qualitative intelligence,* namely, the ability to make effective judgments about the creation and organization of qualities in the service of feeling and imagination.[2]

5. *There is more than one legitimate educational agenda for arts education.* Although we tend to seek a common and certain aim for each of the various fields that populate the school's curriculum, a

field's aim is determined not by the content of the field alone, but by human judgments made by reflective practitioners and policy-makers regarding the way in which a subject can be taught and the direction that learning should take. The direction that learning should take is, in turn, influenced by the population attending a school and by local circumstances of time and location. There is, in principle, a virtually limitless array of aims for any field, including the arts. Chapter 2 described a few such versions. Arts education can be used to attain a wide variety of ends. As times change, needs may change, too. The genuinely competent educator makes judgments about programs not merely on the basis of a single conviction, but upon an analysis of the context in which the program is to function.

6. *The artistic development of the individual is not an automatic con-* ~~dynamic~~ *sequence of maturation.* There has been a relatively widespread ten- ~~development~~ dency, especially in thinking about the development of young children, to conclude that in the arts they are best served when left alone. The basic idea is premised on the view that the child develops primarily from the inside out, rather than from the outside in, or, more correctly, as an integration of what is inside and what is outside the child. Some believe that by getting out of the child's way, by providing the child with opportunities to explore on his or her own, the child's innovative capacities are more likely to be released and the consequences are likely to be substantially educational as a result.

This view of the teacher's role, a kind of pedagogy by neglect, assumes that intelligent teaching is unlikely or that teachers have little to teach students at the elementary or secondary school level. Yet the educator's task consists of more than benign neglect; it requires the design of an environment, including the support of the teacher, that will create those zones of proximal development within which the course of children's development can be promoted. If artistic development were an automatic consequence of maturation, there would be no need for teachers of art, or music, or mathematics, or any other field in which artistic forms of activity are possible. Indeed, I would argue that an unassisted course of maturation is morally irresponsible; the teacher's task is to design

environments that promote the educational development of the young. These environments include creating curricula, as well as engaging in the artistic use of one's self as teacher. All these processes are intended to enhance the educational experience of the young.

7. *The arts should be justified in education primarily in relation to their distinctive or unique educational contributions.* There is a strong tendency, even among arts educators, to seek justifications for the teaching of the arts in terms that the general public values. Thus, if the general public values achievement in mathematics or in science, some arts educators are ready to claim that arts experiences boost test scores in mathematics or in the sciences. What we too often do is to give the customer what he or she wants, whether or not the claims can be supported by a research literature that can stand analysis. But even if such a literature existed, even if one could demonstrate through research that the arts contributed in an educationally significant way to a student's performance in mathematics or in sciences (I use these fields only as examples), the case for art education as a part of the student's general education would be compromised. It would be compromised because if any other kind of activity, from eating vanilla ice cream to playing soccer, could also claim that those activities could even more effectively boost math and science test scores, art's place in the school curriculum would be in jeopardy. If the justification for the arts is made primarily on extra-artistic grounds, any field or activity that could make similar claims would have just as much claim to attention in the school as the arts. That argument is a very slippery rock on which to build our church.

The primary contributions of the arts in education are related to those outcomes that are distinctive or even unique to the arts themselves. The first of such outcomes is the communication of distinctive forms of meaning, the second is the development of forms of thinking that are occasioned by both the creation and perception of objects and events as art forms, and the third is the provision of aesthetic experience

In making the claim that the most secure justification for the arts has to do with their distinctive or unique educational contri-

butions, I do not reject outcomes that are extra-artistic. If students develop a stronger sense of self-esteem through the arts, fine. If math and science scores go up, all to the good. If students develop a more positive disposition toward school as a result of engagement in the arts, wonderful. If students learn to work together effectively and to cooperate constructively, I'm delighted. But those outcomes, as important as they may be, are not distinctive to the arts. Science courses, well organized, could yield the same outcomes. The most secure justification for the arts in education pertains to what only they are likely to provide. Extra-artistic consequences are fine if and when they occur, but they are not our primary justifications.

8. *The sources of learning when working in the arts are multiple.* No one ever learns one thing at a time. The concert hall, the art studio, the stage on which a dance or play is performed are each replete with opportunities for learning many things. Some of these opportunities relate to the ways in which humans working within different art forms associate with one another, the kinds of assistance they provide to one another, the extent to which one's own work depends upon the work of others, and the kinds of resources—tools, paints, instruments, music—one must learn to use in order to work in that art form. The setting is filled with opportunities for learning that are not necessarily a part of the formal agenda of the field but are nevertheless important. In making my previous point about primary justifications for the arts and the current point about the recognition of a multiplicity of outcomes, I hope to make it clear that although what is distinctive or unique about the arts should constitute the heart of our case for them, we should at the same time not deny the fact that outcomes are multiple. We can acknowledge multiplicity without making multiplicity of outcomes primary.

9. *Among all the fields of study in our schools, the arts are at the forefront in the celebration of diversity, individuality, and surprise.* The current pressures upon schools to standardize curricula, to formulate standards for student outcomes, to apply standards to teaching practices, and to use standardized tests to determine what students have learned tend, in spirit and often in practice, to contrast with

the kinds of diversity, originality, individuality, and, indeed, surprise that are important in the arts. Work in the arts invites students to use their imaginative capacities to conceive of possibilities that are distinctive to themselves: the arts invite the application of a personal thumbprint upon one's work. The arts, when well taught, help youngsters learn how to yield to the emerging leads the arts provide in the process of their creation; one needs to learn how to relinquish control in order to find new options in the work. This flexibility of purpose is central to the arts and cultivated when they are well taught. As schools become increasingly beleaguered by an anxious public seeking to prescribe, manage, monitor, and measure performance, the arts provide a needed release for students to do what is most personal. To talk about the celebration of diversity, individuality, and surprise is not in any way to relinquish a concern for both learning and the creation of artistic quality. Indeed, these interests put a premium on the character of such learning, and they complicate rather than simplify the assessment process. When all products are to look alike, the evaluation task is essentially one of matching the student's work to some benchmark or rubric. But when the promotion of productive individuality is the aim of the exercise, then evaluation criteria need to be employed flexibly in order to determine how far a student has come, and doing this requires attention to a baseline and to the use of many examples of the student's work over time. Growth is revealed not in an instant, but in a process.

Schools would be well advised to examine the character of excellent arts teaching as a way of finding approaches to the teaching of other fields that would be genuinely educational. The more our nation embraces a form of technical rationality to manage its schools, the more it pushes toward practices that tend to standardize, the more our children need the kind of experience and opportunities that the arts can provide.

10. *The arts teach its practitioners to think within the constraints and affordances of a material.* One of the conditions that contribute significantly to the development of cognition is the task that every practitioner of the arts confronts: learning how to think within the parameters that any material or process imposes. Working on a

portrait in clay provides a substantially different set of affordances and constraints from making the "same" portrait in marble or granite. Each material has its own distinctive features, and the individual working with such materials needs to think within their possibilities. In this example, the most obvious differences are not only that clay is softer than marble or granite, but also that clay is an additive medium. You can build up a portrait head out of clay, whereas you must subtract or remove marble or granite in order to "unlock" the image from it. These differences have an extraordinary impact on what it is that individuals need to think about in using them, and they impose distinctive technical requirements with respect to the use of tools and procedures. For example, one need not think about the moisture content of a piece of granite, while the moisture content of a head done in clay is critical if it is to survive when fired in a kiln.

The constraints and affordances that materials impose are not distinctive to working in the arts. Individuals working with any tool or any material must think within their constraints and affordances. The diachronic quality of a story conveyed through words requires one to think about pacing and time. The synchronic quality of visual experience requires one to think about the ways in which forms relate in terms of their qualitative immediacy. The former experience is temporal; the latter is largely spatial. Learning how to create forms that have aesthetically satisfying relationships or that are expressive in particular ways requires learning to think intelligently within the constraints and affordances of the materials one elects to use.

The implications of this idea are significant for children. When children are given runny paint with wide brushes to use on a semi-vertical easel, the tasks they must address relate to the fluidity of the paint and the verticality of the paper on which they apply it. If pencils or chalks are given to those same children, the task changes, and so do the forms of thinking needed to address it successfully. If one wants to emphasize the "expressive" character of children's artwork, there are many ways to do so. The use of large brushes and vivid tempera paint is one way. If one wants to promote attention to detail and to precision, colored pencils or ballpoint pens

would be better suited to the task. The material influences what children learn to pay attention to.

11. *Evaluation and assessment should be regarded as educational resources, practices that help improve the educational process.* Evaluation in the context of children's art is typically viewed with great suspicion, and for good reason. Typical evaluation practices emphasize conformity to a predicted outcome. Evaluation is seen as a process of determining whether the student's products match the outcomes specified by the curriculum's objectives. In an ideal performance by a student, the student's work would be isomorphic with the objective, the standard, the rubric, the benchmark, the milestone. Teaching and learning are, in this model, essentially convergent activities rather than divergent ones. Predictability rather than surprise is given priority.

In the arts, individuality is celebrated. Evaluation practices can, in the view of many arts educators, undermine individuality. However, one need not conceive of evaluation or assessment in such rigid terms. Evaluation and assessment can—and, I would add, inevitably does—take place during teaching. Furthermore, the number of "data points" that a teacher has in assessing the student's work and development is much greater than the single one-shot high-stakes test score. Evaluation practices at their most useful are formative; they help improve the student's learning or the teacher's teaching or the curriculum itself. This improvement is achieved by using evaluation not as a device for scoring children but as a means of securing information about what a student is doing and what needs attention.

The basis for making formative judgments about what is needed is often secured by looking at a pattern of performance, locating a baseline, and laying the work out over time. Recordings can be made in the area of music, videos in theater and dance, and the work itself can be displayed in the visual arts over time. What one gets is a display of a process and not only a single example of student work. Thus, evaluation and assessment in the paradigm I have just described are to be regarded as allies rather than as enemies. They are not vehicles for ranking students or teachers; they are ways of learning about what has been taught and learned.

12. *The process of representation stabilizes ideas and images, makes the editing process possible, provides the means for sharing meaning, and creates the occasions for discovery.* Nothing is harder to keep in mind than an idea or image that is not represented through some medium. Representation is, in one way or another, an ineluctable aspect of work in the arts. The creation of an image initiates, with an idea or with another image, an image to be explored, an image of possibility. The transformation of idea or image—and it is always a transformation—gives what is "internal" a public, visible presence. That is its first function. In so doing a second function is made possible. That function is editing. It is in the editing process, whether in the composition of a musical score or in the composition of a tempera painting, that the opportunity to modify the externalized image or idea, to inspect its features, to locate flaws, to make more acute its expressive power, occurs. The editing process is a way of closely scrutinizing what one has initially created. The work is there to be refined, and the editing process serves that end.

Representation enables one to share one's ideas, one's feelings, one's aspirations, one's images with others. Children and adolescents engaged in imagemaking, whether in music or the visual arts, whether through poetry or dance, whether through essays or acting, are engaged in a potentially profound form of communication. Their task is to create a form that will trenchantly communicate their image to others. The arts provide a means for such sharing and represent one of the deepest forms of human communication.

But the act of representation is not only a *re*-presentation of images and ideas held in the privacy of one's cortex. The act of representation also provides an arena in which new possibilities, new images, new ideas can be discovered. The act of representation is not merely a monologue made manifest through the obedient responses of a material; the material itself speaks and creates new possibilities to be discovered by a sensitive eye and a deft hand. The act of representation is an act of discovery and invention and not merely a means through which an individual's will is imposed upon a material.

It is this sense of discovery that affords individuals the opportunity to grow. The unanticipated options emerging in the course

of action are a kind of adventure, and the exploratory manipulation of those happy accidents a form of experimentation. Humans grow through their ability to experiment with aspects of the world they encounter. Such behavior is found in the eighteen-month-old exploring the feel of mashed potatoes with his or her fingers and in the twenty-four-month-old exploring the effects of crayon on paper. Representation through materials is a way to promote one's own growth.

13. *The possibilities for growth in and through the arts cease only when we do.* The ultimate aim of education is to enable individuals to become the architects of their own education and through that process to continually reinvent themselves. I start with the assumption that in a certain significant sense, mind is not present at birth. Minds are invented when humans interact with the culture in and through which they live. Brains are biological. They are conferred at life's beginning. Minds are cultural; and although there is no sharp line between what is biological and what is cultural—they define each other—the overriding perspective I want to commend is that schools have something significant to do with the invention of mind. The invention of mind in schools is promoted both by the opportunities located in the curriculum and by the school's wider culture. They are found in the forms of mediation through which the curriculum and schooling as a culture take place. In this sense, the curriculum is, as I indicated earlier, a mind-altering device.

The important outcomes of schooling include not only the acquisition of new conceptual tools, refined sensibilities, a developed imagination, and new routines and techniques, but also new attitudes and dispositions. The disposition to continue to learn throughout life is perhaps one of the most important contributions that schools can make to an individual's development. This achievement of mind rooted in motivational and dispositional factors is the source of continued transformation. There is no need to assume that beyond a certain age the capacity for growth ceases. On the contrary, growth is always possible and terminates only with the termination of life itself.

The arts are among the resources through which individuals recreate themselves. The *work* of art is a process that culminates in

a new art form. That art form is the recreation of the individual. Recreation is a form of *re*-creation. The arts are among the most powerful means of promoting re-creation. Those of us who have worked in the arts, who have taught the arts, who have tried to understand what the arts contribute to the development of human consciousness can feel a sense of pride that our legacy is one that attempts to engender life at its most vital level. The arts make such vitality possible. They are sources of deep enrichment for all of us.

# NOTES

INTRODUCTION

1. See Ulric Neisser, *Cognition and Reality: Principles and Implications for Cognitive Psychology* (San Francisco: W. H. Freeman, 1976).

CHAPTER 1: THE ROLE OF THE ARTS IN TRANSFORMING CONSCIOUSNESS

1. William James, *The Principles of Psychology* (New York: Holt, 1896), 488.
2. Susanne Langer, *Philosophy in a New Key* (Cambridge: Harvard University Press, 1979), 84.
3. The human infant is one of the most dependent of living organisms over the longest period of time. Without adult assistance, it would perish.
4. John Dewey, *Experience and Education* (New York: Macmillan, 1938).
5. For a view sympathetic to the idea that chimpanzees possess a culture see Frans B. M. DeWaal, "Cultural Primatology Comes of Age," *Nature* 399 (1999): 635–636.
6. Johan Huizinga, *Homo Ludens: A Study of the Play-Element in Culture* (Boston: Beacon Press, 1955).
7. John Dewey, *How We Think* (Boston: D. C. Heath, 1910).
8. Dewey distinguishes between perception and recognition. Perception requires exploration. It seeks to further experience. Recognition takes place when a percept is given a label and then discussed. See his *Art as Experience* (New York: Minton, Balch, 1934).
9. J. J. Gibson, *The Senses Considered as Perceptual Systems* (Boston: Houghton Mifflin, 1966).
10. Leo Tolstoy, *What Is Art?* trans. Aylmer Maud (1896; reprint, Indianapolis, Ind.: Bobbs-Merrill, 1960).
11. Elliot Eisner, *The Educational Imagination: On the Design and Evaluation of School Programs*, 3d ed. (New York: Prentice-Hall, 1994).
12. Susanne Langer, *Problems of Art* (New York: Scribner, 1957), 25.
13. Gilbert Ryle, *The Concept of Mind* (London: Hutchinson's University Library, 1949).
14. Dewey, *Art as Experience* (New York: Minton, Balch, 1934).

15. Edmund Feldman, *Varieties of Visual Experience* (New York: H. N. Abrams, 1972); Terry Barrett, *Criticizing Art* (Mountain View, Calif.: Mayfield, 1994).

16. A succinct traditional conception of transfer can be found in J. L. Fobes, "Transfer of Training," in *Encyclopedia of Psychology*, 2d ed., vol. 3 (New York: John Wiley and Sons, 1994), 546–547.

17. Dewey, *Art as Experience*, 46.

18. It is interesting that the complex of demands in watercolor painting echo the more recent interest in what is called "multitasking."

19. E. H. Gombrich, *The Story of Art* (New York: Phaidon and The New York Graphic Society, 1961).

20. Rudolf Arnheim, *Art and Visual Perception* (Berkeley: University of California Press, 1954).

21. The term *physiognomic* refers to the interpretation of the structure or expressive movements of the body, especially of the cast and expression of the face, as subject to emotional and other mental conditions. In Gestalt theory, physiognomic experience is considered structurally similar to physiological processes. These processes echo the structure of what has been perceived.

22. For an interesting discussion of somatic knowledge, see Jonathan Matthews, "Mindful Body, Embodied Mind: Somatic Knowing and Education" (Ph.D. diss., Stanford University, 1994); and Mark Johnson, *The Body in the Mind: The Bodily Basis of Meaning, Imagination, and Reason* (Chicago: University of Chicago Press, 1987).

23. Antonio R. Damasio, *The Feeling of What Happens: Body and Emotion in the Making of Consciousness* (New York: Harcourt Brace, 1999).

24. Stephen Kuffler and J. Nicholls, *From Neuron to Brain: A Cellular Approach to the Function of the Neuron Systems* (Sunderland, Mass.: Sinauer Associates, 1976).

CHAPTER 2: VISIONS AND VERSIONS OF ARTS EDUCATION

1. See Arthur Efland, *A History of Art Education: Intellectual and Social Currents in Teaching the Visual Arts* (New York: Teachers College Press, 1990); and F. Graeme Chalmers, *A Nineteenth Century Government Drawing Master: The Walter Smith Reader* (Reston, Va.: National Art Education Association, 2000).

2. The orientation called discipline-based art education was initiated at the Pennsylvania State Seminar for Research and Curriculum Development held in September 1965. The leading ideas for DBAE are found in Jerome Bruner, *The Process of Education* (Cambridge: Harvard University Press, 1960).

3. Ralph Smith, ed., *Readings in Discipline Based Art Education* (Reston, Va.: National Art Education Association, 2000).

4. Morris Weitz, "The Nature of Art," in *Readings in Art Education*, ed. Elliot W. Eisner and David Ecker (New York: Blaisdell, 1966), 49–56.

5. The idea of the structure of the disciplines was also developed by Jerome

Bruner in *The Process of Education*. It rests upon the belief that all disciplines have a major idea or array of ideas that enables one to establish relationships among other ideas within that discipline. Bruner believed that the existence of a structure made it possible for information to be both stored and retrieved more easily.

6. Elliot W. Eisner, "Curriculum Ideas in a Time of Crisis," *Art Education*, 18 (October 1965), 7–12.

7. Manuel Barkan, "Transition in Art Education: Changing Conceptions of Curriculum Content and Teaching," *Art Education*, 15 (October 1962), 12–18, 27.

8. The concept of cultural literacy has become increasingly salient as a result of growing awareness of gross social inequities among people based on color, gender, or sexual orientation.

9. E. D. Hirsch Jr., Joseph F. Kett, and James Trefill, *The Dictionary of Cultural Literacy*, 2d ed. (Boston: Houghton Mifflin, 1993).

10. Kerry Freedman and F. Hernandez, *Curriculum, Culture, and Art Education* (Albany: State University of New York Press, 1998).

11. Graeme Chalmers, "Art Education as Ethnology," *Studies in Art Education*, 22 (1981), 6–14.

12. See Herbert Bayer, ed., *The Bauhaus, 1919–1928* (Boston: C. T. Branford, 1959); and László Moholy-Nagy, *Vision in Motion* (Malibu, Calif.: J. Paul Getty Museum, 1995).

13. The Institute of Design at the Illinois Institute of Technology is a prime example of a school influenced by the Bauhaus tradition.

14. See Viktor Lowenfeld, *Creative and Mental Growth* (New York: Macmillan, 1947); and Herbert Read, *Education through Art* (London: Faber, 1958).

15. Lowenfeld, *Creative and Mental Growth*, 7.

16. Read, *Education through Art*, 209.

17. It is ironic that the schools are never given credit when the economy goes well, but are often blamed when it does not.

18. Paul Chellgren, "What Good Is Arts Education? Educating for the Workplace through the Arts," *Business Week*, October 28, 1996, 12.

19. Elliot Eisner, *Cognition and Curriculum Reconsidered* (New York: Teachers College Press, 1994).

20. Rudolf Arnheim, *Visual Thinking* (Berkeley: University of California Press, 1969), 13–14. See also Arnheim, *Art and Visual Perception* (Berkeley: University of California Press, 1954).

21. Ulric Neisser, *Cognition and Reality* (San Francisco: W. H. Freeman, 1976); Jean Piaget, *The Construction of Reality in the Child* (New York: Basic Books, 1954).

22. Eisner, *Cognition and Curriculum Reconsidered*.

23. Nelson Goodman, "Art and Inquiry," in *Problems and Projects* (Indianapolis, Ind.: Bobbs-Merrill, 1972), 307–321.

24. Frances Rauscher and Gordon Shaw, "Key Components of the Mozart Effect," *Perceptual and Motor Skills*, 86 (1998), 835–841.

25. Frances Rauscher et al., "Music Training Causes Long-Term Enhancement

of Preschool Children's Spatial-Temporal Reasoning," *Neurological Research,* 19 (1997), 2–8.

**26**. For a critical analysis of these claims see Elliot Eisner, "Comments on the Question of Transfer," in *Beyond the Soundbite: Arts Education and Academic Outcomes,* ed. Ellen Winner and Lois Hetland (Los Angeles: J. Paul Getty Trust, 2001), 41–48.

**27**. John Dewey, *Art as Experience* (New York: Minton, Balch, 1934).

**28**. Howard Gardner, *Frames of Mind* (New York: Basic Books, 1984).

## CHAPTER 3: TEACHING THE VISUAL ARTS

**1**. Herbert Read, *Education through Art* (London: Faber, 1958).

**2**. The concept of situation was described by Dewey in his essay *The Educational Situation* (Chicago: University of Chicago Press, 1902). Situations are the distinctive relationships existing between an individual and the objective conditions of the environment. Because the relationship between the individual and the environment is a product of what both bring to each other, each individual is, to some degree, in a unique situation.

**3**. Under William Bennett's leadership of the U.S. Office of Education, the publication *What Works: William J. Bennett's Research about Teaching and Learning,* ed. Dana B. Ciccone, 2d ed. (Wooster, Ohio: Wooster Book, 1996), prescribed existing procedures for implementation by professional teachers.

**4**. See Donald Schon, *The Reflective Practitioner* (New York: Basic Books, 1983).

**5**. See Nathaniel Gage, *The Scientific Basis of the Art of Teaching* (New York: Teachers College Press, 1978).

**6**. Elliot Eisner, "The Art and Craft of Teaching," *Educational Leadership,* 40 (January 1983), 4–13.

**7**. For a full exposition of how such feedback might be provided, see Elliot Eisner, *The Enlightened Eye: Qualitative Inquiry and the Enhancement of Educational Practice* (New York: Macmillan, 1991).

**8**. The recognition of the inadequacy of standardized testing procedures for assessing the quality of education is reflected in the term *authentic assessment.* Authentic assessment is by implication a critique of "inauthentic assessment," the kind normally employed in schools.

**9**. Robert Browning, "Andrea del Sarto (called 'The Faultless Painter')," in *Victorian Prose and Poetry,* ed. Lionel Trilling and Harold Bloom (New York: Oxford University Press, 1973), 543–549.

**10**. See Dewey's discussion of flexible purposing in *Experience and Education* (1938; reprint, New York: Collier Books, 1963).

**11**. Maxine Greene, *Releasing the Imagination* (San Francisco: Jossey-Bass, 1995).

**12**. Richard Harker, Cheleen Mahar, and Chris Wilkes, eds., *An Introduction to the Work of Pierre Bourdieu* (New York: St. Martin's Press, 1990).

13. Ted Sizer, *Horace's Compromise* (Boston: Houghton Mifflin, 1992).

14. Eisner, *The Enlightened Eye*. See also David Flinders and Elliot W. Eisner, "Educational Criticism as a Form of Qualitative Inquiry," *Research and the Teaching of English,* 28 (December 1994), 341–357; and Elliot W. Eisner, *The Educational Imagination: On the Design and Evaluation of School Programs,* 3d ed. (New York: Macmillan, 1994).

15. See Michael Day, ed., *Aesthetics* (Los Angeles: J. Paul Getty Trust, Institute for Arts Education, 1995).

## CHAPTER 4: WHAT THE ARTS TEACH AND HOW IT SHOWS

1. See especially Rudolf Arnheim, *Visual Thinking* (Berkeley: University of California Press, 1969).

2. The concept of scaffolding has become prominent in theories of teaching. It is related to the work of Lev Vygotsky, a Russian psychologist concerned with teaching and learning. It is particularly relevant to his notion of a "zone of proximal development."

3. Lev Vygotsky, *Thought and Language*, trans. Eugenia Hanfmann and Gertrude Vakar (Cambridge, Mass.: MIT Press, 1965).

4. Lissa Soep, "To Make Things with Words: Critique and the Art of Production" (Ph.D. diss., Stanford University, 2000).

5. The idea that students might think like artists, or mathematicians, or scientists is related to Jerome Bruner's work, especially *The Process of Education* (Cambridge: Harvard University Press, 1960).

6. Nelson Goodman, *Ways of World Making* (Indianapolis, Ind.: Hackett, 1978).

7. See John Dewey, *Art as Experience* (New York: Minton, Balch, 1934).

8. See Jean Piaget, *The Construction of Reality in the Child* (New York: Basic Books, 1954).

9. See Rudolf Arnheim, *Art and Visual Perception* (Berkeley: University of California Press, 1954).

10. See Jonathan Matthews, "Mindful Body, Embodied Mind: Somatic Knowing and Education" (Ph.D. diss., Stanford University, 1994); and George Lakoff and Mark Turner, *More than Cool Reason* (Chicago: University of Chicago Press, 1989).

11. John Dewey, *Experience and Education* (New York: Macmillan, 1938).

12. James March, "Model Bias in Social Action," *Review of Educational Research,* 42 (1972), 413–429.

13. See Donald Schon, *The Reflective Practitioner* (New York: Basic Books, 1983).

14. See Arnheim, *Art and Visual Perception.*

15. Maxine Greene, "Imagination, Community, and the School," in *Releasing the Imagination: Essays on Education, the Arts, and Social Change* (San Francisco: Jossey-Bass, 1995), 35.

16. See Elliot W. Eisner, *The Enlightened Eye: Qualitative Inquiry and the Enhancement of Educational Practice* (New York: Macmillan, 1991).

17. Harold Rosenberg, *The De-Definition of Art: Action Art to Pop to Earthworks* (New York: Horizon Press, 1972), 103.
18. See Eisner, *The Enlightened Eye*.
19. See Richard Siegesmund, "Reasoned Perception: Art Education at the End of Art" (Ph.D. diss., Stanford University, 2000).

CHAPTER 5: DESCRIBING LEARNING IN THE VISUAL ARTS

1. See Jean Lave, *Understanding Practice* (Cambridge: Cambridge University Press, 1993).
2. Lev Vygotsky, *Mind in Society* (Cambridge: Harvard University Press, 1978); and Alexander Luria, *Language and Cognition* (Washington, D.C.: V. H. Winston, 1981).
3. John Dewey, *The Educational Situation* (Berkeley: University of California Press, 1902).
4. See Laurel Tanner, *Dewey's Laboratory School* (New York: Teachers College Press, 1997); and Arthur Efland, *A History of Art Education: Intellectual and Social Currents in Teaching the Visual Arts* (New York: Teachers College Press, 1990).
5. See Carolyn Edwards, Lella Gandini, and George Forman, eds., *The Hundred Languages of Children: The Reggio Emilia Approach to Early Childhood Education* (New York: Ablex, 1993).
6. Susanne Langer, *Philosophy in a New Key* (Cambridge: Harvard University Press, 1979), 23.
7. John Dewey, *Art as Experience* (New York: Minton, Balch, 1934).
8. Jonathan Matthews, "Mindful Body, Embodied Mind: Somatic Knowing and Education" (Ph.D. diss., Stanford University, 1994).
9. Rudolph Arnheim, *Art and Visual Perception* (Berkeley: University of California Press, 1954).
10. Rhoda Kellogg, *Analyzing Children's Art* (Palo Alto, Calif.: Mayfield, 1970.
11. Anna Kindler, "From Endpoints to Repertoires: A Challenge to Art Education," *Studies in Art Education*, 40 (Summer 1999), 330. See also Kindler, ed., *Child Development in Art* (Reston, Va.: National Art Education Association, 1997).
12. See Harold Rosenberg, *The Tradition of the New* (New York: Horizon Press, 1959).
13. Viktor Lowenfeld, *Creative and Mental Growth* (New York: Macmillan, 1947).
14. Ibid., 131–132.
15. Ernst Gombrich, *The Story of Art* (New York: Phaidon, 1961).
16. See Arnheim, *Art and Visual Perception*; John Matthews, *Art of Childhood and Adolescence* (London: Falmer, 1998).
17. M. M. Bakhtin, *The Dialogic Imagination: Four Essays*, ed. Michael Holquist (Austin: University of Texas Press, 1981).
18. Jessica Davis, "The 'U' and the Wheel of 'C': Development and Devaluation of Graphic Symbolization and the Cognitive Approach at Harvard Project Zero," in Kindler, *Child Development in Art*, 45–58.

**19.** David Perkins, *The Intelligent Eye: Learning to Think by Looking at Art* (Santa Monica, Calif.: Getty Center for Education in the Arts, 1994).

**20.** Leo Steinberg, *Other Criteria: Confrontations with Twentieth-Century Art* (New York: Oxford University Press, 1972).

CHAPTER 6: THE CENTRALITY OF CURRICULUM AND THE FUNCTION OF STANDARDS

**1.** For a discussion of the place of the computer and its uses in schools, see Larry Cuban, *Oversold and Underused: Computers in Classrooms, 1980–2000* (Cambridge: Harvard University Press, 2001).

**2.** For an account of the major orientations to curriculum development see Elliot Eisner and Elizabeth Vallance, *Conflicting Conceptions of Curriculum* (Berkeley, Calif.: McCutchan, 1974). Also see Elliot Eisner, *Handbook of Research on Curriculum,* ed. Philip W. Jackson (New York: Macmillan, 1992).

**3.** The absence of evaluative feedback is likely to engender "secondary ignorance," not knowing that you don't know.

**4.** Curriculum planning ultimately comes down to the activities in which students will be engaged. It is these activities, their possibilities and their limitations, that define opportunities to learn. Inventing such activities is a fundamental professional task in curriculum development.

**5.** The general tendency is for educators leaning to the philosophical left to place greater emphasis on emergent considerations and opportunism in teaching than do those leaning to the right, who tend to emphasize a more systematic, planned sequential approach to curriculum and instruction.

**6.** Elliot Eisner, *The Educational Imagination,* 3d ed. (New York: Prentice Hall, 1994). See especially chap. 9.

**7.** Marcy Singer, "Sound, Image, and Word in the Curriculum: The Making of Historical Sense" (Ph.D. diss., Stanford University, 1991).

**8.** See Elliot Eisner, *Cognition and Curriculum Reconsidered* (New York: Teachers College Press, 1994).

**9.** For a sophisticated discussion of curriculum integration and issues related to it see Basil Bernstein, "On the Classification and Framing of Educational Knowledge," in *Knowledge and Control: New Directions for the Sociology of Education,* ed. Michael F. D. Young (London: Collier-Macmillan, 1971), 47–69.

**10.** To be able to account for the impact of schooling on students' thinking and the values that they embrace will require a much more differentiated approach to assessment. The curriculum is but one feature in a complex system that includes the manner of teaching, what students bring to the occasion, classroom norms, peer values, and the like. See Jerome Bruner, *The Relevance of Education* (New York: W. W. Norton, 1971).

**11.** See Eisner, *The Educational Imagination.*

**12.** Franklin Bobbitt, *How to Make a Curriculum* (Boston: Houghton Mifflin, 1924).

13. See Robert Mager, *Preparing Objectives for Programmed Instruction* (San Francisco: Fearon, 1961).

14. Robert E. Stake, "Program Evaluation, Particularly Responsive Evaluation," in *New Trends in Evaluation*, Report no. 35 (Göteborg: Institute of Education, University of Göteborg, 1974), 1–20.

15. Standards have been formulated to describe not only expectations for student performance, but also expectations for teacher performance and for the content of curricula.

16. For a contrarian view of the state of American schools, see David C. Berliner and Bruce J. Biddle, *The Manufactured Crisis* (Reading, Mass.: Addison-Wesley, 1995).

17. See National Council of Teachers of Mathematics, *Curriculum and Evaluation Standards for School Mathematics* (Reston, Va., 1989); National Council of Teachers of English, *Standards for the English Language Arts* (Newark, Del.: International Reading Association and National Council of Teachers of English, 1996); National Council for the Social Studies, *The Curriculum Standards for Social Studies: Expectations of Excellence* (Washington, D.C., 1994); National Research Council, *National Science Education Standards* (Washington, D.C.: National Academy Press, 1996); Consortium of National Arts Education Associations, *National Standards for Arts Education* (Reston, Va.: Music Educators National Conference, 1994).

18. The concept of standards-based reform was developed by McRel Laboratories and can be found in their report. See Robert J. Marzano and John S. Kendall, *Designing Standards-Based Districts, Schools, and Classrooms* (Alexandria, Va.: Association for Supervision and Curriculum Development, 1996).

19. The concept of "world class" is widely touted, but its precise meaning is far from clear. What is also far from clear is its desirability.

20. Marzano and Kendall, *Designing Standards-Based Districts*, 88.

21. For a description of the efficiency movement, see Raymond Callahan, *Education and the Cult of Efficiency* (Chicago: University of Chicago Press, 1962).

22. John Dewey, *Art as Experience* (New York: Minton, Balch, 1934), 307–308.

23. Quoted in Callahan, *Education and the Cult of Efficiency*, 73–74.

24. For a discussion of Franklin Bobbitt's work see Elliot Eisner, "Franklin Bobbitt and the 'Science' of Curriculum Construction," *School Review Seventy-fifth Anniversary Issue*, 75 (Spring 1967), 29–47.

25. Franklin Bobbitt, *The Curriculum* (Boston: Houghton Mifflin, 1918), 6.

26. Robert Mager, *Preparing Instructional Objectives*, 2d ed. (Belmont, Calif.: Fearon, 1975).

27. See Elliot Eisner et al., *The Educationally Interpretive Exhibition: Rethinking the Display of Student Art* (Reston, Va.: National Art Education Association, 1997).

## CHAPTER 7: THE EDUCATIONAL USES OF ASSESSMENT AND EVALUATION IN THE ARTS

1. See "National Assessment: A History and Sociology," in *New Models for American Education*, ed. James W. Guthrie and Edward Wynne (Englewood Cliffs, N.J.: Prentice-Hall, 1971), 20–34.
2. Conceiving of evaluation and assessment as educational media implies thinking of these processes as ways to advance the educational process more than as procedures for classifying students.
3. With very few exceptions, curriculum materials designed by curriculum designers require the oversight and often intervention of teachers. As computers and their programs become more sophisticated, the role of the teacher with respect to curriculum may diminish. I do not expect it to evaporate.
4. See Elliot W. Eisner, *The Enlightened Eye: Qualitative Inquiry and the Enhancement of Educational Practice* (New York: Macmillan, 1991).
5. Ibid.
6. John Dewey, *Art as Experience* (New York: Minton, Balch, 1934). See especially chap. 13, p. 324.
7. Arthur Powell, David Cohen, and Eleanor Ferrar, *The Shopping Mall High School* (Boston: Houghton Mifflin, 1985).
8. Lissa Soep, "To Make Things with Words: Critique and the Art of Production" (Ph.D. diss., Stanford University, 2000).

## CHAPTER 8: WHAT EDUCATION CAN LEARN FROM THE ARTS

1. Evelyn Fox Keller, *A Feeling for the Organism* (New York: W. H. Freeman, 1983), 118.
2. John Dewey, *Art as Experience* (New York: Minton, Balch, 1934), 38; see especially chaps. 4 and 5.
3. Barbara Tuchman, *The Guns of August* (New York: Macmillan, 1962), 1.
4. George Donalson Moss, *America in the Twentieth Century*, 4th ed. (Englewood Cliffs, N.J.: Prentice Hall, 2000), 87–88.
5. Nelson Goodman, *Ways of Worldmaking* (Indianapolis, Ind.: Hackett, 1978).
6. See Denise Pope, "Doing School: 'Successful' Students' Experiences of the High School Curriculum" (Ph.D. diss., Stanford University, 2000).
7. Hannah Arendt, *The Human Condition* (Chicago: University of Chicago Press, 1998).
8. See Susanne Langer, *Problems of Art* (New York: Scribner, 1957).
9. Blaise Pascal, *Pensées*, trans. A. J. Krailsheimer (London: Penguin, 1995).
10. John Dewey, *Experience and Education* (New York: Macmillan, 1938).

## CHAPTER 9: AN AGENDA FOR RESEARCH IN ARTS EDUCATION

1. Perhaps the most significant development that has taken place in the American educational research community is the exploration of alternative assumptions about the nature of knowledge, the forms of legitimate

inquiry, and the modes of representation that can be employed to display what has been learned. These developments are consistent with growth in pluralism of many kinds: cultural, gender, racial, epistemological, and procedural.

2. On the relationship of objectivity to research, see Elliot Eisner, *The Enlightened Eye: Qualitative Inquiry and the Enhancement of Educational Practice* (New York: Macmillan, 1991); and Eisner, "Objectivity and Educational Research," *Curriculum Inquiry,* 22 (Spring 1992), 9–16.

3. These examples come from Nelson Goodman, *Ways of Worldmaking* (Indianapolis, Ind.: Hackett, 1978).

4. Ulric Neisser, *Cognition and Reality: Principles and Implications for Cognitive Psychology* (San Francisco: W. H. Freeman, 1976).

5. Robert Donmoyer, "Alternative Conceptions of Generalization and Verification for Educational Research" (Ph.D. diss., Stanford University, 1980).

6. See Tom Barone and Elliot W. Eisner, "Arts-Based Educational Research," in *Complementary Methods for Research in Education,* ed. Richard M. Jaeger, 2d ed. (Washington, D.C.: American Educational Research Association, 1988), 75–116.

7. *The Basic Works of Aristotle,* ed. Richard McKeon (New York: Random House, 1941). See especially the *Nicomachean Ethics* and *Physics.*

8. Joseph Schwab, *The Practical: A Language for Curriculum* (Washington, D.C.: National Education Association, Center for the Study of Instruction, 1970).

9. Michael Connolly and D. Jean Clandinin, *Teachers as Curriculum Planners* (New York: Teachers College Press, 1988).

10. See Eisner, *The Enlightened Eye.*

11. Pamela Orman Sharp, "The Development of Aesthetic Response in Early Education" (Ph.D. diss., Stanford University, 1981).

12. Kenneth Beittel and Robert Burkhart, "Strategies of Spontaneous, Divergent and Academic Art Students," *Studies in Art Education,* 5 (Fall 1963): 20–41.

13. Ellen Winner, "Mute Those Claims: No Evidence (Yet) for a Causal Link between Arts Study and Academic Achievement," *Journal of Aesthetic Education,* 34 (Fall–Winter 2000), 11–76.

14. The entire issue of the *Journal of Aesthetic Education,* 34 (Fall–Winter 2000), is devoted to an analysis of studies that claim to have discovered the effects of arts experiences on academic performance. This analysis, the best that exists in the field, leaves little doubt that most of the claims go far beyond any prudent appraisal of the evidence.

15. Richard Luftig, *The Schooled Mind: Do the Arts Make a Difference?* (Oxford, Ohio: Miami University, Center for Human Development, Learning and Teaching, 1993).

16. An example of a demographic study in art education is Charles Leonhard, *The Status of Arts Education in American Public Schools* (Urbana: University of Illinois at Urbana, Center for Research in Music Education, 1991).

17. Good examples of historical scholarship in the field of art education are Arthur Efland, *A History of Art Education: Intellectual and Social Currents in Teaching the Visual Arts* (New York: Teachers College Press, 1990); and Foster Wygant, *Art in American Schools in the Nineteenth Century* (Cincinnati, Ohio: Interwood Press, 1983). See also Diane Korzenik, *Drawn to Art: A Nineteenth Century American Dream* (Hanover, N.H.: University Press of New England, 1985).

18. For a well-written and thoroughly researched book on the life of Walter Smith see F. Graeme Chalmers, *A Nineteenth Century Government Drawing Master: The Walter Smith Reader* (Reston, Va.: National Art Education Association, 2000).

19. Janice Ross, *Moving Lessons: Margaret H'Doubler and the Beginning of Dance in American Education* (Madison: University of Wisconsin Press, 2000).

20. See Elizabeth Cohen, *Designing Groupwork*, 2d ed. (New York: Teachers College, Columbia University, 1994).

CHAPTER 10: SUMMARY AND SIGNIFICANCE

1. John Dewey, *Art as Experience* (New York: Minton, Balch, 1934).

2. David W. Ecker, "The Artistic Process as Qualitative Problem Solving," *Journal of Aesthetics and Art Criticism*, 21 (Spring 1963), 283–290.

# INDEX

Abstraction, children's art and, 105

Aesthetic experience: *v.* anesthetic, 81, 231; form shaped for, 81–82; imagination and, 82–83, 198–199; intrinsic satisfaction in, 202–204; outcome of art education, 44–45; savoring, 207; teaching practices, 58–59; in world, 231–232

Arnheim, Rudolf, 16, 35–36, 76, 101

Art education: aims of, 24, 25–27, 232–233; creative self-expression approach to, 32–33; discipline based (DBAE), 25–28, 156; *v.* efficiency value, xiii; factory model and, 166; German Bauhaus tradition of, 30–31; impact on cognition, 12–15, 24, 35–38; in integrated arts curriculum, 39–42; outcomes of, xi–xiii, 70–92, 121–125, 240–241; position in school curriculum, xi, 158; principles of, 42–45; representational forms and, 102; transfer effects of, 38–39, 218–224; visual culture approach to, 28–30; workplace skills approach to, 33–35. *See also* Assessment and evaluation; Children's art; Curriculum; Learning; Research on art education; Teaching

Artistry: defined, 81–82; in teaching, 48–49, 152, 202

Arts: cognitive functions of, 9–12, 36–37; consciousness transformed by, 19–24; cultural influences on, 43, 89–90, 124; educational contributions of, 3–4, 196–208, 234–235; improvisation and surprise in, 78–79, 235–236; integrated curricula, 39–42, 153–159; personal growth through, 240–241; qualitative relationships in, 231; sensory exploration in, 4–5. *See also* Aesthetic experience; Art education; Representation

Assessment and evaluation, 178–195; art educators' view of, 178–179, 238; clinical *v.* broad-based, 182–183, 190–192; of cognitive process, 192–193; connoisseurship and, 187; criteria for, 183–184; criticism and, 187–189; of curriculum, 150, 184–187; defined, 178; formative judgments, 238; misconceptions about, 179–181; research on procedures, 228–229; responsive, 161; student-conducted, 193–195; unintended outcomes and, 70–71

Attention, 108, 112

Barkan, Manuel, 28

Bauhaus tradition of art education, 30–31, 38

Beittel, Kenneth, 218

Benchmarks, 165–166

Bobbitt, Franklin, 159, 171–172

Bruner, Jerome, 27, 28

Burkhart, Robert, 218

Canonical images, 213

Chalmers, Graeme, 29

Children's art: abstraction and, 105; age-related patterns in, 103–105; exhibition of, 176; expansion of technical repertoire, 113–115, 144, 146; imagination and, 113; intent of, 100–101; Lowenfeld's stages of, 105–106; perceptual differentiation in, 101; postmodern approach to, 102; preschool, 115–120; primary and secondary school, 119, 120–121, 125–147; unconscious process in, 102, 103, visual realism and, 112–113

Clandinin, Jean, 214

Classroom milieu, 74–75, 157, 216

Classroom norms, 73–74

Clinical assessment, 182–183, 190–192

Cognition: assessment and evaluation of, 192–193; broad conception of, 148; concept formulation and, 22–23; defined, 9; functions of arts, 9–12, 36–37; impact of art education on, 12–15, 24, 35–38, 148; learning and, 107–111; metaphorical, 12; representation and, 5–8, 14, 15; research on, 217–218. *See also* Perception

Cognitive culture, 74

Communication function of representation, 6–7, 239

Comparative analysis, 200–201

Concepts, formulation of, 21–22

Connoisseurship, educational, 57, 187

Connolly, Michael, 214

Consciousness, sensory, 1–2, 108

Conventional signs, 18

Creative self-expression, 32–33

Crit (student-conducted assessment), 193–195

Criteria *v.* standards, 169–170

Criticism, educational, 54, 57, 187–189

Culture: classroom, 74–75, 157; communication and, 7; creation of, 3–4; defined, 2–3; influence on art, 43, 89–90, 124; in integrated curriculum, 154–155; schools as, 3, 157–158

Curriculum, 148–177; art activities, 150–152; assessment and evaluation of, 150, 184–187; cognition and, 13, 37–38, 148, 240; common frames in, 85; constraints and affordances, 71–72; explicit and implicit, 158–159; integrated arts curricula, 39–42, 153–156; *in vitro*, 149; null, 159; objectives-oriented approach to, 159–161; public education on, 175–176; research on, 227–228; routine, 56; standards-based, 161–175; student input and, 152–153; teacher-proof, 149–150; views of art education and, 156–157, 163. *See also* Art education; Learning; Teaching

Davis, Jessica, 119–120

Demographic research, 224–225

*Designing Standards-Based Districts, Schools, and Classrooms* (Marzano and Kendall), 165–166

Dewey, John: on aesthetic-intellectual relationship, 199; on art criticism, 187; on artistic expression, 99; on criteria *v.* standards, 169–170; on flexible purposing, 77, 206; on intelligence in art, 14–15, 43; on perception of visual qualities, 12–13, 68; on situated learning, 94, 246n.2

Dialogic process, 111

Discipline-based art education
(DBAE), 25–28, 156
Donmoyer, Robert, 213

Editing process, 6, 239
Educational connoisseurship, 57, 187
Educational criticism, 54, 57, 187–189
Educationally interpretive exhibition, 176
Efficiency movement in education, 170–171
Entry points to teaching, 52
Environment design, 47–48, 57
Evaluation. *See* Assessment and evaluation
Exhibition of children's art, 176
Experimental attitude, 63–64
Experiments: laboratory, 211; on transfer effects, 220–224
Explicit curriculum, 158
Expressive form of representation, 16–19, 87
Expressive outcomes, 161

Flexible purposing, 51–52, 77–79, 205–207
Frames of reference, 45, 84–86, 107–108

Generalizations: canonical images, 213; statistical, 212
German Bauhaus tradition of art education, 30–31, 38
Goals, flexibly purposive, 51–52, 77–79, 205–207
Goodman, Nelson, 36–37, 75, 201
Greene, Maxine, 83

Historical research, 225–227
*How to Make a Curriculum* (Bobbitt), 172

Iconology, 18
Ignorance, primary/secondary, 49

Imagination: aesthetic-intellectual relationship, 198–199; arts' cultivation of, 4–5, 82–83, 236; children's art and, 113; form and structure, 99; teaching and, 53
Implicit curriculum, 158–159
Improvisation, 78, 160, 164, 235–236
Infants, communicative intent of, 100
Inscription function of representation, 6
Integrated arts curricula, 39–42, 153–156
Intelligence, artistic, 14–15, 43, 77, 232

James, William, 1
Jung, Carl, 33, 102

Keller, Evelyn Fox, 198–199
Kellogg, Rhoda, 102
Kendall, John S., 165–166
Kindler, Anna, 102

Langer, Susanne, 2, 12, 98–99
Language: adequacy of art descriptions, 165; distinctions expressed by, 100; as form of representation, 8; literary, 59; metaphor in, 98–99; self-regulation and, 110–111; teacher's modeling of, 54, 59; technical, 92, 95; transformation of experience into, 60–61, 86–89, 98–99; value of nonliteral language, 204–205, 230–231; visual qualities expressed by, 13
Learning, 93–147; assessment of, 186–187; classroom milieu and, 74–75, 157, 216; classroom norms and, 73–74; cognitive skills and, 107–111; individual rates of, 166; multiple sources of, 235; problem resolution and, 95–96; school culture and, 3, 157–158; sequential, 96–97; situated, 47, 93–95; task

demands and, 71–72; teacher prompts/scaffolding and, 72–73; technical repertoire, 109–110, 113–115, 144, 146; transfer effects of, 38–39, 218–224. *See also* Perception
Life drawing classes, 76
Lowenfeld, Viktor, 32, 33, 105–106
Luftig, Richard, 223
Luria, Alexander, 94

McClintock, Barbara, 198–199, 214
McRel Laboratory, 165
Maps, cognitive functions of, 11
Marzano, Robert J., 165–166
Materials and tools: constraints and affordances of, 236–238; introducing, 59–60, 61; as medium, 79–81; qualities of, 62; teacher's mediation of, 185–186; teacher's skills with, 53–54, 55
Matthews, John, 100–101, 113
Metaphor, 12, 98–99
Mimetic form of representation, 15–16, 17

National Assessment of Educational Progress (NAEP), 182
Neisser, Ulric, 36, 213
Nonobjective art, 17
Null curriculum, 159
Nursery schools, 118–119, 120

Objectives, flexibly purposive, 51–52, 77–79, 205–207
Objectives-oriented approach to curriculum, 159–161
Objectivity, research, 211–212
O'Keefe, Georgia, 64–67, 69

Perception: in children's art, 101; as cognitive event, 36; differences in, 58–59; frames of reference and, 45, 84–86; instrumental, 12–13, 83–84; new orientations to, 68; outcome of art education, 91; of

relationships among components, 75–76; somatic knowledge and, 19, 76–77
Perkins, David, 122
*Philosophy in a New Key* (Langer), 2
Piaget, Jean, 76, 120
Play, imaginative, 4–5
Postmodern view of children's art, 102
Powell, Arthur, 189
Preschool children's art, 115–120
Problem resolution, 95–96
Problem solving objectives, 160–161
Prompt cues, 72–73
Purposing, flexible, 51–52, 77–79, 205–207

Read, Herbert, 32–33
*Red Poppy* (O'Keefe), 64–67, 69
Reggio Emilia program, 94
Representation: cognitive function in, 5–8, 14, 15; combined forms of, 18–19; conventional signs, 18; editing process in, 6, 239; expressive, 16–18, 87; mimetic, 15–16, 17; selecting form of, 8–9, 23
Research on art education, 209–229; agenda for, 209; of cognitive process, 217–218; of creative strategies, 218; of curriculum, 227–228; demographic, 224–225; of evaluation procedures, 228–229; historical, 225–227; shifts in view of, 209–215; of teaching, 215–217, 228; of transfer effects, 38–39, 218–224
Rightness of fit, 75–76, 201, 231
Rosenberg, Harold, 87–88
Ross, Janice, 226

Satisfaction, intrinsic, 202–204
Scaffolding, 73
Scholastic Aptitude Test (SAT) scores, impact of art experience on, 38–39, 218

School culture, 3, 57–58

School performance: impact of art education on, 38–39, 218–219; standards, 166

Schwab, Joseph, 214

Science, imagination in, 198–199

Scientific management, 170–171

Scientific research, 213

Self-directed activity, 61

Sensibility, 5, 108

Sensory system: arts' role in, 4–5; consciousness and, 1–2, 108; culture and, 2–3; learning and, 98–100; stimulation of, 20–21

Sequence, teaching in, 55–56

Sequential learning, 96–97

Sharp, Pamela Orman, 217

Situated learning, 47, 93–95

Smith, Walter, 225–226

Soep, Lissa, 193

Somatic knowledge, 19, 76–77, 121, 231

Spalding, Frank, 171

Stake, Robert, 161

Standardized tests, 38–39, 50, 192, 218

Standards-based curriculum, 161–175

Statistically oriented research, 212

Steinberg, Leo, 122

Storytelling functions of visual form, 16

Strand, Paul, 10

Surprise, 7–8, 78–79, 164, 235–236

Synesthesia, 86

Tactile experience, 86

Taylor, Frederick, 170

Teaching, 46–69; artistry in, 48–49, 152, 202; assessment of, 185–186; case studies, 58–69; in community of learners, 95; designing environment for, 47–48, 57; effects of, 49–51; entry points in, 52; feedback on, 49, 57; impediments to artistry in, 56–58, 164; improvisation and surprise in, 7–8, 78–79, 164; nonteaching approach and, 46, 233–234; in nursery schools, 118–119, 120; purposes/intentions in, 51–52; research on, 215–217, 228; skill requirements for, 53–56; standardized tests and, 50; teacher-initiated activities, 139, 143, 144; teacher prompts, 72–73. *See also* Art education; Curriculum; Learning

Technical repertoire, 109–110, 113–115, 144, 146

Thematics, 189

Thinking. *See* Cognition

Transfer effects of art experience, 38–39, 218–224

Visual culture orientation in art education, 28–30

Visual realism in children's art, 112–113

*Visual Thinking* (Arnheim), 36

Vygotsky, Lev, 73, 94

Whitehead, Alfred North, 203

Workplace skills approach to art education, 33–35

Writing. *See* Language

Zone of proximal development, 73